PLAYGROUND

Growing Up in the New York Underground

PLAYGROUND
Growing Up in the New York Underground

Paul Zone with Jake Austen
Foreword by Debbie Harry and Chris Stein

Glitterati
INCORPORATED

New York | London

First published in 2014 by

Glitterati
INCORPORATED

New York | London

New York Office
322 West 57th Street #19T
New York, New York 10019
Telephone: 212 362 9119

London Office
1 Rona Road
London NW3 2HY
Tel/Fax +44 (0) 207 267 9479

glitteratiincorporated.com
media@glitteratiincorporated.com for inquiries

First edition, 2014
Library of Congress Cataloging-in-Publication
data is available from the publisher.

Hardcover edition ISBN 13: 978-0-9881745-5-9

Art Director Pau Garcia

Printed and bound in China by CP Printing Limited
10 9 8 7 6 5 4 3 2 1

DEDICATION

For
Miki & Mandy
and Vita Maria

ACKNOWLEDGMENTS

Thank you,
Debbie Harry & Chris Stein
and Lance Loud.

Special thanks to Marta Hallett & Pat Loud
and Don Marino, for support and encouragement.

With love to Claudio and Camille.

Thank you, Jake Austen
and
Louis Bova; Leee Black Childers; Jayne County; Peter Crowley; International Crysis; Donna Destri; Frank DiGangi; Viki Galves; Richard Gottherer; Emile Greco; Gail Higgins; Kristian Hoffman; James Kleinbergs; Mary "Spanky" Laflure; John Matkowsky; Debi Mazar; Lydia Lunch; Tommy Mooney; Ian North; Denny O'Connor; Ric Ocasek; Bobby Orlando; Man Parrish; Mary Nizzari Perry; Lisa Jane Persky; Binky Phillips; Howie Pyro; John Sex; Marc Shaiman; Dorothy Famali Van Ooy; Steven Van Zandt; Arturo Vega; Scott Wittman; Tony Zanetta; and Jane Wagner & Lily Tomlin.

CONTENTS

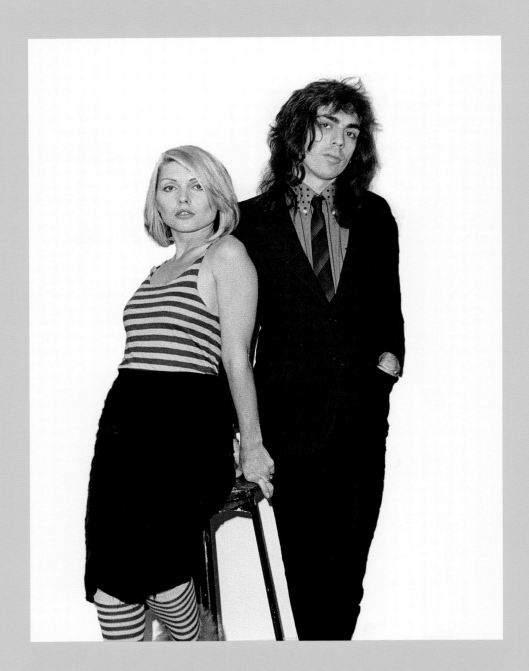

Debbie Harry
and Chris Stein,
1976

FOREWORD

Debbie Harry and Chris Stein

Paul Zone has always been one of our closest friends from the downtown New York scene. He is more well-known to those in the inner circle than to the masses.

He is a mover and shaker and style-maker. Back in the day, he often acted as a therapist to many of us who were subject to the caprices of the milieu.

The story of The Fast, the Zone brothers' band, was heroic. One of our favorite aspects of it was how all of Paul's friends and followers gently pressured his two older brothers, Mandy and Miki, into finally letting Paul front the band in spite of his youth. It seemed like a no-brainer. Had Miki and Mandy not passed away at the start of their game, The Fast would be in the mix of the New York bands that are standardly referenced now.

We miss those times, but, more, we miss the people that are gone.

Paul happily is still with us, and his photos from the period give us an intimate window into that world.

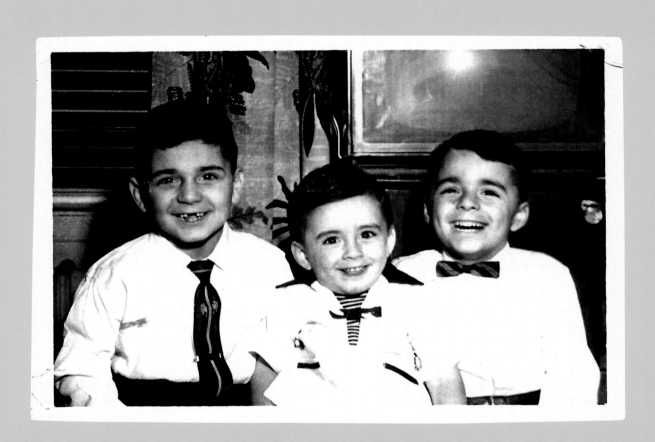

Miki Zone, Paul Zone,
and Mandy Zone,
1959

PREFACE

Jake Austen

Paul Zone was not a better singer than his brother Mandy. He was more traditional perhaps, and he had better pitch, but in the creatively explosive world of the early seventies' New York underground music scene, with its shaky marriage of the avant-garde and the lowbrow, Mandy's bizarre falsetto was certainly more valued than Paul's resonant crooning.

Yet when Debbie Harry and Chris Stein of Blondie (at the time, almost as obscure as the Zone brothers' band, The Fast) and Lance Loud suggested to Miki that his brother Paul should replace Mandy as lead singer, not only did no one object, but the band kicked themselves for not thinking of it sooner. This wasn't because Paul was prettier or had better hair (though he was, and he did), but rather because Paul Zone had become the perfect embodiment, perhaps even the mascot, of a scene where everyone—even broke junkies playing for a dozen people at a dive bar or others who weren't in bands—could declare themselves a rock star . . . and be right.

Even before joining The Fast, Paul Zone was at the heart of this scene. He was a celebrity DJ before that concept existed. He did hair and styling for his countless friends, and he habitually snapped photos that captured the glamour and goriness of the early Max's Kansas City and CBGB scenes. Though technically Zone was a professional photographer (he had a handful of pictures in *PUNK magazine* and a couple in *CREEM* and *Rock Scene*), he was really a hobbyist, and in some ways a prop. He was the make-believe paparazzo for Blondie and others, long before anyone cared about taking pictures of them. And he was the fantasy fashion photographer for such hopelessly unfashionable "scenesters" as the Ramones, transgendered diva Wayne County, and the parade of dangerous girlfriends that kept the musicians on their toes. Though Zone was untrained and used a cheap camera (often showing up un-sober), his photos capture a vibrant scene, and reveal the profound appreciation of style and showmanship that Zone had been developing since his preteen years, when he and his brothers found themselves aghast at the shoddy couture of the Woodstock nation, instead gravitating toward the freak-out, proto-glam of early Iggy and Alice, and the androgyny of the British mods.

Zone's omnipresence in the scene culminated in photographs no one else could have taken. Because his ubiquity and sincere schmoozing made him friends with nearly everyone, Zone could capture moments of realness even in posed photos. Chris and Debbie challenge anyone to try to usurp their glamorous urinal. Dee Dee Ramone and his bloodthirsty girlfriend, Connie Gripp, share lipstick and distant gazes. And in one of his greatest images, Zone takes what could have been a hokey shot (beautiful singer/writer/proto-reality star Lance Loud posing against the New York City skyline) and turns it into a loving portrait that conveys intimacy, lust, and the magic of living for the moment. The portrait is made even more poignant because late 2001 would mark heartbreaking finales to the star of the foreground (Loud died of Hepatitis C-related complications) and the background (the World Trade Center was destroyed in the September 11 attacks). Though Zone's compositions drew from the conventions and clichés of fashion and rock music magazines of the seventies era, his genuine relationships with his subjects made these stolen moments magical.

Rapport with his subjects may have been Zone's secret weapon, but his knock-out punch was his absolute devotion to, and understanding of, showmanship. Growing up in a middle-class Italian neighborhood in New York, the Zones faced the wrath of schoolmates, neighborhood bullies, and their own father every day by attending

school in vibrant, absurd outfits that made them look like circus clowns to their peers. The Zones wore makeup, feathers, spandex, and angel wings—and not only on stage. Paul was disgusted in the seventies when Jobriath, the flamboyantly gay would-be Bowie usurper, referred to his stage ware as a "costume." To Paul Zone, makeup, glitter, metallic fabric, tights, and giant sunglasses were not for a masquerade or a joke. They were for real life.

Because of this attitude Zone is able to seize images with an understanding that would elude most photographers. In perhaps the most striking photo in the collection, a regal Alan Vega of Suicide, his face painted gold and silver, his head covered by a Dolly Parton wig, pouts for the camera, holding his microphone like a royal scepter. Annie Leibovitz could have never taken this photo, not only because she wouldn't have been at this bizarre basement show (the Zones and four friends were the only ones who showed up), but more importantly, because neither she, nor Bob Gruen (who admits being frightened the first time he saw the New York Dolls playing), nor even Andy Warhol, could ever understand the true meaning of Vega's golden dome the way Zone could.

The Fast had a long career—perhaps longer than they should have. They had some highs in the seventies (pioneering the power pop/new wave sound, becoming the house band at Max's, recording with Ric Ocasek, lead singer of The Cars) and long years of trudging along, relentlessly touring and self-releasing records. Their escapades reached an apex in the mid-eighties with a phenomenal dance music triumph, immediately answered by a devastating tragedy.

But the photos in this book are not about a lengthy journey or a dramatic story arc. These photos capture one incredible moment in cultural history, a scene in which everyone was a superstar and everyone was a loser, where the gritty streets, bars, and bathrooms of New York City were a 24-hour stage. Showtime was all the time, and though a handful of LPs, a few snatches of film, and several collections of writing and oral history document that show, you would be hard-pressed to find a better representation of the majesty, drama, and mortality that marked the birth of punk than the snapshots of Paul Zone.

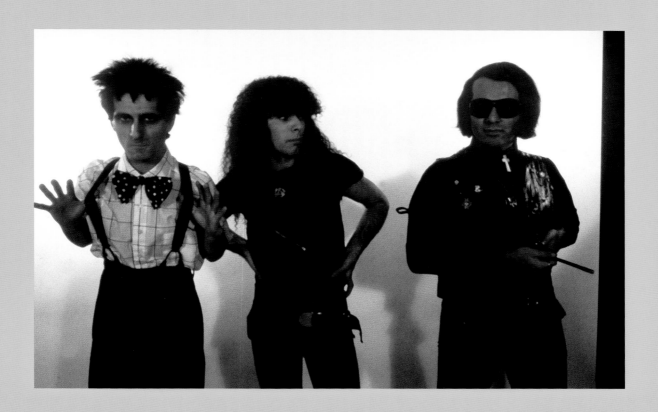

Miki Zone, Paul
Zone, and Mandy
Zone, 1976

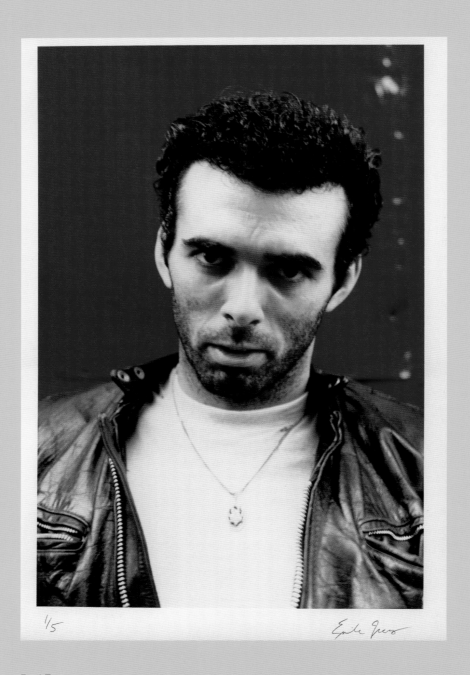

1/5 Emile Grevo

Paul Zone,
1983

INTRODUCTION
Paul Zone

When most people reminisce about their teenage years they might recall playing sports, high school friends, a wild spring break, or a couple of really fun summers. When I recall my early teens, I think about the nonstop fun and excitement of spending my nights with rock stars, underground actors, the New York Dolls, drag queens, drug addicts, painters, artists, and the perpetual madness at Max's Kansas City and CBGB. Growing up, the people and places we attach ourselves to make us who we are, and to be a fourteen-year-old under that kind of influence surely shaped who I am today, good and bad. Due to my young age and unconventional surroundings, I didn't blink an eye at things that would have made most adults blush. It was like being on a never-ending roller-coaster ride.

By the time I entered high school at the birth of the seventies, I had already been perfectly schooled in rock 'n' roll by my older brothers, Miki and Mandy, who had formed a basement band. I would soon find my place alongside them in the music scene as well. I had decided to become a photographer, or should I say, a person who took pictures of rock 'n' roll personalities. I wasn't sure how to achieve this feat, but I was already going to concerts with my brothers, sneaking in a camera to take photos from the back of the auditorium. Soon after I would find myself on the lip of a much smaller stage, taking pictures of friends in bands that only myself and a handful of others in the New York underground cared about. A few years later the whole world would start to care about them.

My high school years were an academic disaster; the only classes that interested me were art, music, and photography. The photography courses at my school in Brooklyn were so inadequate that they discouraged the use of 35mm cameras, so I ended up shooting photos of underground rock royalty with a 110 Instamatic, a Brownie, and a Polaroid. Even after I got my $65 Nikon 35mm, I didn't use it as my main camera, swapping it out for the lesser models indiscriminately. I never thought the camera made a difference, figuring it was the subject that was most important.

In the early seventies no one really cared what you did, and everyone experimented with sexuality and drugs— at least in Manhattan. Brooklyn was another story. Going out to concerts and clubs until 4 a.m., then going to school by 8 a.m. was rough, especially because I had to remove my makeup for school. But I stubbornly wore my platform boots, satin pants, and glitter shirts, which didn't make things easy. My brothers and I were determined to establish ourselves in the city and leave our backward borough far behind.

Photographing at big concerts rarely worked out, but when we would go to the clubs I was always comfortable snapping away at friends and bands I knew. And everyone was our friend (it was so easy to meet people at small clubs), and almost everyone was in a band, or thinking about starting one. The New York Dolls; Wayne County; Debbie Harry and Chris Stein; and Patti Smith and Suicide were already performing in 1973 and 1974, and my brothers' band, The Fast, began cementing themselves into the scene as well. By 1975 the underground had expanded with the Ramones, Television, and Talking Heads. Taking photos during my nights out was natural, comfortable, and satisfying. Friends wouldn't be on guard and never shied away from my lens. I was close to them, I was trusted, and no one felt I was being intrusive.

In 1975 I started to sing with The Fast and had less time for photography, so snapping pictures was downgraded from my mission to my hobby. But looking back on my photos I'm so glad I had a camera around my neck throughout the seventies. For a teenager whose playground, classroom, study hall, and gymnasium were the New York underground, these snapshots became my high school yearbooks.

Drawing for Paul's
first show singing,
June, 26, 1976

AUTOBIOGRAPHICAL TEXT

Chapter 1 > At the Center of the Universe

New York City is the center of the universe. Just ask any New Yorker. And in 1976 everyone I knew agreed that Max's Kansas City was the center of it all. On June 26, 1976, all eyes at Max's were on me. Minutes earlier, Debbie Harry of Blondie waved a checkered flag, kicking off Max's debut of our band, The Fast, finally playing the club we'd been haunting since we were underage eavesdroppers hovering around David Bowie in the backroom. As sirens blared, my brother Mandy (dressed like a rock 'n' roll vampire) fired up the Farfisa, while the working headlight we'd wired into his keyboard bathed the crowd in blinding light. My brother, Miki, hit the frantic first chords of his absurd power-pop composition, "Motorcycle Mania." And I stormed the stage in a checkerboard-patterned jumpsuit, my explosion of corkscrew curls bouncing wildly as I wailed Miki's preposterous lyrics.

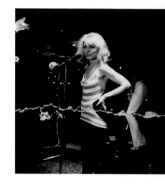

Debbie Harry
introduces The Fast,
June 26, 1976

The club was packed with a dream team of incredible human beings that night. There was Joey, Dee Dee, and Johnny Ramone, who'd played some of their first shows opening for us; David Johansen and Jerry Nolan from the New York Dolls, our gateway band to the New York underground; Lance Loud, America's first reality TV star, and the best friend I ever had; Lux and Bryan from the Cramps; Ace and Paul from KISS; Jimmy and Chris from Blondie; as well as Neon Leon, Kristian Hoffman, Wayne County, and Lydia Lunch. These were all people we loved! In this corner were the neighborhood guys who had chased me around Brooklyn a few years earlier because I was the only kid in school wearing glitter and sequins. In that corner was our manager, Tommy, the owner of Max's, who'd later tell us he invited "a bunch of important people" that night that all left with smiles on their faces. We saw Bobby Orlando, a fan of The Fast who'd soon invite us to record in his tiny studio, where he'd one day build a dance music empire. And most importantly, looking magnificent in a black silk pantsuit, was our number one fan: Our mother, Vita Maria, beamed with shameless pride as her three flamboyant boys conquered the stage.

It was pouring rain outside, but inside it was applause that rained down on us as we finished our first set, the race car show. We'd have a new theme and outfits for the second set. I was euphoric, high on the promise that our years of hard work were paying off and positive that hit records, glorious TV appearances, and lucrative world tours were our destiny. Though my dreams were as outrageous as my wardrobe, fate would prove me clairvoyant, as all those ambitions would eventually come true. What I could not have imagined then was that it would take a grinding decade for it all to happen—and that our glorious success would be coupled with devastating loss.

>>>

I suppose The Fast started in 1965, on Christmas Day, when my mom gave Miki his first guitar, a Sears Silvertone, complete with an amp and a speaker in the case. Our cousin Anthony taught him to play, and for the next few years he'd practice chords and write songs, fantasizing about rocking and rolling like his favorite British bands.

But Miki was saturated with music and pop-star ambition long before he played his first lick, so The Fast really started on January 23, 1954 when Miki Zone (my parents mistakenly named him Bruno, after my father's father) was born. Seventeen months later his future bandmate Mandy (originally Angelo, after my mother's father) came into this world, and on March 7, 1957 his most loyal musical collaborator, and biggest fan, Paolo, Jr. (the future Paul Zone), joined the act. Though he wouldn't rename us for a decade, Miki was always making sure rock 'n' roll

was the most important part of our lives. Credit should also go to our older sister, Camille, who never was in the band, but always had all the right records.

We lived in Boro Park in Brooklyn, a mostly Italian and Hassidic middle-class community, and were raised in a nice house, each with our own room. My parents were both children of immigrants, but had grown up thoroughly American. I'm sure there were some Italian-American stereotypes our family lived up to (we had plastic on the furniture so you couldn't mess up the furniture, and sheets over the plastic so you couldn't mess up the plastic), but for the most part, we weren't clichés. While my siblings and I were in Catholic school we attended services every Sunday, but once we graduated we never went to church again; in fact, no one in our family did. I had some distant uncles that might have been involved in crime, but no close relative was connected to anything like that. And as far as family being first, that was not how my father operated.

The most important thing in Paolo, Sr.'s life was his past, when he served as a Marine during the battle of Iwo Jima in World War II. Stateside, as a beautiful seventeen-year-old in uniform, he won my mother's heart. Overseas, as an MP sergeant, he won the war. When my father talked to anyone, which wasn't often, this was what he talked about.

Even though my mother told us he'd wake up screaming every night for years after returning from combat, he considered those his best days. When he would tell war stories they were never aggressive, never about killing. They were heroic tales of how he and his buddies carried Japanese families on their backs to safety, or survival stories of spending months up to his neck in slush, covered in slugs, leeches, and lice. War was glory to him, he loved serving, and he loved his buddies in the barracks.

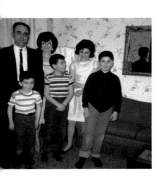

Dad, Paul Zone, Mom, Mandy Zone, Camille, and Miki Zone, 1964

But we never met his old bunkmates, and my father never hung out with any men. When relatives came over he would sit in a room with the women (mostly talking about food), never with my uncles. They talked to my father if they needed to know how to fix a car or a toilet, but they didn't socialize with him. My father never watched a ballgame in his life, and the only time he held a baseball bat was to chase us around when he lost his temper.

He'd wake up every weekday at 4 a.m. to leave for his city job, working as a foreman for the sanitation department. When he got home in the afternoon he'd work for himself as an electrician, carpenter, and plumber in the neighborhood. He was well respected for his work and could be charming or funny in small doses.

But we were not charmed, rolling our eyes when he'd bark at us in Marines' jargon, yelling for us to, "Move out!" At the dinner table, if he asked you to pass the salt and you shook some on your own food before delivering it, he'd scream, "No shortstopping! In the war if you did something like that everyone would throw their napkins at you!"

We weren't afraid of my father. We all had such strong personalities, so much confidence, and such happy lives when he wasn't around, that being fearful didn't figure in. But we had no respect for him whatsoever. Life was genuinely great until the time he came home for dinner, when we'd all sit around the table in weird silence, waiting for something to set him off. I remember wondering as a kid if men used to tell their co-workers at the end of the shift that they were heading home to yell and fight and hit their kids.

My father beat us. By the time I was nine he was hitting me with an open hand or a wooden spoon. I remember crouching in a corner while he whipped me with a belt, my mother screaming, "Don't hit him!" He'd lose his temper about something that was said, or some chore undone, and the next thing we knew he'd be chasing us down

the block, throwing the garbage can at us. Our rooms had locks on the doors, but all the moldings were off kilter because he'd break the doors down so often.

He never struck my mother.

My father was definitely an alcoholic, though I never saw him drunk. He would wake up in the morning and slug whiskey out of the bottle, then drink beer throughout the day. It was never enough to make him stumble, just enough to dull his disappointment in his three strange sons.

Before he gave up on us, there were a couple of things my father did to try to set us straight. He took me on jobs at times, attempting to impart life lessons. "Never do anything for less than $100," he'd tell me, advice The Fast didn't always heed. And when we were younger he'd take us fishing off the pier near the Verrazano Bridge. I remember these trips being awkward, but they may have meant more to Miki, who became completely obsessed with fish, always keeping aquariums, decorating his rooms with aquatic themes, and working on a nautical rock opera called *The Magic Seashore* for the rest of his life. Our friend, Lisa Jane Persky, thinks Miki's decisions to study marine biology in college and wear sailor gear on stage may have been Freudian responses to my father's stint in the Marines, which I doubt. (That would make more sense if he'd been in the Navy.) But fish were a central theme of Miki's life and work.

But by the time my brother was fourteen his music obsession left no time for fishing, and our father dismissed us as lost causes. But there was one thing he did that made a significant contribution to punk-rock history. My father kept his basement workshop locked. After we became a part of the New York underground, Joey, Dee Dee, and Arturo Vega from the Ramones used to come over when we'd rehearse in the basement, and they'd joke about what was in my father's locked room. "That's where Paul and Miki and Mandy keep the shock treatment machine that keeps them so happy," they'd say. They threatened to write a song about it, and the first few times they played "Shock Treatment" Joey announced, "This song is about the Zone Brothers."

Dad, Japan, 1940s
(second from right,
top row)

Although it never occurred to me back then, considering that all of his kids ended up being gay, I now wonder if my father struggled with his sexuality. His isolated hours in his workshop, his lack of friends outside the family, and the way he spoke reverently about being around all those guys in the barracks make me curious. To his credit, he never called us out for being flamboyant or different, even when we were older and obviously living openly gay. When he'd scream, "No good is going to come from your lifestyle," it was because we were musicians, not gay. "That's no kind of life," he'd say. "You got to work with your hands!"

But as bad as things were with my father, my mother loved us so much it made up for it. I have talked to her every day for my entire life, and I still can't figure out what their relationship was about. But she was always there to get between him and his targets, to protect us. And she was always there, along with her sisters, and her mother, to make sure our young lives were wonderful.

On the one hand, we were spoiled rotten. We had whatever we wanted: bicycles, clothes, records, anything. When the band became the thing, we got guitars, amplifiers, lights, and a public address system.

On the other hand, there was no judgment. When I started getting stylish at age eight, wearing my belts cocked to the side, or going to the girls' department to buy puffy-sleeved jackets, or midriff-baring tops, she never questioned me when I said this was the way rock stars dressed. She was a homemaker who taught me how to

use the sewing machine and took me to fabric stores to buy textiles with stars or polka dots to make outfits for myself and the band, even when the band was more conceptual than real.

Our glitzy clothes had nothing to do with gayness or sexuality, but had to do with the Zone brothers living the pop-star life. The clothes did not represent our wanting to be pop stars; for us, it was about deciding we were already pop stars, and had to dress this way. Our zeal for the spotlight was something our mother connected with. Though she'd never sung (other than around the house with her sisters), she'd fantasized about being a big-band singer as a girl, and would wait in line backstage at the Paramount and the Brooklyn Fox to get autographs from Frank Sinatra, Benny Goodman, and all the stars. She hoarded scrapbooks and movie magazines, and is still an avid fan of old-time stars. She especially loves the books about who was gay and who was involved in scandals.

Our mother let us do whatever we wanted in our rooms behind locked doors. She let us turn the basement into a practice room. And between 5 a.m. and 5 p.m., when our father was away, she let her house become a warm, welcoming place for all our friends, even in the mid-seventies when our friends included misfits like the Ramones. In the Max's days we'd bring our buddies back to Brooklyn after the club closed at 4 a.m., arriving just after my dad left for work. My mother would greet us with pancakes, eggs, and bacon. She never treated us like we were doing anything bad, and we weren't doing anything bad. We were just playing rock 'n' roll and making friends, and she understood that.

However, my mother was not the family role model who blazed the trail for the eccentric Zone boys. That would be my mother's mother, who was a complete freak. Our grandmother would dress up in crazy outfits, coming downstairs to greet us in a hula skirt or a wedding dress. One time she came down dressed as the Pope.

She was also supernaturally lucky. When we'd go to bazaars she would always bring a shopping cart because from the moment we entered she'd start winning raffles and contests and games, and by the end of the night the cart would be filled with toasters, dolls, and other prizes. Her husband was also great. He had a company that pumped black oil out of a giant truck into people's basements, and he'd always give us wine when we visited. He had no other male grandchildren, so when we went to church as kids he took us in his giant Cadillac every Sunday to St. Patrick's Cathedral on Fifth Avenue. It was the only day he drove that car.

My grandmother would host sex Tupperware parties with boob Jell-O molds and lipsticks shaped like penises. It was mostly joke stuff, but that may have been a cover so these suburban women could access actual sex toys and vibrators. Where else were they going to buy that stuff back then? My mother and all the females in the family would go to these and let us hang out in the house, always close enough so we could see everything going on.

My grandmother was wild, but she was also generous and loving, and holidays were always at their house. That was where we'd hear live music when we were little. Our uncles would play guitars, accordions, and spoons, and everyone sang. My grandmother sang Sophie Tucker songs, and my mother and aunts did the Andrews Sisters. Years later when she'd host Thanksgiving or Christmas she'd let us bring members of Blondie or other young people that were away from their families. Whether it was a touring musician or a teenage runaway stripper we hung out with at Max's, my mom and grandmother would make them feel at home. The first time my boyfriend Bucky met my grandmother she asked him, "Do you like dirty magazines, because I got a lot of them." There's no doubt my mother let us be who we had to be because of the influence of her big-hearted, off-the-wall mother.

Mom with sisters
Paula and Betty,
Easter Sunday,
1967

>>>

Because Miki made it clear that music was our future, we didn't take school too seriously, academically or socially. In grammar school I never played a sport, was never in a club, and had no school friends until I started hanging out with girls in sixth grade, including Donna Destri, who remains one of my best friends. Years later we helped her brother, Jimmy, become Blondie's keyboard player.

By seventh grade I refused to wear my school uniform, and was expelled several times for wearing satin pants, platforms, and outfits decorated with stars, stripes, and sparkles. I simply couldn't comply with a dress code: As soon as I came of age I knew this is who I was and this is how I would dress.

Observing this credo in Brooklyn should have gotten me beat up, but it never happened. Boys would call me names, I'd have to strategically navigate my way home to avoid confrontation, and I sometimes got chased. But I never got caught, and I've never thrown a punch in my life. At school I took classes where I wouldn't have to deal with people who might bother me, classes like home economics, sewing, art, and photography (all of which also helped with the band).

Paul Zone (going to see Bowie at Carnegie Hall), 1972

I did tone things down when my father got home. At the dinner table we'd all tuck our hair into our collar so he wouldn't see how long it was getting. I'll never forget how we had to handle my dad the time Bowie played Radio City Music Hall and Gene Shalit was outside interviewing people. He chose me, probably because I had my hair painted silver, with red lipstick over my eyelids. Before we went into the show I rushed to a phone booth and called my mother to make sure my father didn't watch the 11-o'clock news, and it worked. But the next day at school (with traces of red still over my eyes) I got called into the principal's office. "We saw you on television last night," the Catholic nun said, "and we don't want that kind of thing going on here."

My brothers went to an all-male technical and vocational high school in Brighton Beach, but all they seemed to get from it was how to fix amps and rig lights. I was forced to go there also, and met two music-loving longhairs, Vinny Appice, whose brother Carmine was in Vanilla Fudge (Vinny later joined Black Sabbath) and Angelo Arcuri (who later played bass with John Lennon). The three of us convinced our mothers to let us transfer to a regular high school in Bensonhurst. I never graduated because I failed eight terms of gym (which is funny, because I go to the gym almost every day now). After that I considered going to the School of the Visual Arts, but my dad thought that anything other than taking the sanitation exam was a waste of time. Considering that we had an outrageous rock band, dressed like freaks, and all turned out gay, it's incredible that the thing that enraged and offended my father more than anything else was my brothers briefly going to Brooklyn College. The prospect of them becoming something other than a blue-collar worker had my father one hundred percent horrified. "Fucking Joe College up there," he'd spit out whenever the subject came up, his eyes angrier than when he beat us as young boys. By our early teens he had given up on hitting us. The fight was over.

The Fast was our main concern long before school ended. I can remember Miki and Mandy being hypnotized by the Beatles and Rolling Stones on TV when I was seven. They were always interested in the British bands more than American groups, and after Miki finally got his guitar, the ambitious fourteen-year-old and his thirteen-year-old vocalist Mandy spent 1968 and 1969 in the basement playing "Words" by the Bee Gees (his favorite

group); "Tattoo" by The Who (his heroes); and "Dedicated Follower of Fashion" by The Kinks. They soon recruited my cousin to play drums, forming a real (though basement-bound) band, and other early members included a friend's cousin on bass, a drummer named Mike we got through the classifieds, and even Donna Destri, jamming Alice Cooper's "Black Juju" on organ. But the lineup that eventually stuck included two of Mandy's classmates, drummer Peter Hoffman and bassist Tommie Mooney. They weren't the sharpest rhythm section in the tri-state area, but they were good looking, willing to dress up, and they were down for anything Miki dreamed up.

And Miki was a dreamer. He never considered joining another band, and never played with another guitarist. His trips to the sole record store in Brooklyn that sold British imports, coupled with train rides to Manhattan to see America's last hopes, the Stooges and Alice Cooper, convinced him that his band wouldn't cover top 40 or play boring blues rock. He wanted to be the space-age Monkees and the bubblegum Who. His favorite adjective became "animated," because he wanted his band to become a living Saturday morning cartoon. He knew that fashion and flash were as important as anything else. While other kids were thinking about homecoming and prom, Miki was in shop class cutting out plywood heels to turn his old shoes into platforms that he later painted silver and covered with rhinestones.

As soon as Miki thought they were ready, the band started playing anywhere they could, and even though it was only school auditoriums and battles of the bands, they went all out. With our mom's financial backing we bought smoke machines, feather boas, angel wings, and stage lights that Miki and Mandy would wire using their vocational school know-how. My mother and I sewed glitter trim on bright green blazers and stars on red satin scarves. Miki's concept, "Science Fiction-Acid Rock," was a poor fit alongside the boogie rock cover bands and acoustic post-hippies we shared stages with. At block parties we'd be asked to play the "Hokey Pokey" for neighborhood children, and instead we'd cover Alice Cooper's "Is It My Body" and spray fire extinguishers in the air while Mandy yielded a plywood star on a stick like a psychedelic majorette.

Of course we'd never be invited back, so Miki would change the band name to trick places into re-booking us. Originally called Clown Wrasse, named after one of the exotic fish Miki was obsessed with, we became For Sale, and later Cold Power. But by 1972 we were The Fast, and that title stuck.

Even though I wasn't technically a member in the early days (I was only thirteen years old, but looked sixteen), I never thought twice about my place in the band. People who came to see us often said to me, "I thought that was your group?" I just told them it was. I was in The Fast since the band started; I just wasn't on stage. Even though he was proud of his songs, Miki knew The Fast wasn't just about music. I designed and sewed the wild clothes. I did the styling. I worked the lights, the door, and played records before and after the set. I was the band photographer. And from the earliest days of the group I was cutting and styling hair for my brothers and our friends. Years later when we started hanging out in the city I continued the practice, grooming such greats as Debbie, Clem and Jimmy of Blondie, Ian of Milk 'n' Cookies, and Dee Dee Ramone. In fact, Dee Dee, who had some hair-cutting experience, gave me pointers in my parents' basement on how to hold the scissors correctly and how to balance layers.

I did perform with the band once, sort of. I played tambourine, Miki played guitar, and Miki and Mandy sang the Bee Gees' "Holiday" when our sister got married on October 30, 1971. It was the only wedding we played, but far from our most unusual gig.

We'd do anything. We'd play in the back of empty restaurants. We'd play in the park. We'd play high school

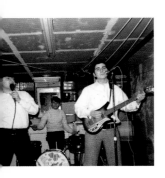

Basement Band,
1968

dances. We played the Brooklyn College cafeteria during lunch. The funny thing is that even when we started to make it we continued to play schools. In 1975 The Fast and Blondie played a dance at Hawthorne High in New Jersey. Can you imagine being an adolescent boy and having Debbie Harry in your gym?

Though Miki's ambition, Mandy's stage presence (his cocky charisma and bizarre falsetto made Brooklyn audiences cringe, but eventually made Manhattan crowds fall in love with him), and my outfits would have been enough, what put The Fast over-the-top was theatricality. The props, shtick, and extracurricular activity included pounds of flying glitter, buckets of confetti, and girls called "the Fastettes," handing out "eat me" cookies at our "Direct From Wonderland"-themed performances. Inspired by Alice Cooper breaking open pillows on stage, with a subsequent explosion of feathers, we'd rip open boxes of Cheerios, showering the audience in oats. Miki would buy $30 guitars, play them for the last number, and then saw them in half. After discovering a store named Think Big that sold giant objects, Miki developed his most ridiculous bit, "the pencil solo," which featured a seven-foot-long, bazooka-sized #2 yellow pencil. The combination juggling act/guitar-hero solo/vaudeville bit had Miki stuffing a hundred pencils in his shirt and pants, under his armpits, and between his legs, until he could hardly move. This was followed by a fifteen-minute guitar solo whereby he'd liberate himself by using all the pencils as picks, hammers, slides, and arrows, ultimately using the giant pencil as a violin bow. It made no sense musically, but in The Fast's world, it was perfect.

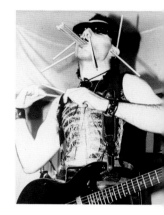

Miki Zone,
1981

When our crowd-challenging antics left us with nowhere in Brooklyn to play, we'd invent our own venues. We started rehearsing a few blocks from our house in a decrepit, closed-down discothèque underneath the 46th Street Theatre in Bay Ridge, Brooklyn called the Foundation. An old alcoholic and his wife lived in the basement and we'd pay them $20 a day to rehearse and store gear, practicing for thirty hours a week on stage with a full lightshow. We'd put up posters and have shows there, and a dozen of our friends would show up. There was really no place for a non-cover band to play in Brooklyn, and we quickly discovered that there wasn't much of an audience for one either.

What we had to do was make the transition from Manhattan audience members to Manhattan band. The city had become our second home, as several times a week the Zones would be joined by one or two rock 'n' roll guys and a half dozen girls from the neighborhood, going to concert after concert. Seeing the Bee Gees at Philharmonic Hall, the Stooges at Electric Circus, and The Who doing *Tommy* at the Fillmore and the Metropolitan Opera House inspired us to make our shows more outrageous, despite audience ambivalence and talent judges' rejections. Probably the first show we saw that wasn't at a large concert hall was the band Sparks, upstairs at Max's. That set was so amazing that to honor Ron Mael, I became the only teen in Brooklyn sporting a Hitler moustache to school.

We didn't only go to rock concerts; we liked disco, too. Unlike the "Disco Sucks" people later in the seventies who saw dance music as a threat to rock 'n' roll, we'd also go to Brooklyn and Manhattan discos. That music meant a lot to us, and when the New York underground was at its most intense, we were proud to be worshipping ABBA, Kraftwerk, and Donna Summer. We were really excited when the Bee Gees moved to Florida and started working with rhythmic-backing musicians. Our openness to dance music would serve us well later on.

Going into the city with our adventurous friends was its own reward, and seeing international glam superstars play Manhattan's grand venues had us fantasizing about The Fast's future glories. But in May of 1972 one souvenir we picked up in Manhattan led us to re-access our dreams and worship a whole new set of heroes. We picked up the *Village Voice* every week to read album reviews and concert listings, but the idea that the paper

was a key to unlock a world where unknown bands played raw, loud, dirty music in cramped, re-purposed hotel halls and hole-in-the-wall nightclubs, was outside of our worldview. The only bands we'd ever seen that did not have records out were the terrible cover acts we lost to in battles of the bands.

In the days before Craigslist, small ads and classifieds in alternative weeklies were your best source to promote naughty, damaged, or unusual goods and services. While we were not in need of escorts, it turned out that we were the perfect demographic for a different kind of deviant act. Staring at us from the black-and-white newsprint were five pretty boys with shaggy hair, heavy eyelids, and wild clothes dominating a small advertisement declaring "New York Dolls Invite You Beyond the Valley." To say we were intrigued is an understatement. These guys looked nothing like the typical American rock bands. They had an off-kilter androgyny that reminded us of the British groups we were fascinated with; but there was something else to them, something original that we'd never seen before. It didn't look like the Dolls were dressing up, it looked real. All we knew for sure was that we had to find out more, we had the $2.50 admission, and we had to see them. What we didn't know was that this tiny advertisement would unlock the door to a fantastic world that would alter our perception, validate our follies, and change our lives.

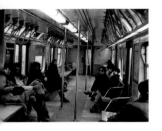

F train to
Manhattan,
1972

Chapter 2 > New York Glitter Rock

I can't remember why we had to miss the New York Dolls show at the Diplomat that we first saw advertised, but two weeks later we headed into New York City to discover what they were all about. Miki, Mandy, and I first caught the Dolls at the premiere night of their residency at the Mercer Arts Center, and our initial descent into the underground was not only thrilling . . . it was a revelation. At big shows during the dirty jeans/post-Woodstock era, my brothers and I would be part of a scattered handful of people making a statement by dressing flamboyantly like our favorite British acts. Walking into the Mercer and seeing everyone dressed like *us* was like a religious awakening. We instantly knew that we had found the place we wanted to be and the people we wanted to be around. As I snapped pictures of some of the most beautiful, fashionable, fearless individuals I'd ever seen, I realized that the outlandishly attired, relentlessly denigrated, perpetual oddball Zone brothers finally fit in!

The Mercer was 35,000 square feet of Greenwich Village real estate, housed in the old Broadway Central Hotel, and broken up into theaters that mostly hosted plays that regular people might attend, like *Macbeth* or *One Flew Over the Cuckoo's Nest*. There was a piano cabaret called the Blue Room for theatergoers to grab a drink and a space for experimental film/video and avant-garde music in the kitchen (which evolved into the Kitchen, an arts space that still exists on West 19th street). But for us the Mercer was about something else, thanks to dancer/actor/musician/artist/Warhol star Eric Emerson, whose band, the Magic Tramps, brought outrageous rock 'n' roll performances to the Oscar Wilde Room. Emerson, well known on the scene for being a wild, willing stud to men and women alike, went to California in 1971 to be the lead singer in the Magic Tramps and soon brought the band back East where they became the first glitter rock act in Manhattan. Looking like a rock 'n' roll version of San Francisco's theatrical hippy drag troupe the Cockettes, they wore feathers, lace, spangles, sparkles, velvet, paisley, satin, glitter, colored tights, and face paint. They were the first band without a record contract to play Max's Kansas City, but the most historical thing they ever did was invite the New York Dolls to be their opening act at the Mercer, allowing the most important band in the pre-punk underground to develop, and putting the venue on the rock 'n' roll map. The Center, which opened in December 1971, closed when the Broadway Central collapsed on August 3, 1973. In that brief window it was the capitol of the underground.

We saw the Dolls at the Mercer every Tuesday for months, and were introduced to the kaleidoscopic swirl of artists that made up the pre-punk New York underground. We loved the bizarre, experimental Magic Tramps, the boisterous, gender-bending Wayne County, the abrasive, minimalistic Suicide, and the theatrical, naughty Ruby and the Rednecks. But none of them could compete with the Dolls. The fashion and the moves and the attitude that David Johansen, Johnny Thunders, Sylvain Sylvain, Arthur Kane, and Billy Murcia brought to the stage were like nothing we'd ever seen. Even if guitarists Thunders and Sylvain were playing secondhand blues riffs, somehow they made it all seem fresh and new. The band had an amazing vision and their early audiences loved them deeply. We caught them at the Mercer, the Diplomat hotel, the Coventry club in Queens—we'd follow the Dolls anywhere. We quickly came to know everyone in the bands, and everyone in the audience (it was a tiny scene back then). I always had a camera in my shoulder bag, hung around my neck, or tucked in my pocket, and I couldn't believe the images I was capturing. That summer was a turning point for us, a brief window of time that set the course for the rest of our lives.

In October the Dolls went to London to open for Rod Stewart, where Billy, their drummer, asphyxiated in a bathtub after overdosing. Undeterred, the Dolls returned to the Mercer on December 19, starting their set with Chuck Berry's "Back in the U.S.A." Suzi Quatro's drummer, Jerry Nolan, took Murcia's seat, and Thunders looked amazing in his girlfriend Janis Cafasso's black monkey fur coat.

The Dolls' shows kept getting bigger and more exciting, peaking with their New Year's Eve concert at the Mercer with Ruby and the Rednecks, the Magic Tramps, Jonathan Richman and the Modern Lovers, and Wayne County. Inspired by that magical night my brothers and I made a New Year's resolution: 1973 would be the year that The Fast become a part of the New York glitter scene.

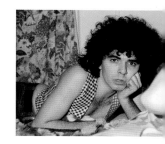

Paul Zone,
1973

Since The Fast's first public shows in 1971 the act had developed from satin pants, platform shoes, and frilly shirts to over-the-top fantasy wear, incorporating and going beyond what we had seen at the Mercer Arts Center. We were completely unknown, so it was very difficult to find our way onto Manhattan stages. The first thing we did was get money from our mom to rent out little theaters and put 2" x 2" ads in the *Village Voice*, always with some ridiculous band photo I took. We'd flood shows with flyers in hope that maybe some of the other acts and their audiences would be interested. We were constantly making friends with bands and trying to get on their shows as an opening act, or play at (or rent) some of the same venues they were playing. The first performance The Fast did in Manhattan was at the Abbey Theatre, a run-down, off-off Broadway-type storefront with a small stage and velvet seats. We created a dynamic show with an *Alice in Wonderland* theme. There was a candy cane backdrop, strobes and sirens, and an intro tape playing audio clips from *Alice in Wonderland* and *The Wizard of Oz*. The flyers and *Village Voice* ad ("Direct from Wonderland . . . The Fast") must have worked because the place, although far from full, was well-stocked with the type of colorful people we'd come to love. Like many shows those days, it seemed like most of the audience was in other bands. Along with members of Milk 'n' Cookies, Harlots of 42nd St., the Planets, Another Pretty Face, and the Magic Tramps, Paul and Gene from KISS showed up. Paul was obviously taken by Miki's big black heart on one eye and the next time we saw KISS, Paul was sporting a black star over his eye. But it was an era of rapid transitions, and by that time we had already moved on to another look.

KISS was a band we never expected to amount to anything. Like the Dolls and The Fast, KISS would rent out hotel ballrooms, charging a few dollars at the door, hoping to draw fifty to a few hundred adventurous music fans (we played the Hotel Diplomat's Townhouse Theatre, a tiny room with seats, while the Dolls and KISS played the hotel's 300+ capacity ballrooms). KISS would pack the Diplomat with suburban boogie-rock followers, and though their music wasn't too different from the minimalist rock 'n' roll of the Dolls, we never considered KISS a cool, underground band. Maybe it had something to do with their black-and-white makeup and hard-edged leather costumes that defied glam's Technicolor androgyny. In retrospect, what probably turned us off was exactly what KISS founder Gene Simmons would be most proud of: their calculation and ambition. The hotel sets that we saw as parties they saw as showcases.

But we had plenty of like-minded allies. We became good friends with Wayne County and his band Queen Elizabeth after we showed up early to see them at the The Circus, only to find the band loading out gear because the fire marshal discovered violations. We went to a bar with the band and they invited us to start opening for them at clubs like Coventry, Marshmallows (in New Jersey), and Mothers. The fact that we owned our own PA and lights we could share didn't hurt the relationship, but Wayne really was our first true friend and supporter from the scene. The Fast played our first show with Wayne on a day my parents were taking me on a weeklong cruise to South America that they had been planning for six months. Of course, I did not go. I figured, South America will always be there—but how often can you see Wayne County and The Fast at Coventry?

There were so many amazing bands in those days. The first time we saw the Planets was their debut show, opening for the Dolls at the Mercer. Miki bonded with Planets' guitarist Binky Philips through their mutual love of Pete Townshend, and we became good friends and shared many stages. Another Pretty Face was from Pennsylvania but relocated to New York just in time for the Club 82/Diplomat/Coventry glory days, and The Fast often played with them. They had a huge following, and singer T. Roth was really captivating. Though I remember them as mostly being a glam cover band, they had original songs that embraced gay themes and sounded similar to Jobriath. We would see Ian North and Justin Strauss of Milk 'n' Cookies at all the same shows we were going to (Dolls, Sparks, and Iggy) and all the same clubs we were hanging out at (Max's, Club 82, and Coventry). At the first Manhattan show at the Abbey they told us they also had a band, and we quickly became close, and started sharing bills. Ian North would later help us produce some of our most important recordings, and would briefly join The Fast in 1981.

Not many people were drawn to Alan Vega and Martin Rev's challenging duo Suicide the way we were. When they performed at the Mercer Arts Center my brothers and I would often be the last people in the room after Alan chased audiences to the exits by terrorizing anyone close enough for him to jump on, kiss, lick, or smear his silver face paint on. When they would play their loft on Green Street sometimes we and our girlfriends would be the only people to show up. We knew they were fantastic, with Alan whispering, crying, screaming, dancing, and sometimes even singing along with Martin's thunderous, crackling, and distorted, broken-down keyboards, fantastically sequenced with his drum machines so that they seemed to be playing themselves. At their best they excited and entertained us with theatricality and genius possessed by no other act in the scene at the time. We loved Suicide and couldn't be happier when New York and the world caught up with a band we thought to be our discovery.

Of course, the Dolls were still our obsession. We would regularly take the train into Manhattan during the day to hang around the St. Mark's Place clothing stores so that we'd see the band shopping with their girlfriends and entourage. To us this was the perfect way to get our faces noticed by chatting with them about their show later

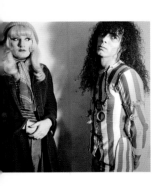

Wayne County
and Paul Zone,
December, 1977

that night. The "Dolls' women" were as exciting as the band; Johnny's girlfriend, Janis Cafasso, and David's girlfriend, Cyrinda Fox, were the best-dressed women on the scene. Arthur Kane's girlfriend, Connie Gripp, gained infamy for trying to cut off his thumb, and sealed her reputation as hazardous to bassists a few years later when she stabbed then-boyfriend Dee Dee Ramone, inspiring the scornful song, "Glad to See You Go." (She was also the "girlfriend crying in the shower" in the song "Chinese Rocks.") In 1973 the Dolls released their debut LP. One month after it came out they played ten shows in five nights at Max's Kansas City, and we were there for most of them. With their album finally released and a tour booked across the US, we were sure they were on their way to becoming the biggest band in the world. The last day of the Max's stint was when Connie maimed Arthur Kane because he refused to take her on the tour. Cast on hand, Kane left for California, leaving Gripp behind—reluctantly, according to bandmate Sylvain Sylvain.

Throughout 1973 The Fast hustled to play shows, and we continued to haunt the underground, my eyes wide as saucers as I snapped photos of new friends so strange and glamorous, as though they came right out of my imagination. But we still loved overground rock 'n' roll as well, and never missed Alice Cooper, The Kinks, Sparks, Lou Reed, Bowie, or Queen in concert. But we saw everything through a different lens. When we caught T. Rex on the *Slider* tour they had two 30-foot-tall pasteboard photos of Marc Bolan descend from the rafters to open the show. Even though The Fast had a Cheerios budget, we took things like this as both an inspiration and a challenge to make our stage shows as spectacular and optic as possible. I had been a big fan of Bolan from back in his Tyrannosaurus Rex days and was hoping T. Rex would conquer America just as they had the UK. In March of 1971 I had seen them at Carnegie Hall, promoting *Electric Warrior* (one of my favorite LPs of all time), and he was amazing, becoming my favorite pop star (until Bowie became Ziggy Stardust in the summer of 1972). But after that, Marc Bolan began to seem bloated and unspectacular to me, which was a good metaphor for the way all mainstream rock felt compared to the visceral, participatory magic of the New York underground.

Although Max's is now considered one of the birthplaces of New York punk, the original version of the club, owned by Mickey Ruskin, was a place where national touring bands played upstairs, important painters and writers hung out downstairs, and Andy Warhol presided over the back room. But it was inspirational to future punk rockers, both before our era (the Warhol-sponsored Velvet Underground used it as a home base), and during our first years playing in Manhattan, because the club embraced glam acts like Alice and Iggy. So even though none of us (other than the Dolls and Magic Tramps) played there, we all went to the shows. At Iggy and the Stooges' set in the summer of 1973 it was fantastic to see him dancing and jumping around, collapsing onto a table covered with drinks, then emerging on stage, dripping with blood from the broken glass on his chest. We knew or soon would know so many people in the stunned audience that night. There were members (or future members) of the Dolls, Milk 'n' Cookies, the Ramones and Blondie; photographer/behind-the-scenes impresario Leee Black Childers; Bowie tour manager Tony Zanetta; Wayne County; and many more familiar faces. For concerts Max's wasn't always a hangout place; you would usually go to the show and then leave, but if Mickey let you get a table in the back room you stayed all night. Anyone could come into Max's and hang out in the bar/restaurant or go to a show upstairs, so it wasn't exclusive like Studio 54, but Ruskin definitely curated the downstairs, and he always let us in. I don't blame him—I was 15 and wearing feathers, platforms, satin trousers, platform shoes, with my head held high. I was obviously underage, but I was adorable!

As much as we loved hanging out at Max's, there was nothing like seeing our friends' bands play, and prior to Tommy Dean taking over Max's, the club in the city that best knew how to pull this off was Hilly Kristal's CBGB, which opened at the end of 1973. The Bowery bar eventually became the home of Television, Patti Smith, the

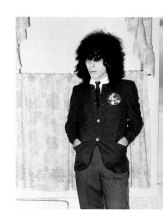

Paul Zone,
1974

Ramones, and Blondie, so we made it our home, as well. Kristal was really supportive of the bands and the scene. He was always at the door so none of us regulars had to pay, and he always said, "hi," and treated us nicely. Because The Fast would eventually be so closely associated with Max's, we didn't play CBGB as much as some of our peers, but the shows we played there were memorable, and I took some great photos at that club.

We said goodbye to 1973 at the Academy of Music with a spectacular concert by Iggy and the Stooges, touring behind the *Raw Power* LP. When the spotlight drenched Iggy's pale body, with his white terrycloth short-shorts and bleached silver hair, it looked like he was nude, glowing, and haloed—our glitter rock angel! On the bill that night were headliners Blue Öyster Cult, Teenage Lust, who played before the Stooges, and show openers KISS, who had yet to release their first album. I'll never forget Gene Simmons accidentally setting his hair on fire that night, and the band shooting flares over the audience, so low that the flares hit someone.

Chapter 3 > Post-Glam/Pre-Punk

The year 1974 was decent for The Fast, but for me it was a landmark. It was the year I became friends with some of my favorite people in the world.

I suppose we had seen the members of the Ramones at shows in 1973, but we didn't meet them until Dee Dee and Johnny ran into us on 48th Street in early 1974 and introduced themselves, telling us that they were fans, and that they were headed into Manny's Music Store to "take the plunge," as Dee Dee called it. Johnny later said that the Ramones were born that day when he bought his Mosrite at Manny's, so I guess we were there from the beginning. They rehearsed at a place called Performance Studios where their friend Monte worked, and when they felt they were ready they gave out flyers inviting people into their practice space for shows. They asked us to headline one of their first Performance Studio parties, and over the years we'd play together many times, especially after I became The Fast's lead singer. It was a wonderfully weird time, a post-glam/pre-punk moment where scenesters were mixing black leather jackets with colorful platform shoes, so it was great to see the Ramones exert a kind of fashion purity.

Joey Ramone was as nice, sweet, and caring a person as you could ever meet. Though he was quiet as a mouse and shy and giggly, when he did speak he'd be witty and funny, joking around or making really clever off-the-cuff comments. We used to listen to records in my room, and when the Ramones first went to England Joey brought me back some great British pub rock records by Dr. Feelgood and Joe Strummer's band, the 101ers. Maybe the best thing about being a part of this scene was having people who liked what you did, or wore, or played, gravitate toward you and show you the kind of love that really means something. To get that, and be able to return it, is very, very special.

My first sighting of Arturo Vega was at a Dolls show in 1974. He was disguised in a colorful Mexican wrestling mask with a long black horsetail of hair coming out from the top, wearing a leather jacket with lettering across the back spelling out "NUEVA YORK." Less unusual, for our scene at least, were his black stilettos, which the King of New York style, David Johansen, was so comfortable in, and a few years later would become a signature look for Lux Interior of the Cramps. Once Arturo connected with the Ramones and became their non-performing fifth member, Johnny (who dictated members' wardrobes) must have seen his theatrical garb as unfitting attire. I became close friends with Arturo and spent many nights in his loft around the corner from CBGB marveling

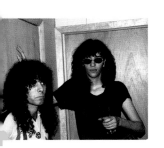

Paul Zone and
Joey Ramone,
1975

at his oversized paintings of grocery store specials. His artistic talent is well documented: Vega designed the Ramones logo, t-shirts, and some of their early LP covers, as well as creating the dramatic lighting for their live performances. He also helped me design and paint a few large backdrops for The Fast.

Joey, Arturo, Dee Dee, and other friends used to come to our house in Brooklyn after the clubs closed at 4 a.m. My dad left for work at 4:30 or 5:00, so we were sure to get there after he'd left. We'd phone our mom and tell her we were on our way, and she would get up and start cooking big platters of pancakes, eggs, and bacon. We'd sit around in our bedrooms or in the basement playing records and messing around for a couple of hours and then crash out on the sofa and in our rooms.

One evening in 1974 I met Lance Loud; this was one of the most important nights of my life. Club 82, a fading drag cabaret turned glam rock hangout, was hosting a New York Dolls show. I was running around and doing what I usually did; snapping photos, talking to everyone, popping backstage, and promoting The Fast. I met Lance and told him The Fast would be performing the next week, and after he came to that show we were inseparable. To PBS viewers Lance Loud was the breakout star of *An American Family*, the show that bridged the gap between the cinema verité of Frederick Wiseman and modern reality TV. A camera crew shooting 300 hours of footage of a supposedly typical California family captured the disintegration of a marriage, an on-camera declaration of divorce, and the revelation that teenage son Lance was gay, the first overtly homosexual character on television. Though edited in such a way that the teen dramatically "comes out," Lance's response always was, "I didn't come out on television, I was always out." Shot in 1971, by the time the show aired in 1973 Lance had relocated to New York City, where he spent his nights hanging with Warhol superstars, and becoming a fixture in the pre-punk scene. We were a perfect match. We shared an energy that made us perpetually excited by our surroundings, and a drive to keep the night going in search of the next thrill. He was writing for *CREEM*, Circus, and Andy Warhol's *Interview*, and I became his roving photographer, as well as his drinking and drug buddy, and partner in crime. We got in free to every concert and every club, and we just had crazy, fun times.

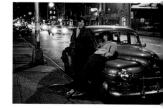

Lance Loud
and Paul Zone,
23rd St., 1974

Whenever Lance got a writing assignment he'd tell them I was coming along as the photographer (he'd even convince them he needed a photographer on stories for which I wasn't allowed to take pictures, like when we were brought into the studio while Bruce Springsteen was recording *Born to Run*). It felt like we were perpetually on the move to an interview, show, or party to meet an artist, but I was always more concerned with having fun than getting published. They almost never used my pictures—I certainly never got paid by a magazine. Now and then I got a few hundred to give some pics to the label's PR people, and maybe a couple of my shots of Grand Funk or Golden Earring saw print. But even though I was obsessed with capturing the scene on film, and with collecting The Fast's clippings, I really think I didn't care if these photos got used. I just wanted to have fun and spend time with Lance.

The Dolls show where I met Lance was also where I became friends with Debbie Harry and Chris Stein. Debbie was one of three female lead singers in the glam rock/cabaret act the Stilettos. During 1974 Debbie and the Stilettos' guitarist Chris Stein left the band and formed Angel & The Snake. They soon changed their name to Blondie & The Banzai Babies, with vocalists Tish and Snooky Bellomo. By the end of 1974 Debbie and Chris dropped "The Banzai Babies" suffix, and Tish and Snooky were dropped, too. The duo landed on their feet, starting a new band, the Sic Fucks; becoming occasional backup singers for The Fast; and eventually opening Manic Panic, the first punk clothing store in New York City. (I spent many nights shagging employee Linda Limey atop the vintage clothes in the back of the store.)

After meeting Chris and Debbie at Club 82 we became pretty close. I'd regularly spend time at their Bowery loft, just down the street from CBGB, with its spare room allocated for an intimidating mountain of clothes, shoes, and wigs. Before leaving the loft they would dive in and fish out whatever wasn't too linty, wrinkled, or ripped to wear. But it was the birth of punk, so sometimes they chose whatever was the *most* linty, wrinkled, and ripped.

By 1975 the band, featuring bassist Gary Valentine and drummer Clem Burke, were playing regularly. Jimmy Destri, who became their keyboardist, was older brother to Donna Destri, whom I had known since sixth grade, in Catholic school. I gravitated to her after witnessing her being sent home daily for wearing black eyeliner, mini skirts, and unruly, corkscrew hairdos. Donna and I were instrumental in Jimmy's introduction to Blondie at Mothers one night when they were opening for The Fast.

My relationship with the band allowed me to indulge all my passions. Some of the best photos I ever took were of Blondie. My interest in styling and clothing was as satisfying as my interest in photography, and I was constantly scouting out hidden thrift shops and flea markets, looking for clothes for Debbie when I wasn't getting things for myself and my brothers. For one photo shoot at Arturo's loft (which had perfect white walls) I styled the boys from Blondie in mod sixties suits and brought along my collection of tab collar, polka dot, and striped shirts for them to wear. A few days before the shoot I gave Debbie a Sassoon-ish haircut, short in the back with a parted one-eye jack that could be flipped over from side to side, messy or blown straight and angular.

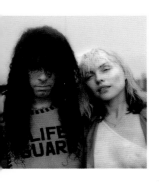

Paul Zone and
Debbie Harry

Although the Ramones were the most influential band to come out of our scene, Blondie definitely became the most successful after they were signed in 1976 and became international stars in 1977 and 1978. I have read accounts of the early days of punk that say that the bands were terrible when they started out, and couldn't play their instruments, but I never thought that. These acts were fantastic from their first rehearsals. I always felt they were great, maybe more raw in the beginning, but just as brilliant from the start. And though it was fun going to Studio 54 with Debbie or picking up clothes from designer Steven Sprouse's place when she became a pop star, Debbie had been a star to us at CBGB and Max's for years, so it didn't feel different.

In 1974 none of us were thinking about mainstream success; the underground was too amazing. Spending my teenage nights at a place like Club 82 was better than anything the mainstream could have offered. It was a drag club in the sixties that became a glitter rock hangout in the early seventies without any redecorating: the ruffled glitter valance curtains, backdrop, and three-sided wraparound stage framed our glamorous icons perfectly. All the local bands played there, including Debbie and Chris' Stilettos, who opened for the performer best suited for the venue, Wayne County.

Club 82 would stay open until about 6 a.m., but after 4 a.m. you would have to enter and exit through a back kitchen service elevator that would let you out in a building around the corner on 2nd Avenue. I remember one night my brothers and I were in the elevator alone with John and Yoko. We were silent, not because we were starstruck or intimidated, but because we really didn't have anything to say to them. It was all happening so fast those days, and everything in our scene seemed so important, that it felt like there was nothing before glam. We were never that excited being around people like them because they felt like something from another time. But I must have still cared about their opinion, because after Yoko broke the silence by complimenting my 6-inch-heeled, red–and–yellow-checkered boots, I felt as proud as if I'd skinned the cow, tanned the leather, and designed the boots myself.

Another interesting nightspot was Trude Heller's, a gay cabaret piano bar on 6th Avenue and 9th Street, where

Lance's band the Mumps debuted as the opening act for actress/poet/singer Cherry Vanilla, doing two shows a night for seven days in early 1975. Lance had a popular name due to *American Family*, and everyone in New York knew Cherry, so it made for a sold-out week, with a guest list that was a who's who of the underground. Lance's personality was always high voltage, which translated into manic, sweaty, uncontrollable dancing when he got on an actual stage. Kristian Hoffman, the gifted songwriter and leader of the band, had a flair for melody, wit, and style. Kristian was also an artist who drew beautifully and created (though wasn't credited for) the "Bendover Girl" insert in the Dolls' first album.

Though Lance and I lived for the downtown clubs, we could also have a blast after hours at the uptown discos like Le Jardin on 43rd Street (in the basement of the Diplomat, the hotel that hosted so many important underground rock shows in its ballrooms and theaters). Booze and pills were always free, and meeting up with new people would always guarantee coke and sex as a chaser. My most memorable night at a disco, though, may have been on November 10, 1974 at Blue Hawaii, a discotheque in a ballroom at the Roosevelt Hotel. That night Patti Smith and her band (guitarist Lenny Kaye and pianist Richard Sohl) did a show. I'll never forget the beautiful strangeness of seeing Smith, a flag bearer in the stripped-down, anti-glam movement, performing underneath a big, mirrored disco ball. Capturing that contrast on film was the reason I brought cameras to shows. I loved Patti, and would catch two or three sets each weekend when her band and the band Television performed together at CBGB every Thursday through Sunday. (Television's debut shows were at the Townhouse shortly after we booked the first rock show in that room.)

Kristian Hoffman,
Paul Zone, and
Lance Loud,
CBGB, 1975

Mothers nightclub could have just been a regular gay piano bar in Chelsea, but because it was booked by Peter Crowley, who we knew as Wayne County's manager, it became one of New York's most exciting clubs. What made Peter so special was his sincere love for the genuinely weird and his ability to see beauty where others saw ugliness. Wayne was a genius, not a freak show to Crowley, and punk futurist Von LMO was a visionary, not a kook. Miki's joyous animated pop might not have appealed to Crowley's sensibilities, but Peter loved Mandy, whose off-kilter, heavy metal falsetto and proto-Goth/German soldier outfits made The Fast much weirder than Miki meant it to be. The Fast played there every Thursday night for months. Peter also chose Suicide to be regulars at the club, and when they weren't in England, the supergroup the Heartbreakers (Johnny Thunders and Jerry Nolan from the Dolls, Television's Richard Hell and the Demons' Walter Lure) played Mothers.

In 1974 there was a seismic shift in the New York underground after Mickey Ruskin closed Max's and Tommy Dean reopened it. Though Dean had considered making it a disco (which would have been okay with us), by hiring Crowley as the booker, and opening the upstairs stage to local bands, Max's joined CBGB as a breeding ground for punk rock's early bacteria. By the beginning of 1975 Peter Crowley was booking Max's upstairs, eventually programming seven nights a week of diverse, bizarre, underground talent. He brought along Wayne and myself to be the alternating DJs throughout the week. We'd play British Invasion pop, glam, surf, rockabilly, and garage rock. We'd also play the Dolls' LPs and Patti Smith's "Piss Factory" single, which were pretty much the only records that existed by any of the bands on the scene. That would change in 1976.

Even though it seemed like everyone was in a band, many of the most colorful characters in the underground contributed in other ways. Like myself, some documented the scene with their photographs, including Nan Goldin, Eileen Polk, Christopher Makos (whom I met through Lance and became neighbors with when I moved to the West Village in 1980) and Mandy's close friend, the teenage Michael Anthony Alago (who later became a major label talent scout, signing Metallica).

Style was as integral as sound to the scene, so we treasured visionary designers like Anna Sui (later a fashion superstar), and Natasha, who introduced spandex for ladies' pants, and never missed our shows. (I had an amazing crush on her, but was intimidated by her overt sexual power.) Anya Phillips was an aspiring designer (she made the hot pink spandex dress Debbie Harry is wearing on the second Blondie LP, *Plastic Letters*) who created an amazing futuristic blue-collar worker suit for me to wear on stage in 1976, with a slate-grey, crisp cotton jacket and pants, six purple straps across the chest fastened with silver buckles, and smaller straps and buckles across the crotch. She later met James Chance and helped nurture the No Wave movement. Abbijane Schifrin's exquisite "Ready-To-Couture" designs were brilliantly presented in shows in which one model played records while trying on clothes from the collection that were laying on chairs and a bed, as if she were in her room getting ready for an evening out.

The groupies and girlfriends were often as exciting, creative, and dynamic as the bands they followed. Roxy Ramone (Cynthia Whitney) was an exotic dancer, as were many young girls on the scene; it was the quickest and simplest way to make good cash in the city. Johnny Ramone's girlfriend (they were on and off from 1975 through 1983) was also a dancer. Around 1978 she went back to the Midwest to live at home, and on one of The Fast's cross country tours we all stayed at her family's giant house outside Chicago. Teen groupie Sable Starr (Hay Shields) met Johnny Thunders at Rodney Bingenheimer's English Disco in Los Angeles, then came East, to help inspire Richard Hell, Stiv Bators, and others. Honi O'Rourke was our good friend, as was her boyfriend Neon Leon, who performed with The Fast many times (sometimes recruiting Honi on bass). They lived in the infamous Chelsea Hotel and were among the last people to visit Sid and Nancy the night Nancy was stabbed to death.

When I look through my photos of Manhattan in the seventies I'm excited to see stills from the amazing performances I saw on stage, but it's the intimate pictures of my friends from every corner of the scene—friends who always trusted me to capture their image, to take a loose, fun snapshot—that I most treasure.

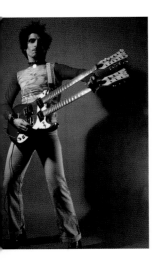

Miki Zone,
1976

Chapter 4 > Miki's Dream, My Reality

The Fast was one of the most exciting bands in New York in 1975. Miki Zone's songwriting and guitar playing helped keep joy and absurdity at the heart of the scene. Mandy was as dynamic a showman as any of his genre-defying, cross-dressing colleagues. And my Op Art styling and stage design helped the band maintain their goal of walking a tightrope between blood and guts reality and Saturday morning animation. But in Miki's eyes, we weren't good enough. The hopeful emotions we felt after playing to a packed house of colorful friends at Mothers were tempered by the discouraging nights opening for a Lenny Bruce impersonator at Marshmallows in Jersey. We were still operating on the same plane as Blondie, the Ramones, and the rest of our peers, but it felt like those bands were about to take the next big step, a step Miki didn't feel The Fast was ready for.

Despite being an amazing performer, Mandy was a roadblock to Miki's ambitions. His dramatic, sometimes shrill falsetto appealed to the avant-garde sensibilities of fans like Mothers/Max's booker Peter Crowley, but it was imperfect for the pop music in Miki's head. Mandy also remained devoted to the leather dusters, and platform shoes he'd been sporting for years, defying the fashions Miki and I were always gauging. And despite being the handsomest Zone, Mandy's weight fluctuated. To someone as image conscious as Miki (who wore uncomfortable contacts his whole life, never considering glasses), this was a problem.

So in February 1976, when Debbie Harry, Chris Stein, and Lance Loud suggested that I be the lead singer, Miki was intrigued by the idea. The fact that I had never sung didn't concern him: my looks and popularity were enough.

Miki called a band meeting in my parents' dining room, announcing, "I've made a decision. Paul's going to be the singer of the band, and Mandy, you will be the keyboard player. It will be better for the band because we're not going anywhere, and Paul's more popular."

This took Mandy by surprise. "He doesn't know how to sing!" my brother blurted out, as if I wasn't sitting right next to him. I remember asking him for help, to which he snapped, "I'm not helping you! This isn't my idea, he's going to have to help you," pointing at Miki.

The demotion was difficult for Mandy. Although all three Zone brothers shared rock 'n' roll fantasies, Mandy was different from Miki and I. Though he was as grandly self-assured as any of us, Mandy was more moody and introspective, spending hours in his room alone. And while he shared our love for pop, punk, and disco, Mandy also worshipped Heavy Metal, which didn't interest us. His falsetto singing paid tribute to metal god Rob Halford (of Judas Priest), not pop prince Lou Christie. Mandy had a separate group of friends who went to metal shows with him. He also delved into different fantasy worlds than us. He had thousands of Marvel comics (inspiring our song, "Comic Books," that Debbie Harry covered in 1989) and was really into Nazi history. He didn't idolize Hitler and we weren't raised racist. Mandy just thought Nazi imagery looked cool, and probably liked the idea of celebrating my brutal father's foes. Mandy drew Nazi-like figures, taught himself German, and even designed his own faux-swastika logo that he wore on an armband.

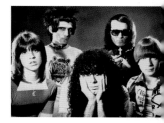

The Fast,
1976

This distinct personality needed the spotlight, so he was not happy giving it up. But he believed in Miki, and when this band made it big, he didn't want to be Stuart Sutcliffe, missing out on the glory he'd worked so hard for. And it felt like this band might make it big. Miki was very happy with my singing, and wrote ten new tunes for my voice, including our signature song, "Boys Will Be Boys." Peter Crowley, despite his love for Mandy, was excited by our new commercial potential and promised to make us a prominent headliner at Max's. Inspired by Crowley's faith, Max's new owner, Tommy, became our manager. For the next four months we dropped out of circulation, rehearsed, and let anticipation build for the triumphant night when Debbie Harry would wave the checkered flag, allowing the all-new The Fast to start its engines.

We looked good, sounded good, and the New York audience finally embraced us as one of the original punk bands on the scene. We were as different from the other acts as they were from each other. You couldn't compare any of the bands to each other at that time. Using the heading Punk Rock was more of a feel, time, and place than a sound for the groups playing at that time. John Holmstrom of *PUNK Magazine* recently told me that he wasn't a fan of The Fast, but now realized that we had a sound and look that didn't come into style until the early 1980s.

The Fast had been a dream since Miki was born, a goal since my brothers banged around the basement in 1969, a prototype since the garage band gigged Brooklyn as the seventies dawned, and a hardworking club band since 1973. But on the rare occasions when people still talk about The Fast, they usually mean the band after I joined. The Fast's records, the band's modest media appearances (playing in the background of the Carter Stevens porno movie, *Punk Rock*; performing on the New Jersey cult-fave kiddie show *Uncle Floyd*), the national tours, The Fast fanclub, The Fast zine—all happened after I became singer.

In the Bicentennial summer it really felt like we were the next big thing. Tommy's support was tremendous, and we were playing big shows at Max's on a bi-weekly basis, becoming a default house band. He bought radio ads announcing our appearances, there was a drink on the menu named after us ("THE FAST $2.50 Tequila gone bananas. Drink it FAST!"), and Max's paid for us to go to Los Angeles and play the Whiskey-A-Go-Go. Most exciting to us was the fact that we had the underground equivalent of a hit record.

After Wayne County (who alternated with me as DJ at Max's) began playing an acetate of "Boys Will Be Boys," the buzz was on. *Trouser Press* called it the best demo of any New York band, and an acetate in the Max's jukebox was quickly worn out. That recording came about because of Miki's friend Louis Bova. Lou had been coming to shows with us for years, and because he lived out in Yonkers, he'd often stay with us rather than go home, becoming like another brother. Miki taught him how to play bass, and he was good. We always knew he'd be The Fast bass player if the spot opened up.

Lou worked at a recording studio in Yonkers called S.B.S. Recording run by an eighteen-year-old named Bobby Orlando and his father, Jerry. Louis had been bringing Bobby to The Fast shows and he'd become a fan, excited that we reminded him of Sparks. Bobby offered to record us, and we did an album's worth of material, which Jerry tried to shop around to labels, operating as a de facto manager. Although still a kid, Bobby was really focused and impressive. During the weeks we were recording with him he revealed himself to be a virtuoso at every instrument. He was also a fitness nut, randomly dropping to the floor to do three hundred sit-ups, or exclaiming, "Look at my stomach, look at this six pack!" We thought his eccentric Italian Yonkers family was fantastic. His mother and sister used to come by the studio, and his sister had long, painted fingernails that curled around both hands, like the guy from the *Guinness Book of World Records*. They all came to our shows.

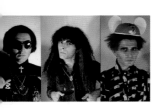

Zone brothers,
1977

It was the first time we had ever been in a real recording studio, and I was very surprised how easy it was to sing and how good it sounded in playback. Bobby definitely knew what he was doing, and he was ambitious. We had one song called "Hawaii" and Bobby brought in a pedal steel player. When Tommy at Max's heard "Boys Will Be Boys," he was impressed and sent Wayne County in to record at S.B.S.

Things were happening fast for The Fast. Tommy decided to do a Max's Kansas City album spotlighting all the bands, and it came out in 1976 on his own label, Ram. CBS licensed the album in England and released "Boys Will Be Boys" as a single. Throughout 1977 every record company and producer was coming to see us. We thought it was strange that we never heard back from any of them, but Tommy told us not to worry. He was going to take care of it and make us stars.

Dean facilitated a recording session with Richard Gottehrer, who had expressed interest in the band. Gottehrer was one of our heroes for his production work on "My Boyfriend's Back" by the Angels, and "I Want Candy" by his group, the Strangeloves. I brought my Strangeloves LP for him to sign when he came to our rehearsals, where he urged us to keep it simple and clean. We did two songs in four days at the studio hidden in the rafters of Radio City Music Hall, where Gottehrer recorded Blondie's first album and the Ramones recorded their first LP. We did "Kids Just Wanna Dance" and "It's Like Love," a song Miki wrote just for the session that features innovative sequencer and synth parts by Mandy. We expected to come back and do a whole album, under the impression that Gottehrer was negotiating a record deal with Private Stock, Blondie's label.

But when Private Stock came to Tommy Dean he insisted the label had to take on his Ram label and other artists he brought them. Peter Crowley later told us that Tommy had been telling everyone that if they wanted The Fast

they had to take on Tommy's label as a subsidiary. We freaked out, and told Dean that we had to have a record deal within the next few months, or we'd move on.

To appease us Tommy released the tracks as a single on his own label, and produced a low budget video for "It's Like Love." More importantly, Tommy Dean brought in Ritchie Cordell to produce the band. The Brooklyn pop legend, who wrote and recorded the best Tommy James and 1910 Fruitgum Company records, oversaw three weeks of rehearsals, five days a week, preparing us to do originals and a Gary Glitter cover he thought might work as pop hits in the US (a few years later Joan Jett had an international hit with a Cordell production of a Glitter cover). He was going to go the full bubblegum/punk/pop route, bringing in slick studio musicians to replace our rhythm section. One day we came to rehearsal and Cordell wasn't there.

"Ah, Ritchie won't be coming any more. It didn't work out," Dean told us.

We were completely fed up with Tommy. During the two fruitless years we spent with him, we saw our friends the Ramones and Blondie record their first albums; Patti Smith become a star; and Talking Heads, the Dead Boys, and Tuff Darts sign to Sire. It seemed like everyone was getting signed, but us. We weren't jealous of those bands, we were lonely. Our friends with record deals were on tour, or moving to Europe, or Los Angeles. We felt like we lost friends when they got signed, and we could be together again if we caught up with them. We no longer had patience for Dean's screw-ups, this was the last straw. But for a band that never quits, there really is no last straw. We moved our gear out of Max's, which had been our rehearsal space, and started playing other clubs in the city, to less enthusiastic audiences. But we still played Max's, I still DJ'd there, and we still hung out there. We just no longer believed Max's was our path to pop stardom.

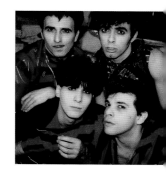

The Fast, Pat and Lance Loud's house, Hollywood, 1979

In 1978 Tommy Dean wasn't our only problem. Frustrated with his role as keyboardist, Mandy left The Fast and re-entered the spotlight with his own band, Ozone, with Tommy Mooney, our bassist who'd left the band, and he got the support of Peter Crowley, who booked Ozone as headliners immediately. The band was great, he got to write and sing his own songs, and we were really proud of his career after The Fast. His style and sound finally worked.

But our main concern was how to be new, how to recreate The Fast. Miki decided we had to be tighter, tougher, and better than ever. We jiggled the lineup and eventually got a great drummer named Joe Poliseno from a newspaper ad, and we finally got Louis Bova in the band. It was, by far, our best rhythm section.

But as good as we sounded, and as much as we played, we knew we were just not connected to the new generation of bands the way we were to the pre-punk acts we came up with. This is not to say we didn't love the new faces. James Chance's brilliant band the Contortions were one of the original New York No Wave bands that filled the void created when many of the original punk groups left New York to tour in support of LPs. Lydia Lunch's band, Teenage Jesus and the Jerks, were completely original. Nothing that came before prepared you for them. Lydia and I became good friends, going to Coney Island to ride in the first car of the Cyclone roller coaster, where Lydia would lift her shirt, scream, and shake her tits to everyone on the ground who was watching. I designed and built the leather and nails bustier she's wearing on her first solo LP, *Queen of Siam*. We loved Philippe Marcade's R&B greaser band The Senders; Stiv Bators' Dead Boys (who were managed by Hilly from

CBGB's, so we never played with them because of our Max's connections); and the Cramps. We even mentored young bands. Miki helped rehearse and write songs for the Blessed, New York's first teen punk band (bass player Howie Pyro went on to play in D. Generation and Danzig) and also put together a girl group called Crayola (Laura Hayden from Crayola became The Fast's drummer for a few weeks in 1981). We made friends with the new young scenesters, including West Coast imports like Kid Congo Powers and Pleasant Gehman, but it just didn't feel the same as it did when we were those wide-eyed kids.

Because the New York club scene constantly reminded us of our failure, we began touring insanely, playing more than a hundred dates a year in any club that would have us. This wasn't a sensible itinerary, either. Boulder to San Francisco to Texas. Detroit to Minneapolis to Chicago. Touring was fun, but brutal. We had great friends in every town. In Chicago, like-minded musicians such as Cheap Trick and Skafish came to see us. In Canada, where we were surprisingly popular, we knew the Viletones and the Diodes. Los Angeles was great, because lots of New Yorkers we knew had moved out there, including Lisa Jane Persky, who took amazing photos of us after we snuck into the Hollywood Bowl, and Lance, who was spending more time out West. In Washington, D.C., we played six shows with The Police over three nights.

But it was tough. At times we weren't paid. When we were, the most we got was $500, and we would have to pay the bass player, the drummer, and the roadie (because Miki didn't drive we had to have a driver/roadie to help out, Frankie "Bogart" DiGangi. Later we hired a tough Brooklyn Metal chick named Spanky). We never had a good car, we'd either rent a van or buy a $100 car and hope it lasted the week. We'd either stay in one motel room, two on the mattress, two on the box spring, or one of us would have to have sex with whatever guy or girl would give us a place to stay.

But we loved performing, so it was worth it, and it was sort of like being successful. The Ramones and Blondie were playing in the same towns, at the really good clubs, while we were playing at the cheesy, horrible places. But the same crowd was there. Last week they went and saw Blondie someplace else. This week they would come see us because we were from New York. To them we were just another up-and-coming group. We were gonna break, any day.

And we almost did.

On October 29, 1978, we performed at the legendary Rat, in Boston, opening for Nervous Eaters. The Fast had some of our most loyal fans in Boston (the guys from Mission of Burma used to tell us they were going to start a band and hopefully be as good as us) and always played to a full house. This time the full house included Ric Ocasek, lead singer of The Cars.

In 1978 The Cars were as big as any band, so we were nervous, but the nervous energy translated into a great performance. As we came off the stage the crowd roared for an encore. After a few more songs we went to the dressing room, then Miki turned to us and declared, "The next knock you hear on that door will be Ric Ocasek coming in and saying he wants to produce us."

There was the knock. It was Ric Ocasek. He came in and said he wanted to produce us.

He told us we were great and reminded him of the Stooges. "Listen, I'll give you a call next week," he said, "I'm going to be in New York, I'll call you a day or two before and we'll set up some studio time." Ocasek exited, then came back in, and asked, "Sunday we're doing a show up in Maine, do you want to come and open for us?" It was Friday.

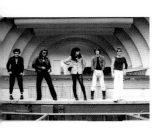

The Fast,
Hollywood Bowl,
1978

Two nights later, Halloween, we were playing on The Cars' equipment, entertaining 20,000 incredibly receptive people. Miki wore a bolo tie, had a pencil-thin mustache and, like the rest of the band, sported black leather. For forty-five minutes we played fun, hard, animated rock as The Cars watched from the wings. Although we assumed that was the first of many such glorious gigs, that show was a high point for The (new) Fast.

Ocasek booked five days at Electric Ladyland studios. Ric had not done much production, and I noticed he was reading instructions to the engineer out of a notebook. It turned out that he'd copied The Cars' (and Queen's) producer Roy Thomas Baker's notes from their recording sessions, and was following Baker's lead on what microphone to put on every piece of equipment.

His notes worked, because the recording session was amazing, and we were certain these five tracks would land us a record deal. What we got was one song on a compilation, a lot of waiting, and more frustration. But one good thing came out of this fresh disappointment: a decision to forget about record labels and release our own stuff. Compiling recordings by Ocasek, Bobby Orlando, Richard Gottehrer, and Ian North, we released our LP, *The Fast For Sale* (with *Who Sells Out* parody cover art), to sell at shows. It didn't get us glory, fame, or money, but it was great to set free this music we were proud of, and it was great to launch Recca Records, a venture that would eventually pay off.

When people ask about the New York underground rock scene in the seventies they often seem interested in hearing about sex, drugs, and money. The easiest of those topics to explain is money, because basically we didn't have any and we didn't need any. You could live for so cheap in New York in those days—rents were a few hundred dollars a month, if that. And we always knew there was a room waiting for us at our mother's house (all three of us lived on and off at home throughout the decade). Once we were part of the scene we never had to pay for drugs, cover charges, or (if we were at Max's) food. What little money we needed we could usually scrape together. If our pay from shows or from managers (when we had them) didn't cover expenses, we sometimes sold a guitar or Christmas trees or plasma. We would also help out at a friend's boutique for a few hours. And if things ever got really bad—say our car broke down on tour—we could always have mom wire us $500.

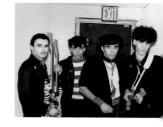

The Fast: Miki Zone, Joe Polesino, Paul Zone, and Louis Bova

The only one who had any inkling about how to actually generate income was Mandy. Even as a Brooklyn teen he had a job at a clothing store, and during the Manhattan days he was downright entrepreneurial. For a while he was a smalltime pot and coke dealer, selling to friends. At one point he managed a phone sex call center in a West Village apartment. Miki would help out, sometimes doing calls, and Mandy had other boys and girls that worked the phones. Mandy was the foreman and dispatcher, but if someone didn't show up, he would have to do the calls himself. I remember how funny it was when the Asian girl played hooky and he had to be a sexy, orgasmic Asian.

As far as sex, the Zone brothers had an interesting history. We certainly didn't consider ourselves gay when we were young, but we were practicing bisexuals throughout the seventies. Miki stopped dating girls early in the seventies, but didn't start seeing guys until late in the decade. He just focused on music, talking shop with other guitar players after shows while the rest of us cruised for sex. Among Miki's nautical interests was an obsession with seahorses—he had seahorse candles, statues, and a tank of live ones—which we thought was funny because seahorses are asexual.

Of course, he always knew that there was a camp aspect to the lyrics he was writing and there were pretty obvious gay subtexts in songs like "Jack is a Jock" and "Boys Will Be Boys." But at a time, when straight guys in

the Dolls would kiss each other for the hell of it, and transsexual and out-performers like Wayne County, Lance Loud, and Another Pretty Face were so bold, no one considered The Fast a gay band. We never had a gay following (nor did Wayne or Lance), hecklers never yelled homophobic stuff (even on tour in the Midwest), and we always had plenty of girl fans. There were lots of gay and bisexual guys and girls on the scene and in bands then. It was no big deal. On tour sex was currency. If we didn't want to share a cheap motel room I would usually have to sleep with a local rock scenester in exchange for a place to stay, and it was almost always with women (or sometimes bisexual couples).

Mandy dated girls more regularly than Miki and I throughout the seventies, though he'd see guys as well. I was probably more actively bisexual than my brothers were, just because I liked to have sex with both. I started sleeping with boys when I was around fourteen or fifteen, then girls at eighteen. But because we were part of a community that valued androgyny and wasn't burdened by anxieties about sexuality, we didn't really have a need to "come out," ever. It wasn't until 1980, when I settled down with my partner, Bucky, that I felt a real emotional attachment to someone I dated.

In the late 1970s I dated Jill Monroe, a famous transsexual model and porn star that I met years after her change. She was pretty and at times glamorous, and we used her as a cover model on two records. She later married Mark "10½" Stevens, a famous straight male porn actor, probably as a publicity stunt. Her drug use eventually turned to heroin. When Jill died in 1982 her funeral was the most surreal of the too many surreal funerals I've had the misfortune of attending. Late in life she'd gotten a series of plastic surgeries, but for the open casket service they removed her giant implants and somehow made her look like a little old Italian lady in a floral dress and wig. At the funeral parlor there were a dozen transsexuals who shared the same plastic surgeon, so they all looked like bizarre Brazilian Stepford wives.

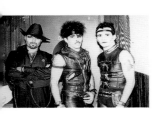

Zone brothers,
Max's Kansas City
offices, 1981

Though she ended up looking odd, when I was with Jill she had a fresh, natural beauty. I've been asked if I could tell the difference between sleeping with a transsexual and sleeping with a woman, and the answer is no, but to be fair, we were always pretty high. At times we would end up bringing home another guy or girl to spend the night with us. A year or so after we broke up, I ran into her at Xenon, a disco in midtown, and she said she was living with a woman. Jill joked that she was now a lesbian. I suggested to her that maybe she was just always straight. We had a few drinks, did some coke, laughed, and tried to figure it out. That was the last time I saw her alive.

Which brings us to drugs. Although our father was an alcoholic, my brothers and I didn't really have addictive personalities, and mostly kept drug use recreational. None of us were ever junkies, and heroin scared us (even when Dee Dee was offering it).

Mandy was a relatively heavy smoker, getting stoned in his room at our parents' house, but Miki never smoked, and I didn't smoke grass much. But we all took pills like black beauties and yellow jackets, always "up" stuff, never downers. Miki would buy those little pink pills from the back of the comic books, with ads promising, "like a thousand cups of coffee." He used to say, "I gotta take my pinks." It seemed like the proper drug for the music we were making.

Some friends inspired more dramatic drug use. When I'd hang out with a girlfriend who went on to become a revered photographer we used to supplement our wild, sex-crazed nights with the elephant tranquilizer called MDA. I took quaaludes when I dated Jill Monroe because she loved them so much (though they just made me fall asleep).

People at Max's and CBGB weren't doing cocaine regularly, it was just too expensive. However, coke was not scarce when I was hanging out with Lance at discos and with his friends. When we toured later in the seventies Miki and I became more frequent coke and speed users, often as a courtesy to hosts or friends. One time, around 1979, we were snorting speed in San Francisco with performance artist Camille O'Grady and all of a sudden both of us started vomiting and felt really stoned. Obviously it had been cut with heroin. But that bad experience was a rarity. Throughout the seventies our drug use was always social and never a problem. The eighties would be different.

>>>

In 1981 we were playing a show in Providence at the Living Room. We were popular there, and I remember really going crazy, hanging from the rafters, climbing the speakers, and putting on an over-the-top show. My manic performances may have had something to do with how much cocaine we were offered at that time. Every girl you went home with seemed to have a bottomless supply. This was especially true of my Providence girlfriend, who would bring some to the club, then would take me to her house between sets for sex and to dive into a huge mound of cocaine on a glass coffee table. It was ridiculous, like something from a movie.

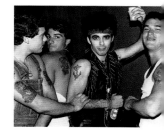

During our last set I was sweating and breathing heavily, and I remember thinking maybe I'm just really stoned. When Frankie drove us home that night I started to feel like my body was inside a refrigerator. I considered getting dropped off at the hospital, but thought, "that's ridiculous, why should I go to the hospital, I'm just stoned?" But at six o'clock the next morning I was cold, sweating, couldn't breathe, and felt pressure in my chest. I called Bucky and he convinced me to go to the Emergency Room.

Paul Zone with
Brooklyn guys,
1981

The doctor told me I either had a collapsed lung, pneumonia, or was having a heart attack, none of which I wanted to hear about. X-rays revealed a collapsed lung and they directed me to a hospital more equipped to handle it. I called my mom, and when she asked why my lung collapsed, instead of telling her about the coke I said "exhaustion." When I got to the hospital, they immediately gave me a couple of shots, cut me open, and used a big iron bar to shove a rubber tube into the side of my chest. They can't put you to sleep during this because they need you to breathe a certain way. I spent the next two weeks in the hospital with a tube inside my lung hooked up to a machine.

The doctors told me this happened because of my lifestyle and, if it happened again, they would have to cut open my back and put in a fake lung. That was inevitable, they said, unless I completely changed my habits: no more smoking, drinking, or drugs.

So that was it. I think basically I survived the 1980s because I never did drugs again. Unfortunately, Miki didn't learn a lesson from my misfortune and continued to increase his speed and cocaine use.

Oddly, my sobriety coincided with the reinvention of the band as a dark, decadent entity. Inspired by goth and the West Side gay leather scene, The Fast's leather era featured Miki and the band in black leather, draped in chains and capes, and me in loincloths, animal skin chaps, and a leather straitjacket. We had a more sinister sound musically, and anxious to document our dark odes to serial killers and ritual sacrifice, we recorded our Leather Boys From The Asphalt Jungle LP on a shoestring budget. By the time the album was finished we had no drummer or bassist. Because of the increased rigors and decreasing rewards of touring as a less popular band,

we went through a series of musicians in the early 1980s, including Ian North from Milk 'n' Cookies, Tommy Victor, (later of Prong), and Laura Hayden, the drummer from Crayola, the girl group Miki produced.

But to make it seem like a full band, Miki and I each appear twice on the cover, as twin sets of leather clad clones in robotic oversized shades. Choosing to become a duo was now an economic reality. It was also the most important reinvention since Miki put me in The Fast.

Chapter 5 > Rock 'n' Roll in a Disco World

Abandoned by bandmates, we got an idea for a new phase of The Fast in 1982 when we saw Depeche Mode play with a reel-to-reel tape recorder spinning on stage. We wrote new material, went into Ian North's bedroom studio and recorded a single called "Moontan," and made a tape of drum beats for our full set of songs. Onstage we would have Donna Destri and another guy on keyboards, Miki on guitar, and me pressing play on a big tape recorder, unleashing muffled boom-box beats. Soon we wouldn't even use keyboard players; it was just Miki on guitar, me playing some synths, and pre-recorded tracks: The Fast gone electric. We played a few shows like this, then we started playing dance spots like the Mudd Club, Snafu, and Pyramid Club with just a backing track and us singing live. Miki never played an instrument live in our act again.

We had some tour dates in Canada booked, and we didn't know how our old fans would take to this, but people ate it up, and everyone was dancing. We knew right then we didn't need anyone else on stage. In New York, however, our followers (what was left of them) were less enthusiastic. We were basically excommunicated from the rock 'n' roll community. People would come to see us at the Pyramid Club with backing tapes and ask, 'How come Miki's not playing guitar?'

Paul Zone & Joey Arias / Paul Zone & John Sex, 1984

The death of the rock 'n' roll group The Fast was liberating in a way. Miki and I now had a lot more spare time and were able to perform free of expectations. Miki began doing Gene Pitney tribute shows, and worked on his rock opera, *The Magic Seashore*. I was hanging out in the East Village and at gay discos like the Saint and Paradise Garage with Keith Haring (and his entourage of Puerto Rican guys). I had also fallen in with performance artists who saw my rock 'n' roll pedigree as an amusing footnote. I entered that world a few years earlier when David McDermott, Ann Magnuson, Susan Hannaford Rose, and Tom Skully asked me to be in the New Wave Vaudeville show at Irving Plaza (which introduced Klaus Nomi to the New York avant-garde). Using a scratchy 78rpm record of "You Made Me Love You" as my backing track, I dressed in my father's Marine sergeant uniform and sang as if I was preparing to go to war. By the early eighties this had morphed into high concept variety shows at the Palladium and Danceteria where I was a regular, alongside friends like John Sex, Joey Arias, Donna Destri, and Magnuson, performing campy versions of things like *Bye Bye Birdie, South Pacific*, and *The Wonderful World of Disney* (I played Walt Disney). These zany productions were written, directed, and produced by future Tony winners Scott Wittman and Marc Shaiman (*Hairspray*).

We also felt free to release singles that we knew were not going to be popular—a Christmas record, an electro rockabilly 45, a collection of Mandy's bedroom tapes. Recca Records could be a fun hobby until we figured out our place in the music world again.

We'd always loved dance music, but now that we were working with synths and drum machines we started paying

closer attention at the clubs. One of the most popular records at the time was drag queen/actress Divine's "Native Love." We'd met Divine in 1976 when we went nightly to see him star opposite our friend Lisa Jane Persky in the play *Women Behind Bars*, and we had seen him in John Waters' films since 1970. But this record was not some celebrity novelty project. It was one of the finest examples of a genre of upbeat electronic dance music called Hi-NRG made popular by pioneering gay disco producer Patrick Cowley. When we learned that Divine's record had been created by our first producer, Bobby Orlando, we immediately called him up and said we wanted to be a dance group. Bobby O was thrilled to welcome us into the O Records family.

Hooking up with Bobby in 1983 and getting into the dance world meant that life became fun again. The Fast were invited to play an O Records showcase with Divine, the Flirts, and Frankie Avalon at the Fun House disco. Bobby recorded three over-the-top electronic dance songs with us, "At The Gym," a riff on the Village People's "YMCA," "Unisex Haircut," and "Male Stripper." The latter featured lyrics celebrating exotic dancing over a beat based on Kraftwerk's "Numbers" and Bobby's perfect Hi-NRG bass line.

I don't know why Bobby never released the tracks, but he did hook us up by introducing us to his promoter Denny O'Connor. Denny knew all about the gay disco industry, and generously mentored us. He suggested a name change, so The Fast finally ended, as we became Man's Favorite Sport (after a Rock Hudson movie). Denny got the Zones in touch with the owner of Media Sound, a 24-track recording studio, where we were hired as in-house demo producers. There we made backing tracks that helped paying customers fuel their semi-talented girlfriends' disco diva dreams. The job was amazing because we got to learn how to work a board, program a drum machine, and get the most out of a cowbell. We also got free studio time after hours (with an engineer) to work on our first real dance recordings. Miki's new compositions sported campy titles like, "When A Hot Man Turns Cold," and "World's Best Lover."

The Fast go ELECTRO:
Paul Zone & Miki Zone,
Mudd Club, 1982

We stayed there for about a year, and immediately afterward took our new know-how to our friend Ian North's 24-track studio to make our first serious attempt at a dance club hit. One thing we had been told by dance labels was that records needed a girl singer to be hits. But we felt that if we were making gay records, not only should it be a man's voice, it should be outrageously manly. Our idea was to do a Hi-NRG cover of "Walk Like A Man," which we were sure would be a hilarious gay club hit. We had a vision to combine the kind of dance music we loved, like Yello, Depeche Mode and New Order, with the kind of animated pop/punk sensibility The Fast had. The record came out exactly as we envisioned.

With our surefire hit in hand we went to England to shop it around. Everyone went to England in the punk era to try to make it, so why not us now? Denny put us in touch with record labels and we brought them cassettes of "Walk Like A Man." Proto, Divine's label, was our first stop. We played it for a guy named Nick Price, who didn't seem too interested, but kept the tape. We got the same indifference from the other labels. The best reaction we got was when the tape was played at Heaven, the top gay disco in England. They asked us to come back the next night and perform it for five hundred appreciative gay Brits. They loved us, so we felt somewhat encouraged that Britain got us.

We returned to New York and waited weeks to hear something, but when we finally did get news it was from an unexpected source. A friend who ran a nearby record store called me up and said I had to come into the shop. When I got there they took out the new British import, Divine 12, and put it on the turntable. It was "Walk Like a Man." Not only was it the same song, the production style and arrangement were identical. At one point the

chorus stops and you hear a cowbell solo, at the exact second we had the cowbell solo. They completely stole our record. I was devastated. I brought it home to Miki, and the first thing he said was, "It doesn't matter, this proves that we're doing the right thing, we're not ahead of our time, we're on the right track."

Undeterred, we had our friend Martin Bisi of Material help us record a track called "Hottest of the Hot," basically the bass line from Donna Summer's "I Feel Love" sped up to Hi-NRG tempo, with crooned vocals ("Hottest of the hot, your flaming arrow hit my heart . . .") and sparse, crisp sequencing. We released it ourselves on Recca with "Walk Like A Man" as a B-side. Having had little luck with Man's Favorite Sport, we decided to change our name to Man 2 Man.

Denny O'Connor, acting as Man 2 Man's manager, helped promote the record and taught us how to send cases of free discs to "record pools," coalitions of influential deejays like Dogs of War in Chicago and B.A.D.D.A. in San Francisco. Denny knew every gay DJ in New York in the eighties, so it was soon spinning everywhere. It was fantastic. We could go to the Saint and a thousand shirtless guys would be dancing to our record. We'd proudly tell our old rock 'n' roll friends about this, and they'd be baffled, saying, "You should be embarrassed about that, and you're bragging about it?"

In early 1985 we were probably selling fewer records than we were giving away to record pools, but a long distance call changed that. Morris Katz was a short, chubby, red-haired Jewish Mexican who owned a record store in the heart of Mexico City where everyone bought their dance records. He also ran a label called Mastered, a subsidiary of the major label Peerless, Mexico's first commercial record label. Katz called us and offered a $200 advance for the Mexican rights to "Hottest of the Hot." Apparently Hi-NRG was pretty hot in Mexico, and icons like Divine and Sylvester were playing to huge crowds. If that story ended with Miki and I splitting that money we would have been happy (as would our father, if he'd known we'd honored his $100-a-job credo). But that wasn't the end of the story.

Our song "Hottest of the Hot" went to #1 on the pop charts in Mexico.

The next thing we knew we were being flown to Mexico, wined and dined by record executives, put up in luxury hotels with all expenses paid, and playing a show for three thousand screaming fans. This was a record that we had hoped to get spun in decadent gay discos, or possibly by black deejays in trendsetting urban underground clubs. But to Mexican ears these campy novelty records were pure bubble gum, chewed by children, pre-teens, and high school students. We were bonafide pop stars, with kids waiting for our autographs outside the hotel. We spent most of 1985 in Mexico, living the high life, making more money than we'd ever imagined, and playing to huge crowds in boxing stadiums and convention centers. We did an outdoor festival with Jessica Williams, Divine, and Sylvester, for ten thousand people. We'd drive in vans for hours to small towns in the mountains where everyone knew the words to our songs.

Our dream had come true, except that it was such an intense manifestation of Miki's "animated"/living cartoon concept that it was hard to appreciate it as reality. Nobody around us was speaking English, everyone was shorter than us, and we couldn't drink the water. After a decade of getting paid gas money to play intense live shows where we'd haul amps, construct backdrops, and sweat on stage for two hourlong sets of live music, we were now being given thousands of dollars a night to sing to backing tracks of gay novelty tunes. It was like we went to another planet and became pop stars!

Paul and Miki
Zone, 1983

I'm not sure I would have even believed this had happened if it weren't for the VHS evidence. We made countless appearances on Mexican TV shows, the best one being *Hoy Mismo!* The popular *Good Morning America*-type show also appeared on Spanish language TV in the United States, so we'd call all of our friends and tell them to turn on channel 64 at six o'clock in the morning. We would wear absolutely outrageous outfits—Madonna-inspired thrift store mish mashes, bullfighter costumes, and Carmen Miranda fruit hats—while lip-synching to our absurd songs, and jumping around while pretending to play accordions, grand pianos, unplugged synths, or whatever they had in the studio.

We were having the time of our lives. Everyone knew our faces because we were on TV almost every day. On the street people of all ages would yell, "Dos Hombres!, Dos Hombres!" On one trip to New York we tried to record a Spanish-language version of a Man 2 Man hit Miki wrote called "Mexico," but because we had it translated by John Sex's Peruvian boyfriend Wilfredo, it was in a Peruvian dialect. They loved the record in Mexico, intrigued to know what mysterious language we were singing. We thought it was Spanish! We also made friends with the owners of El Taller, the biggest gay bar in Mexico City, where we would go on weekends or after our shows. We never played a gay club in Mexico because we were a pop act. The guys at El Taller were excited and proud to learn that the new big pop stars from America were gay.

Chapter 6 > Happy New Year

Back in New York (to record more music for our demanding Mexican fans) we ran into Man Parrish on the street. Manny, also a Brooklyn boy, was already an underground star, producing people like Klaus Nomi and our friend, Donna Destri. He also scored an urban hit in the US and chart hit in the UK with his solo single, "Hip Hop Be Bop." We told him about our surreal Spanish-language adventures and arranged to work on some tracks together.

Man 2 Man,
1984

Man Parrish's recording empire consisted of an 8-track reel-to-reel in his second bedroom. We were there for about a week, recording our new single, "All Men Are Beasts." For the b-side we decided to revive "Male Stripper," a song we'd done with Bobby O. We wanted to keep our raw, stripped-down electronic sound from our first single intact. We brought with us some of our favorite records to Manny's and picked out the best parts. We played him the horn line from Lime's "Babe, We're Gonna Love Tonite," and we programmed something similar. We brought in Yello's "Bostich" which had great sequencers. We used Kraftwerk sounds. And of course, we used Bobby O's bass line, which was borrowed from Patrick Cowley. Manny knew Cowley, but had never done anything in that style for himself, so it was silly and fun for him. I spoke-sang my faux-sexy vocals ("ripples on my chest, never got a night's rest . . ."), and we used a vocoder for the catchy, tabloid tell-all chorus ("I was a male stripper in a go-go bar . . ."). Miki brought in two girls from his Gene Pitney show to sing backup.

We finished the recording, and while Manny and Miki slept, I stayed up all night working on the extended edits. This was before music was edited on computers so I had to cut the tape with a razor blade, back up the mix, delete or add in parts, back up the mix, over and over, splicing until 5 a.m. to finish the 12-inch version.

When we were done we sent the tracks to Mexico, but also pressed our own Recca version of "All Men Are Beasts," with the b-side "Male Stripper." We sent it to record pools, and not long after, while visiting a friend in Bucks County, Pennsylvania, I went to a gay bar and introduced myself to the DJ as Paul from Man 2 Man. "I got your new record," he tells me, and picks it up. There's a big red circle around "Male Stripper." He put it on and

everyone in the club knew it, so I called up Miki and told him that the DJ was playing the b-side, "Male Stripper."

The success of "Male Stripper" raised our popularity in American gay clubs. We did shows in Florida, Boston, and Chicago where the record was hot. For Man 2 Man's debut in New York City, Jim Fouratt had us headline a sold-out show, July 4th, Independence Day, at the Limelight. Oddly, it was ten years (almost to the date) since my debut with The Fast on stage at Max's. With all we had been through, Miki and I thought it a good omen. Tony Zanetta designed an elaborate show for us that included performance artist International Crysis with dancers and sets, and featured Crysis as a She-Devil surrounded by fake flames and smoke, as we sang "Hottest of the Hot" in Hell.

But soon we'd be hitting the stage in Heaven.

That adventure began when our distributor called to say he needed one hundred "Male Strippers."

"A hundred? Where are you sending them?"

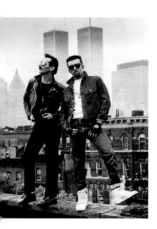

Man 2 Man, Grand St., NYC, 1985

"There's a store in England called the Record Shack, and they're snatching it up."

Then he calls back and says he needs five hundred. We normally didn't have funds available for that kind of re-press, but we had "Mexico money," so we did it. But when he called back the next week wanting one thousand copies, we told him it's impossible. That would cost us $4,000.

"OK, I'll pay for them."

We soon got a phone call from Bolts, a small London label that was interested in releasing "Male Stripper." After we struck a deal, the guy says, "You know, you guys know me. Remember you came and dropped off a cassette of "Walk Like A Man" for me when I was working for Divine's label?"

"So you're the creep that stole . . ."

And that was the creep we signed with. And it worked out pretty well. The song went on to be the #1 dance record of 1986 in England.

Although we continued to be successful in Mexico, and returned throughout 1986, becoming pop stars in the Mysterious Land of Oz couldn't compare to selling records in the home of Bowie, Bolan, and The Who. Things were definitely looking up for the Zone boys. The only setback was that Miki was getting sick sometimes and acting weird. But he'd bounce back and I just attributed it to speed and too many late nights. This wasn't a time for worrying. It was a time to enjoy the success we'd been working to achieve for more than a decade.

We were invited on a two-month-long Summer tour of every gay club in England and Scotland. We'd play venues that were 100% gay, most holding 500 people or less. We didn't wear our outrageous Mexico outfits, we wanted a different look for London. Miki wore black, red, or white denim with his white sailor hat and I'd wear jeans, a wife-beater undershirt, and a leather jacket. For "Male Stripper" I'd nightly perform an "impromptu" striptease down to white BVDs (a decade before Marky Mark). I didn't have breakaway pants, so I'd have to awkwardly remove my jeans as if it were a spur-of-the-moment treat for the guys.

When we did our subsequent tours in 1986 we were playing the biggest dance clubs, which were not all gay. Heaven held almost two thousand, and was world renowned as the grandest gay club in Europe. But it had

become so trendy that we played to a mixed crowd. The Hippodrome, which held more than two thousand, was definitely mixed. People told me our record was crossing over because male stripping was really big at the time in England. When we released a follow-up song ("Energy is Eurobeat") we were eager to see if that would reach beyond the gay clubs as well.

I had never seen Miki happier. It was mostly because we were doing what we wanted to do and being successful at it. But I also think he was excited to see things from my perspective: He was now a singer, free from instruments, and the center of attention. He was so glad that people liked us, and that, unlike the grind to become popular that The Fast went through (again and again), this was immediate. We were on top instantly. England was amazing.

>>>

After we released "Energy Is Eurobeat," which did okay, we returned to New York and got together with Man Parrish to work on some new ideas. Because outrageousness seemed to sell, we decided to do a gender-bending cover of Grace Jones' "I Need A Man," presented as the funniest, gayest, record ever. What DJ in a gay club isn't going to play this record? We laughed all throughout the recording process, and Miki seemed really vibrant.

UK Tour, Summer, 1986

But there were other times when I was noticing him coughing or acting sick. He wouldn't go to the doctor, but I was hoping that when we slowed down he could get some rest. However, we weren't going to slow down anytime soon. We were ready to release "I Need A Man" at the beginning of the year when "Male Stripper" was sure to run out of gas. And we were also making plans to revive Miki's opus, *The Magic Seashore*, as the first Disco-Opera. Unfortunately, when we got back to England, Miki wasn't doing too well.

He looked very thin, and I tried to tell him that he needed to see a doctor. But Miki was in denial. He was getting high a lot, and his drug hazes were starting to look a lot like dementia. When we did a return show at Heaven, Miki backed up and sat down on the edge of the stage, barely able to move. He seemed almost comatose. It was really, really hard to see him like that. Lance Loud met us on the tail end of this tour in Bath where Pat Loud was living. He traveled back to London with us for our show at Heaven. He witnessed Miki's state of mind and fatigue. We had both seen it too many times already in our closest friends.

On the 23rd of December we flew back to New York, with Miki vomiting or unconscious the entire flight. I carried him off the plane and took him to our parents' house, then to the doctor, and then to the hospital. This was New York in the mid-eighties, and the staff had seen this so many times that they didn't even test him for AIDS. They immediately skipped to the next step of figuring out what was wrong with him because he had AIDS. In addition to dementia, they diagnosed spinal meningitis. The only silver lining at this point was the fact that Miki didn't know any of this.

"Paul, where are we?" he'd ask.

"We're in the hospital," I'd respond. "You're not doing too good. But you're gonna be okay."

This was a day after Christmas, December 26th. People were coming. At times the whole room would be filled with all of our friends and family, and he'd be talking to everybody. I was sleeping in the hospital with him every night. In the morning my father would come to shave him and feed him, and I would go home while family members and friends hung out. Then I would come back and spend the night with him. He never slept while I was

there, he only slept in the daytime. I'd be sleeping on the chair, and he'd wake me, talking to all of these people in the room who would be coming to visit him. Of course the room was empty, it was the middle of the night. There would be angels, too. "'Don't you see them,'" he'd say. "'They're right over there.'" He'd be having conversations with the angels. This went on for a week. And then on December 31st, 5 a.m., New Year's Eve morning, he began coughing, choking. I told him to spit it out, and held him in my arms, trying to help him. He was turning blue, choking and gagging. As I pushed the buttons and screamed for the nurse, my brother Miki died in my arms. The nursing staff rushed in and ushered me out of the room. I looked through the door and saw them start to cut his neck open, it was a shocking sight.

A few minutes later they all walked out of the room, and someone told me, "I'm sorry we couldn't save him, you can go in now." And that was it. They all left. I went back into the room, and Miki was just laying there. I sat on the bed thinking, paralyzed, unsure of what to do next, who to call, and how to deal with this. I couldn't bring myself to call my mom so I called my sister Camille and told her. I then called up Bucky, and he called Lance and they came to the hospital within fifteen minutes and sat on the bed with me. The staff told us it would take a while for them to move him to the morgue. Miki was still warm, just laying there. I put on a cassette of Gene Pitney singing, "I'm Going to Be Strong," one of his favorites, and we waited a few hours, just sitting there with him. It was surreal.

The Ramones, Blondie, Bobby Orlando, Man Parrish, and the rest of the New York punk and dance scene royalty attended Miki's funeral. I sat with my mother the whole time thinking how he was so young, only 32. Mandy could not control himself throughout most of the funeral. After all, Miki was his big brother also. The three of us had been through so much together. My brother who was so alive and so excited and so animated was gone.

And that was it. Happy New Year.

My favorite photo
of Miki (Brooklyn)

Chapter 7 > Top of the Pops

After Miki's death I couldn't bring myself to care about anything to do with music. He was my brother, we had been side by side onstage since he'd asked me to front The Fast, and he was gone. I had absolutely no idea what I was supposed to do next. There was a complete lull in my life.

But in late January I started getting enthusiastic calls from Bolts, our record label in England. "Male Stripper" looked like it was going to be a hit, maybe debuting in the Top 20. In early February they called back, gushing with excitement. "Get on a plane, tomorrow," they said. "You're going to be on *Top of the Pops*."

All this was happening because someone at the label had been hyping Miki's death to the tabloids, throwing in a half-truth about a guy who OD'd at Boy George's house (he'd worked for Man Parrish, but not, as reported, on "Male Stripper"). If you think I'd take offense at my family's tragedy being exploited, you never met my brother. Miki came from the school of "throw an ax on the stage and I'll cut my arm off, anything for the show." He was always like that, so it never occurred to me that this would have bothered him—especially if it meant appearing on our favorite TV show.

Though we'd never actually seen it, we were obsessed with Britain's *Top of the Pops* from reading about it in UK magazines. The Kinks had a song about the show, and everyone we idolized had been on the show: Bowie, the Bee Gees, The Who, T. Rex, the Move, the Sweet, and Roxy Music. Packing for the flight, I threw in a few items of Miki's so he could be with me on that legendary stage.

The day after my plane landed, jet lag be damned, I was at the BBC studio at the ungodly hour of eight o'clock in the morning, with six hours of rehearsals ahead of me. All the artists were mulling around downstairs in the catacombs of the BBC studio. There was a group with a girl singer, Westworld, who had a single out called "Sonic Boom Boy," and a Brit pop act called Curiosity Killed the Cat. Eric Clapton was there and asked me if it was my first time on *TOTP*, laughing that he hadn't been on in ten years. But other than that brief exchange, nobody was really talking to me. It seemed like all the people working on the show were really supporting the other acts, but no one was helping me with anything. The others were being pampered, especially during rehearsals with cameramen and floor directors offering encouragement and advice. And when I was on stage the crew literally had their backs to me. I don't know if it was because there was so much publicity about this being a "gay" record (sure, the gay clubs spun it, but it was about a man stripping for women), or because of the press saying a member of Man 2 Man had died from AIDS. Maybe it was about me being American. I just felt really unwelcome.

A part of me felt in control, but another part felt too fragile to fight for myself. I asked to be billed as "Paul Zone of Man 2 Man," but my label said the show refused (they probably never even asked). Because the song was "Male Stripper," Bolts had hired male dancers (two working go-go boys named Tony Frisco and Private 69) to back me up. When I tried to let the cameraman know these dancers weren't in the group, and shouldn't get a lot of close-ups, he wouldn't talk to me. I'd ask who was in charge and no one would answer. When I moved the microphone and stand off stage, they told me that even though everyone lip-synched, I had to hold a mic, threatening to put me off the show unless I complied. My record company assured me they were just trying to scare me, but that didn't make me feel any better.

When they announced that we'd be taping with the audience in an hour everyone disappeared. It seemed like the dressing rooms were empty, the halls were empty, and it really hit me that I was as alone as I'd ever been. I rewound to the Mercer in 1972, Max's in 1976, to the years when my friends' bands got major label contracts, leaving us behind. Miki was disappointed that The Fast didn't succeed, but we both believed we could still make something of ourselves, and Man 2 Man proved it. Thinking about how happy and proud Miki would have been at this moment, I broke down, and it was awful. Throughout my brother's sickness, even holding him as he took his last breath, even sitting with him after he was gone, I'd never really fallen apart, but now I seriously didn't know how I was going to go on that stage without him by my side. I was mad at Miki. Mad that he got sick. Mad that he was missing this. Mad that he wasn't here to help me push these rude people aside, so we could move forward like we always did. This was supposed to be our triumph, but without Miki here I felt like I was dealing with another death.

I hadn't even decided what to wear. I opened the crates I'd dragged across the Atlantic and tossed aside the monkey faux fur coat and the stars-and-stripes spandex biker shorts and settled on a black patent-leather suit. It had cowboy fringes down its sleeves and legs, but I suddenly felt compelled to tear them off. I know it's the gayest of references, but I couldn't stop thinking of Mama Rose in *Gypsy* ripping off the tacky trim on her daughter Louise's dress for her first time on stage as classy stripper Gypsy Rose Lee. I just started ripping away, pondering my horrible reality. I have to do the most important performance of my life *(rip!)*, without Miki *(rip!)*, without anybody I know here, *(rip!)*, no manager *(rip!)*, a record label I don't trust *(rip!)*. I'm three thousand miles from home *(rip!)*, no friends *(rip!)*, no family *(rip!)*, nobody's shoulder to lean on *(rip!)*, and on *Top of the FUCKIN' Pops!*

Then I looked over at the case and something seemed to be glowing. I saw a light shining off Miki's beloved white nautical captain's cap, and I smiled. I'd wanted to wear something of his, but didn't know what until right then. As I put it on, I thought about how much I needed a part of him on that stage with me.

Paul Zone,
1987

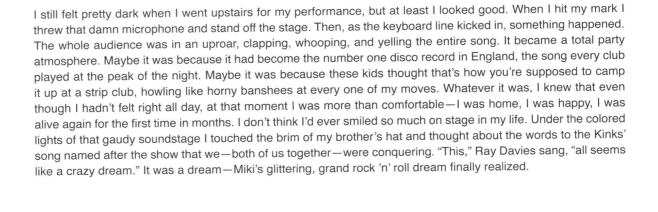

I still felt pretty dark when I went upstairs for my performance, but at least I looked good. When I hit my mark I threw that damn microphone and stand off the stage. Then, as the keyboard line kicked in, something happened. The whole audience was in an uproar, clapping, whooping, and yelling the entire song. It became a total party atmosphere. Maybe it was because it had become the number one disco record in England, the song every club played at the peak of the night. Maybe it was because these kids thought that's how you're supposed to camp it up at a strip club, howling like horny banshees at every one of my moves. Whatever it was, I knew that even though I hadn't felt right all day, at that moment I was more than comfortable—I was home, I was happy, I was alive again for the first time in months. I don't think I'd ever smiled so much on stage in my life. Under the colored lights of that gaudy soundstage I touched the brim of my brother's hat and thought about the words to the Kinks' song named after the show that we—both of us together—were conquering. "This," Ray Davies sang, "all seems like a crazy dream." It was a dream—Miki's glittering, grand rock 'n' roll dream finally realized.

>>>

"Male Stripper" was a legitimate pop hit, spending 16 weeks on the UK charts, peaking at #4. For the next three years I lived in England, releasing a series of records and touring around Europe. I would make trips back to New York to see my mom and friends, and make new recordings (taking Miki's old songs out of the cupboards and revamping them, or writing my own). I enjoyed modest chart hits with "Energy Is Eurobeat," "Who Knows What Evil," Grace Jones' "I Need A Man," and covers of "These Boots Were Made For Walking."

It really was like a dream, with so many unbelievable things happening. I re-recorded "At the Gym," our homage to "YMCA," with Village People's producer Jacques Morali in Paris. I got to shoot music videos, a couple of which were designed and styled by Leee Black Childers and Gail Higgins, including a drag re-creation of *Shindig*, featuring Jayne County hosting with me and my backup singers as the Ronettes. I was able to give Mandy a chance to experience the rock stardom he always coveted when I had him cover Sylvester's "Do Ya Wanna Funk" (the international club hit allowed him to perform for thousands of fans in London and Miami). I got to see my face in *Melody Maker* and *NME*.

I was having a great time every night, going to parties, and running with the pop stars of the moment, befriending Boy George, Mel and Kim, Angie Bowie, Kevin Rowland, Limahl, and Pete Burns. I got to see familiar New York faces when they passed through, like Debbie and Chris; Johnny Thunders; Stiv Bators; Keith Haring (who did a Man 2 Man record sleeve); the actress Debi Mazar (whom I'd met through the stylish Viki Galves, a great friend to Lance and myself; Debi and I are godparents to Viki and Martin Bisi's daughter, Angelica); and Madonna (whom I met through Debi).

I genuinely enjoyed myself those years, but I was always reminded there was a void: The act was called Man 2 Man and the other man was missing. The moment this struck me hardest was in 1987 when I was in Heathrow airport, flying in from a show in Germany. While waiting for my luggage I looked up and standing right in front of me, waiting for their bags, were the Bee Gees. It was one of those moments where I felt a huge heaviness inside, because all I could think was that if Miki were here he would have been beside himself. I just stood there and looked at them, seeing those three brothers all together and thinking about what it meant for me to be alone. That night I called my mom and Mandy, and we talked about how much Miki loved the Bee Gees.

By 1989 Man 2 Man records were still popular in clubs but weren't registering on the pop charts, and live bookings tapered off. Although Miki might have tried to convince me otherwise, I wasn't willing to reinvent myself

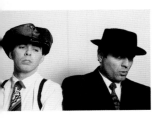

Paul and Mandy wearing Miki's ties, 1988

and start over again like we did with the five-piece Fast, the four-piece Fast, the leather Fast, the electric Fast, Man's Favorite Sport, and Man 2 Man. I didn't want to struggle anymore. I didn't want to be in the back of a van in the day and on a box spring at night. I'm a happy person, so I didn't need to put that stress on myself when I could be satisfied doing other things. And I didn't need the money.

It's amazing how much money you make when you have a hit record—I recommend it to everyone. The actual record sales were not particularly lucrative, for me at least. Bolts certainly made money off "Male Stripper" (I received a Silver record for sales exceeding 250,000 singles) but somehow managed to declare bankruptcy by the end of 1987, so I saw little of it. I own all the publishing and master rights, so I licensed records to other countries, and released domestic versions on Recca, but profits were modest. However, touring was incredible. I would travel around Europe, getting $10,000 a show, with my hotel, travel, and food all paid for. My only expense those years was a beautiful townhouse in West London. You hear about musicians with hit after hit blowing all their money, and maybe if I hadn't spent ten years struggling so much, I might have been more reckless myself, but I knew exactly how rare and special this was.

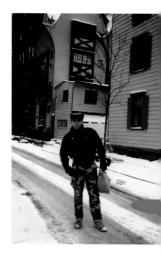

Paul Zone, West
Village, NYC,
1990

Chapter 8 > Way Out West

I moved back to New York, purchased real estate in the West Village, invested, put the rest in the bank, and retired at home. But my return wasn't as easy as I'd hoped. Miki's death was not an isolated incident. AIDS devastated the gay community and the arts community in the eighties and early nineties, and my circle of friends was diminishing. I would soon lose John Sex, Sylvester, Keith Haring, video artist Tom Rubnitz, and Emile Greco (who took every photo of Man 2 Man), not to mention our friends who had died earlier, like Klaus Nomi, and George Harris (Hibiscus of the Cockettes). In a weird way it reminded me of the end of the first underground era, when everyone was leaving us because they got signed and were touring the world. But this time, instead of missing my friends because something wonderful happened to them, I was missing them because of something terrible: young, beautiful people were withering and dying.

I was ready for a fresh start. All throughout the eighties I had taken any free stretch of time I had to visit Lance in Los Angeles, where we'd drive around on motorcycles, go out to clubs and bars, and have parties at his house with his mom and their Hollywood friends. I'd parted ways with Bucky, but we were still good friends, and he'd also moved out to LA, so I asked my new buddy Claudio if he wanted to come to California with me. We zigzagged across the country on motorcycles, going to Gay Pride day in Chicago, sightseeing in San Antonio, visiting Viki Galves in Denver. We had considered checking out San Francisco, but when we got to LA, there were so many old friends there—Lance and Kristian, Lux and Ivy, Johnny and Linda Ramone, Lydia Lunch—it just felt like home.

But it wasn't an upbeat Hollywood ending with me riding off into the West Coast sunset blasting the Beach Boys' "Don't Worry Baby." Life kept interrupting, no more powerfully than in 1993 when word came to me that Mandy was sick.

Mandy had dropped out of music after the mid-eighties. He still looked the same, with his black clothing, multiple crucifixes, and heels just a little too high, but he'd fashioned a more conventional life than Miki or I ever could. He'd met a nice Italian guy from Brooklyn named Danny and they had a place near Brighton Beach, with a Medieval-style, four-poster bed, and crystal balls and cherubs everywhere. Cher's house couldn't have looked any better. He managed a factory that made the cakes you see in display cases at diners around the tri-state

area, and in his house he had this giant freezer filled with the most amazing, delicious cakes, which he'd bring over in big boxes whenever he visited anyone. But domesticity didn't spare him.

In the fall of 1993 Mandy, Danny, Tommy Mooney, Claudio, and myself went up to the Catskills to do some whitewater rafting. Mandy had always been robust, but on this trip he was coughing and feeling terrible. When he got home he was diagnosed with pneumonia and went into the hospital. By the time they realized he was HIV positive and dying, dementia was already setting in.

We were in shock. My mother and I couldn't believe this was happening, again. Danny kept him at home until it got so bad he had to go into a hospice. The one positive thing I can say is that, just like Miki, he never knew what happened. They both drifted into a dreamscape and never knew they got sick. I came back to New York and stayed with him often, but shortly after one return to Los Angeles I received the news that he was gone. The next time I saw him I was dressing him in his coffin in a bright royal blue suit that he loved.

I had to organize Mandy's funeral. When Miki died my sister and I made the arrangements, and dressed him in a big, black, shiny suit and bow tie that my family got to see before the service began. But this funeral, I had decided, would be closed casket. Miki wouldn't have wanted his friends to see him like that, and I just don't think people should see a young person dead. But when Mandy died my mom said, "Please leave the coffin open, I want to see him for as long as I can!"

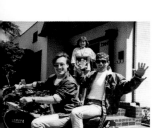

Lance Loud, Pat Loud, and Paul Zone, Hollywood, 1988

Less shocking, but no less painful, was Lance's death. In 2001, after decades of behavior that would have killed a normal mortal, Lance Loud succumbed to complications from Hepatitis C, after decades of drug use ate away at his immune system. He was also HIV positive, probably since the early eighties.

When I first moved to Los Angeles it was like old times with Lance. He was really one of the closest people to me in the entire world. I never had anyone that I was a true, close friend with that wasn't a boyfriend or a brother. And Lance genuinely became a brother to me, and just like Miki and Mandy, he was the best and worst role model, always letting me do whatever I wanted and always introducing me to new dangers, temptations, and adventures.

But by the mid-nineties I stopped hanging out with Lance because his crystal meth use got really bad. He was bouncing off the walls, and the people he was hanging around with were uncontrollable, crazy druggies and hustlers. One time he came to my place with some sleazy guy, and I told them they couldn't come in because I didn't know his friend. "C'mon Paul," Lance pleaded, "he just got out of prison!" I never got mad or fought with him, that's just not me, but it was a really horrible, horrible situation. Years passed without seeing him, even though we lived blocks apart. In 2001 his mother, Pat, and sister, Michelle, called me and said he only had weeks, maybe days, to live, and would I like to see him? When I entered his room, an emaciated figure greeted me with a severe gaze from a chair in the corner, and in a bitter tone he said, "I'm really glad you came here to see how ugly I am, to see me dying because you're feeling guilty!" But I didn't see any ugliness. On that visit all I could see was the beautifully handsome man whom I'd photographed on that Manhattan rooftop, the man I'd spent hundreds of nights getting into mischief with, the person who had made the underground feel like a thrilling adventure—as well as a warm loving home. We sat together and talked for hours that day, but I never saw him again. And I didn't feel guilty. I just felt very, very sad.

I was less sad four years later when my father died. I was so happy for my mother. I'd never seen her as calm and comfortable as she was after being liberated from his verbal abuse, mood swings, and the burdens of nursing him.

There were some nostalgic tinges when she moved out of the house that had been our headquarters, practice space, and the site of our 5 a.m. Ramones breakfasts, but I can honestly say I didn't feel bad when he died. I can't really speak for how my brothers would have reacted. In some ways their lives constantly reflected my father's influence. Mandy spent the last years of his life domesticated, happily working, cooking, going to the beach, and in a loving relationship. My father and mother would even visit him and Danny at their home for dinners. And Miki, whom I can never even remember speaking to my father, must have taken the fishing excursions he and my dad had to heart, as he was absolutely obsessed with fish for his entire short life.

My father's relationship with us was far more complicated than it seemed while we were averting his blows and ignoring his presence. Years later, Viki Galves told me that during Miki's funeral my dad gripped her hand and wept, whispering, "Goodbye, little buddy." He had a stroke six months later and was never the same. And just recently my mother gave me a yellowed, tattered 1960 photo booth picture of myself that my father kept in his wallet until the day he died. When I look at my happy pre-adolescent face I'm not sure what to think about the man who took me on jobs and tried to make his son turn out right.

>>>

Flying down to Los Angeles from San Francisco a couple of years ago I noticed a pair of men in orange robes boarding my flight, one of whom resembled the Dalai Lama. A quick Google search confirmed the Tibetan leader was in California, and any doubts were erased when fifty followers greeted him at LAX.

I handed my camera to a friend and nonchalantly stood behind the distracted monk, posing for a covert snapshot of me and the Dalai Lama. I was surprised when the spiritual leader turned from his flock, and said hello. I told him it was nice to meet him, and apologized for not knowing much about his work or teachings. He said that if I felt a need to know more I could find a book, but that I didn't need to know his teachings, I just needed to love everyone. Then he looked at my face and said, "You have happiness in your eyes, are you a happy person?"

"I feel like I'm a happy person," I replied, but thinking of Miki, Mandy, Lance, and so many others, I added, "I'm happy, but I feel I shouldn't be, because I've seen so much unhappiness and experienced so many bad things."

"Those things have nothing to do with your happiness," he responded. "That sadness is outside of you. I can see in your eyes that you are a happy person."

And he was right. The joys I've experienced, the good memories I have of those who left too soon, the faith that something better is coming no matter how many obstacles block my path—those things have defined my life, a life where joys and discoveries ultimately overwhelm sorrows and losses.

As a number of people began to recognize him, a larger crowd gathered around the exiled leader, but before he turned his attention away from me he reached into his fanny pack and took out a small piece of candy. As he gently put it in my hand he looked into my eyes and said, "It's always good to give a gift."

It *is* always good to give a gift, and as I look back on my absurd, animated life, I'm humbled by the generous gifts I've received from the amazing people I've been blessed to have around me. My mother gave me the gift of freedom, disregarding Brooklyn standards by accepting, indulging, and enabling me to be who I felt in my heart

Paul Zone, 1962
(photo from dad's wallet)

I needed to be. My brothers gave me the gift of rock 'n' roll, letting me share their dreams, songs, and spotlight. And my beautiful friends, Lance, Debbie, Chris, Wayne, Joey, Dee Dee—really everyone who welcomed me into the New York underground—gave me the gifts of acceptance and affirmation, admitting me into a world where the wonders of reality turned out to be better than any fantasy I'd ever had.

And I hope all of the family, friends, fans, bands, lovers, haters, collaborators, rip-off artists, record collectors, heroes, villains, freaks, and ghosts that I've known appreciate the gifts I've been lucky enough to be able to offer them. And more importantly, I hope they also see the songs, photos, haircuts, stylings, dances, laughs, love, sex, glorious days, and sleepless nights I've shared with them as my attempt, however futile, at reimbursement.

Not that there's any way I could ever repay them for guiding me through this adventure that started that summer night in 1972 when the New York Dolls became my soundtrack—and the world became my playground.

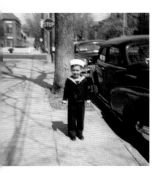

Paul Zone,
1959

Miki and Mandy,
1960

PHOTO ALBUM

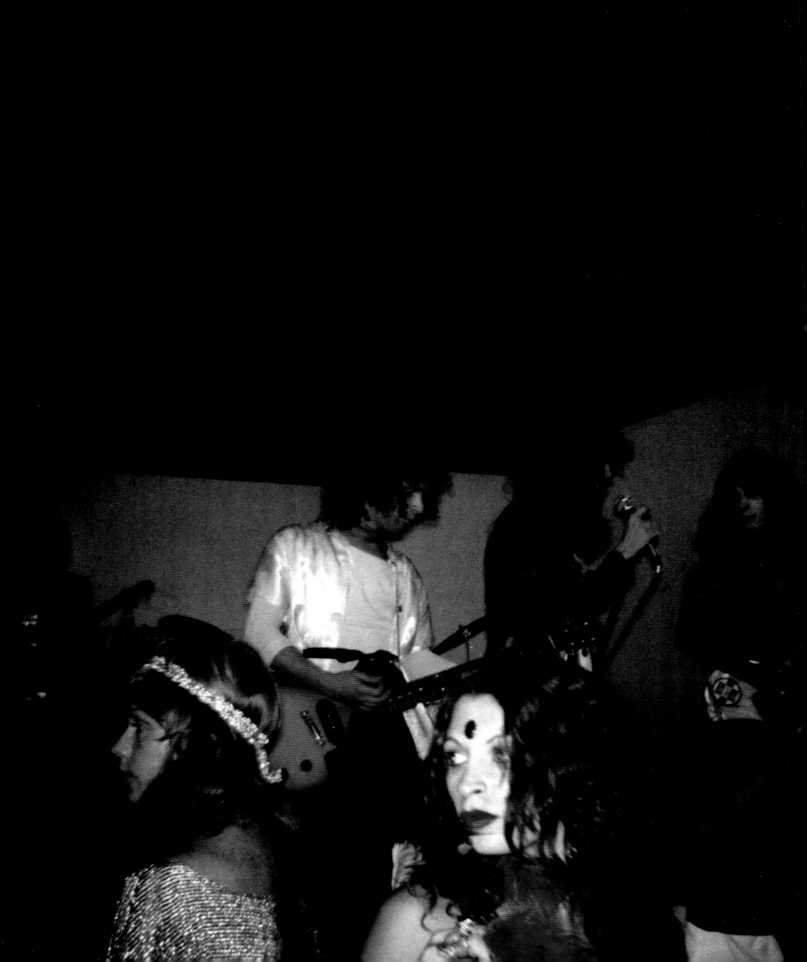

New York Dolls /
Mercer Arts Center,
June 13, 1972

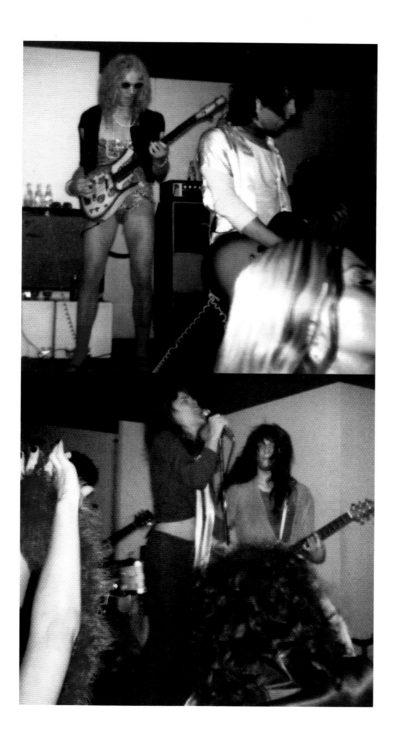

Arthur Kane, Sylvain Sylvain
(New York Dolls) /
Mercer Arts Center,
June 13, 1972 (top)

David Johansen, Johnny
Thunders (New York Dolls) /
Mercer Arts Center,
June 13, 1972 (bottom)

Marc Bolan (T. Rex) /
Academy of Music,
September 14, 1972

Marc Bolan (T. Rex) /
Academy of Music,
September 14, 1972

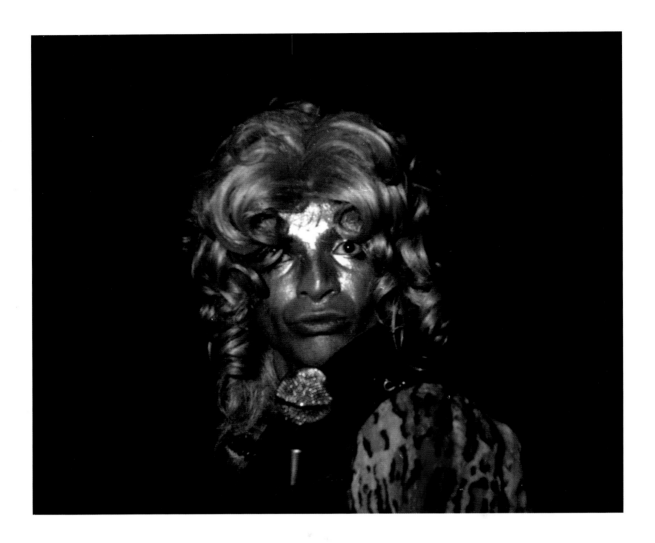

Alan Vega (Suicide) /
The Green St. Project,
May 25, 1973

Alan Vega, Martin
Rev (Suicide) / The
Green St. Project,
May 25, 1973

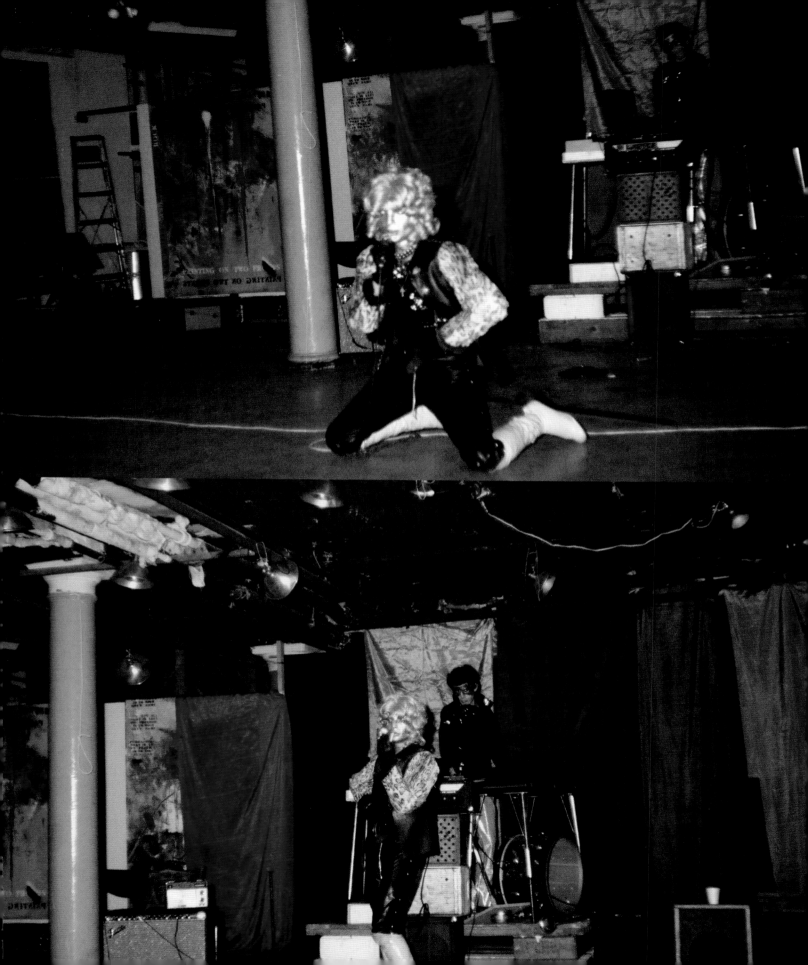

Tommy Moonie, Mandy
Zone, Peter Hoffman, Miki
Zone (The Fast) / Abbey
Theater, June, 1973

DIRECT FROM WONDERLAND FAST-TASTIC
AN EXPERIANCE NOT TO BE MISSED FANTASY
 ROCK

 SCIENCE
VE AT THE ABBEY THEATRE-136 E.13 ST.OFF 3RD AV. FICTION
IDAY & SATURDAY JUNE 15 & 16 AT 11 P.M. THRILLER
M. 2.50

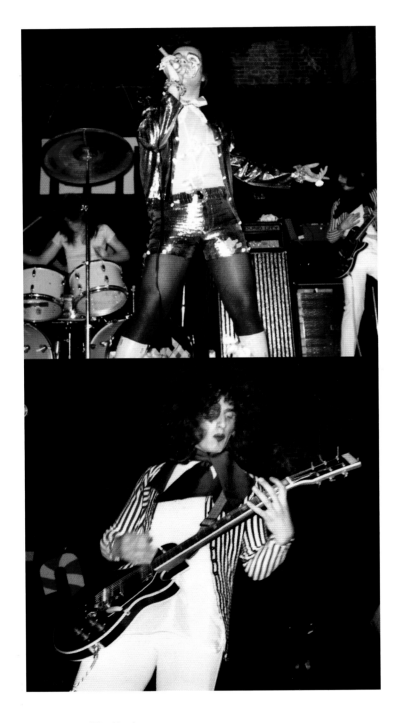

Mandy Zone (The Fast)
/ Abbey Theater, June,
1973 (top)

Miki Zone (The Fast) /
Abbey Theater, June.
1973 (bottom)

The Fast /
Abbey Theater,
June, 1973

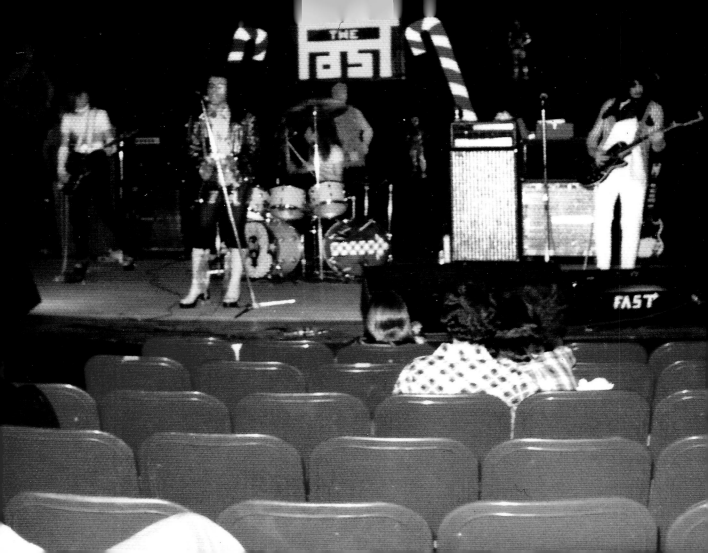

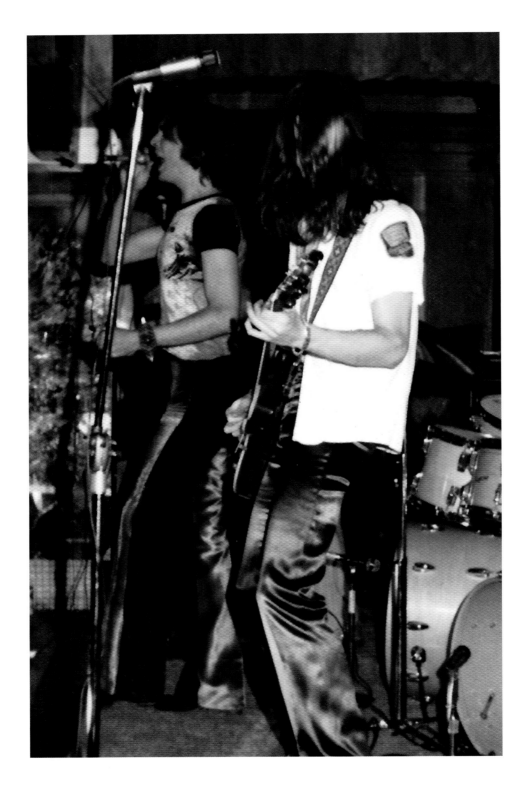

John Bellamy Taylor, Binky Phillips
(The Planets) / Hotel Diplomat,
July 13, 1973

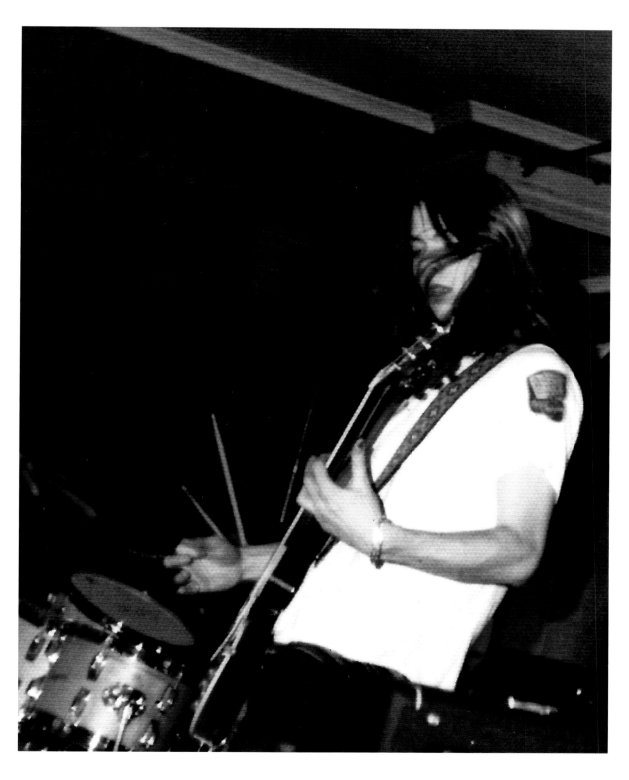

Binky Phillips (The Planets)
/ Hotel Diplomat,
July 13, 1973

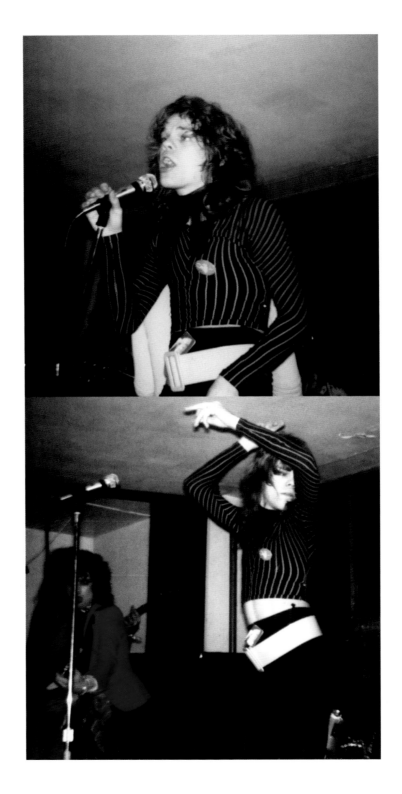

David Johansen (New York Dolls) / Max's Kansas City, August, 1973 (top)

Sylvain Sylvain, David Johansen (New York Dolls) / Max's Kansas City, August, 1973 (bottom)

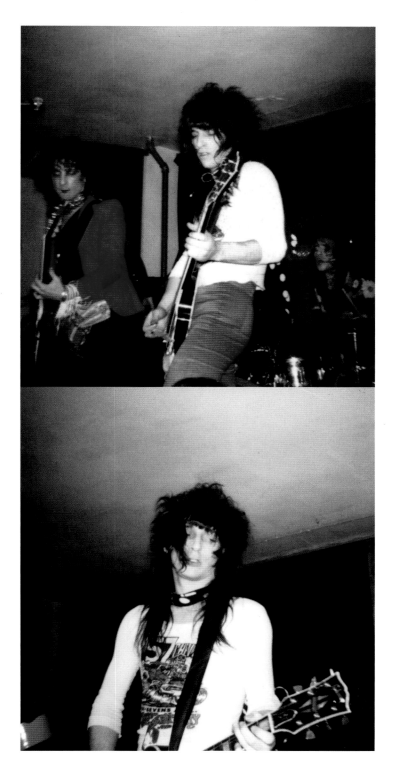

Sylvain Sylvain, Johnny
Thunders, Jerry Nolan (New
York Dolls) / Max's Kansas City,
August, 1973 (top)

Johnny Thunders (New York
Dolls) / Max's Kansas City,
August, 1973 (bottom)

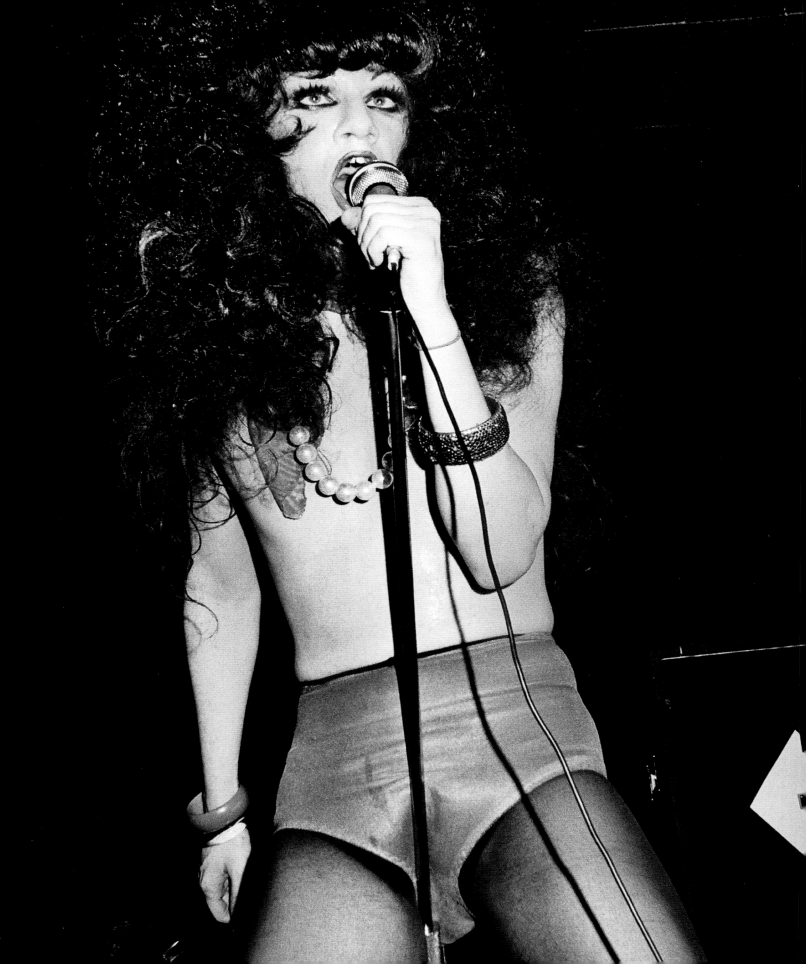

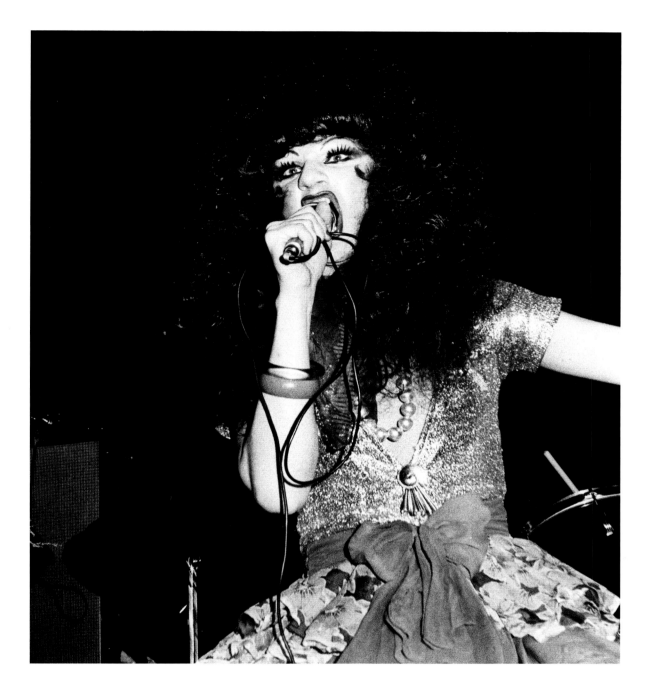

Wayne County /
Coventry,
Queens, NY, 1973

Wayne County /
Coventry,
Queens, NY, 1973

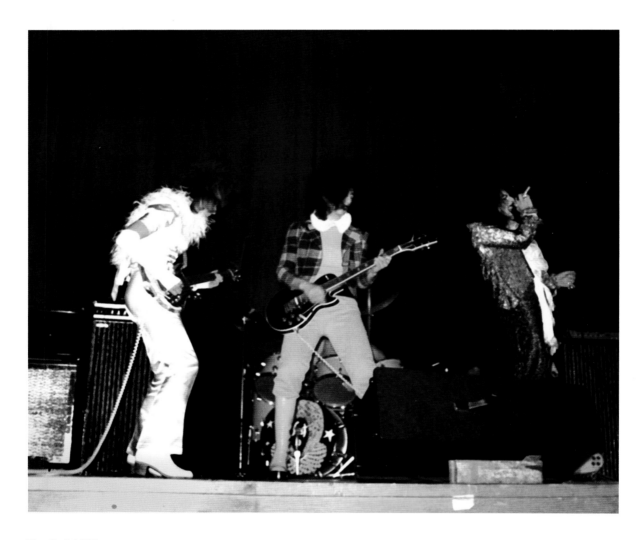

The Fast / 46th
St. Theatre,
Brooklyn, 1973

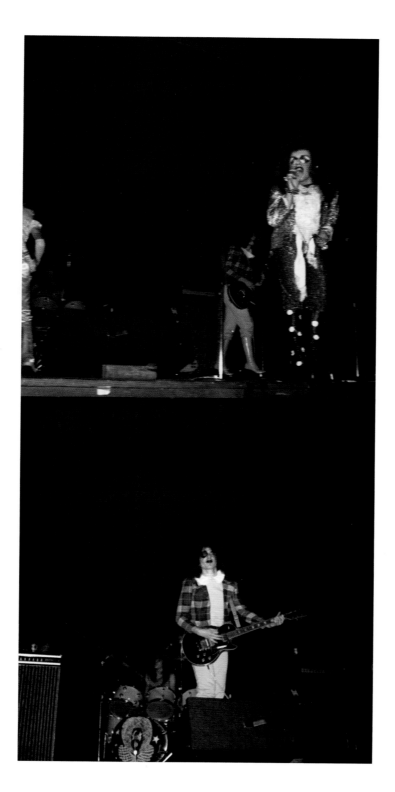

Mandy Zone (The Fast)
/ 46th St. Theatre,
Brooklyn, 1973 (top)

Miki Zone (The Fast)
/ 46th St. Theatre,
Brooklyn, 1973 (bottom)

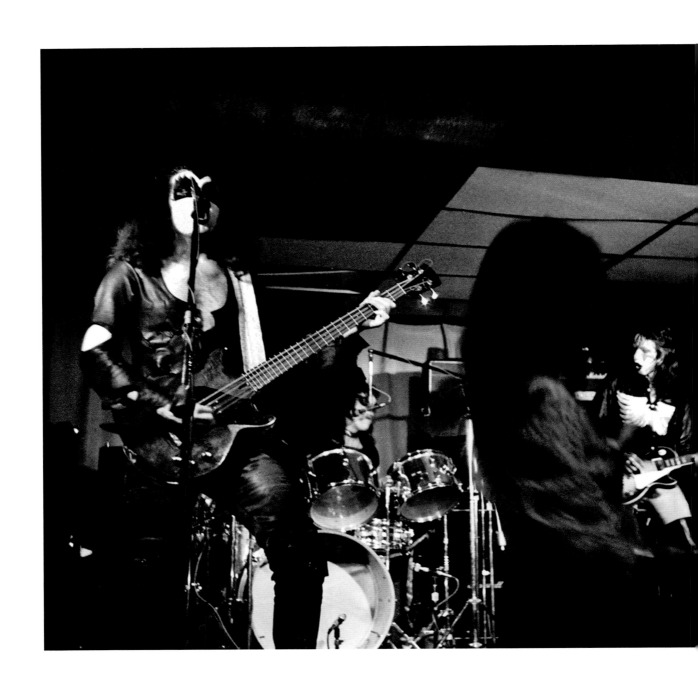

Gene Simmons, Peter
Criss, Ace Frehley,
Paul Stanley (KISS) /
Coventry, Queens NY,
August 31, 1973

Tommy Moonie, Peter
Hoffman, Miki Zone,
Mandy Zone (The Fast)
/ The Foundation,
Brooklyn, 1973

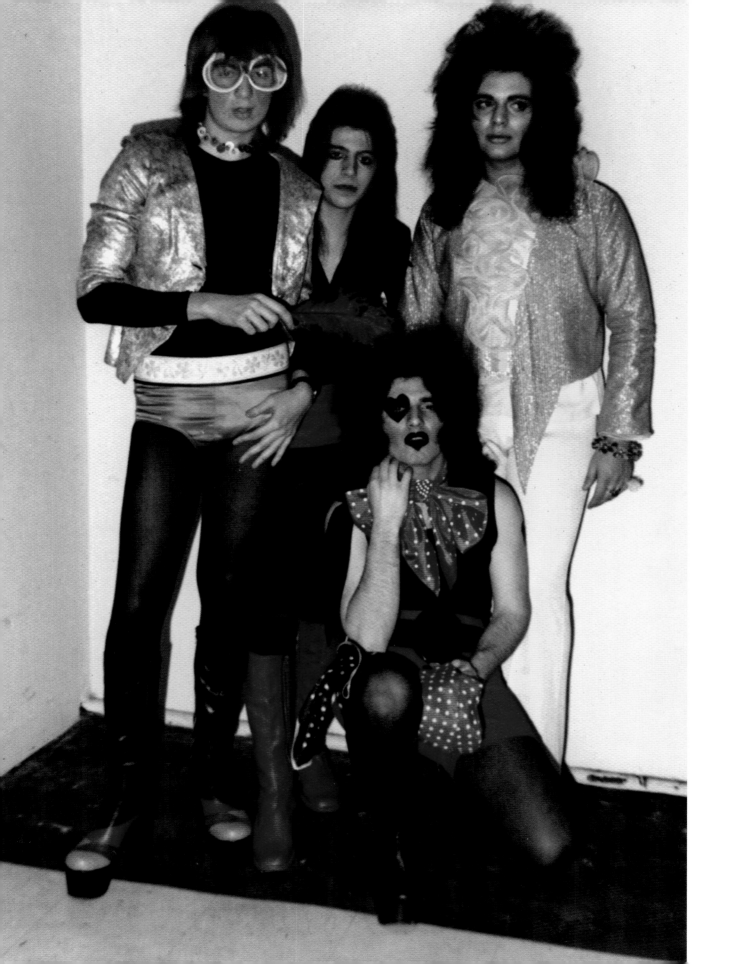

Lou Reed /
Academy of Music,
December 21, 1973

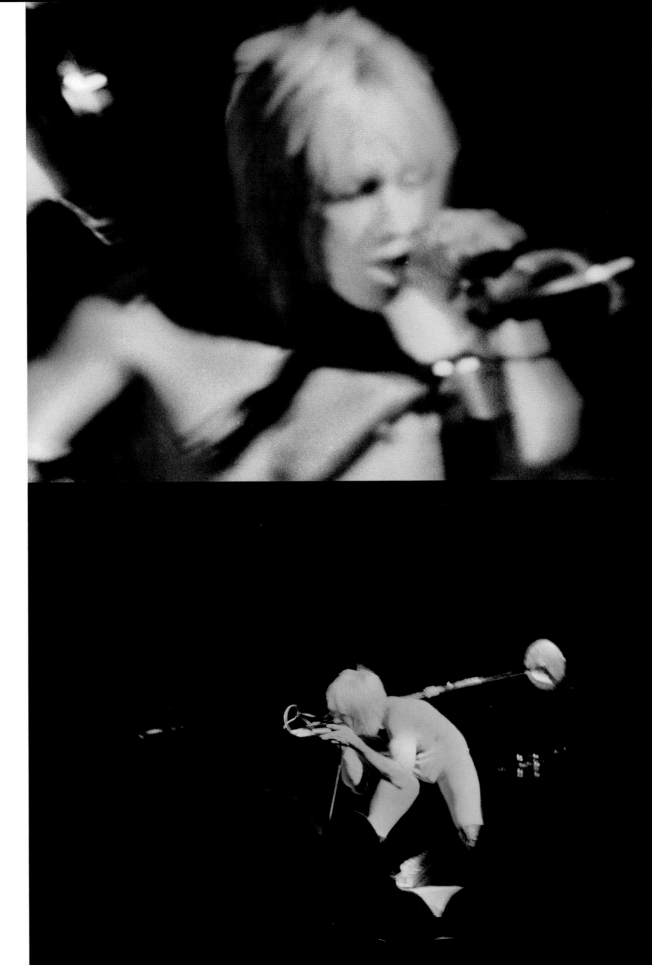

Iggy Pop /
Academy of Music,
December 31,
1973 (top)

Iggy Pop /
Academy of Music,
December 31,
1973 (bottom)

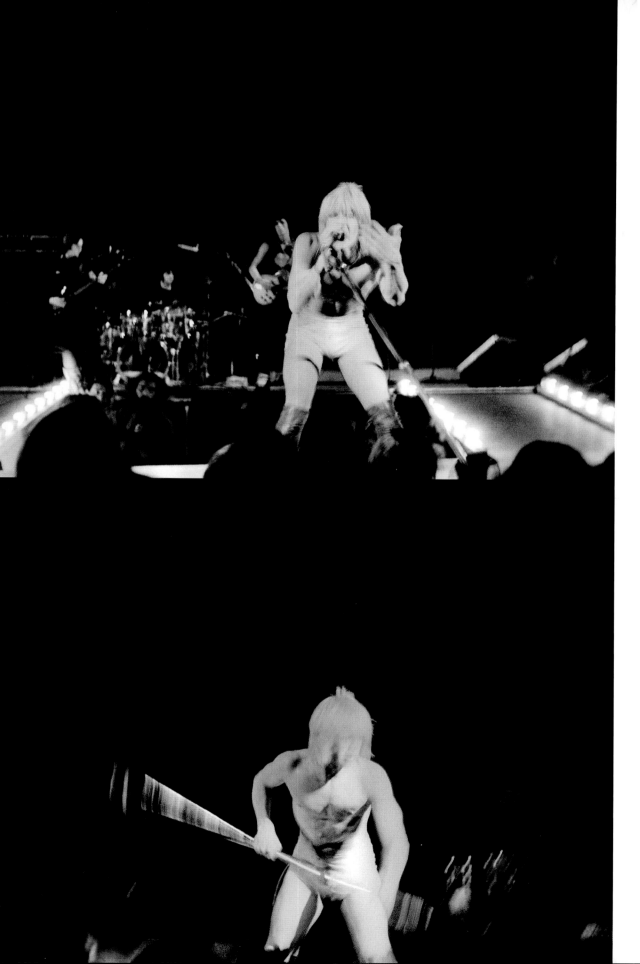

Iggy and the Stooges
/ Academy of Music,
December 31,
1973 (top)

Iggy Pop / Academy of
Music, December 31,
1973 (bottom)

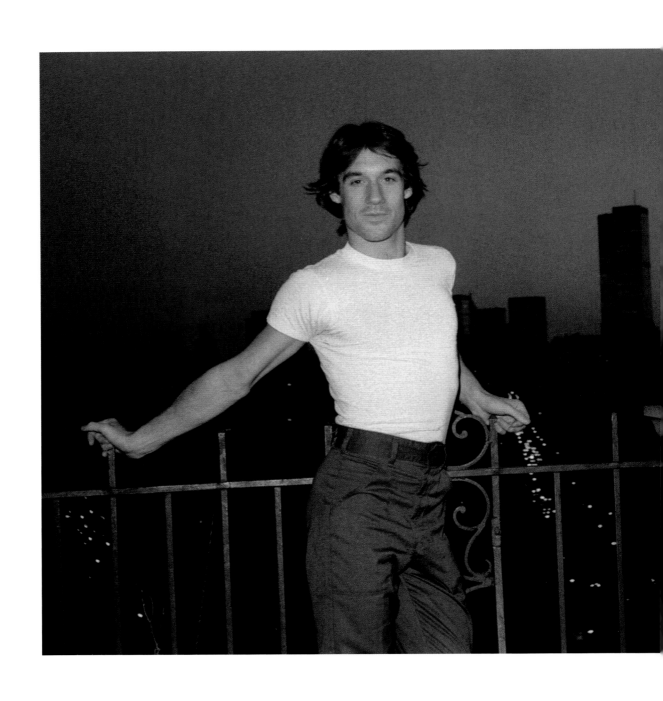

Lance Loud /
Greenwich Village,
1974

Pat Loud / At Home,
Upper East Side, 1974

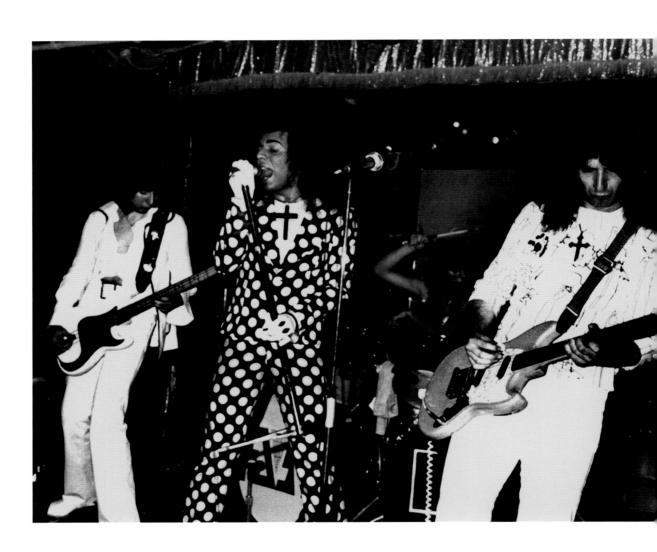

The Fast / Club 82,
June 26, 1974

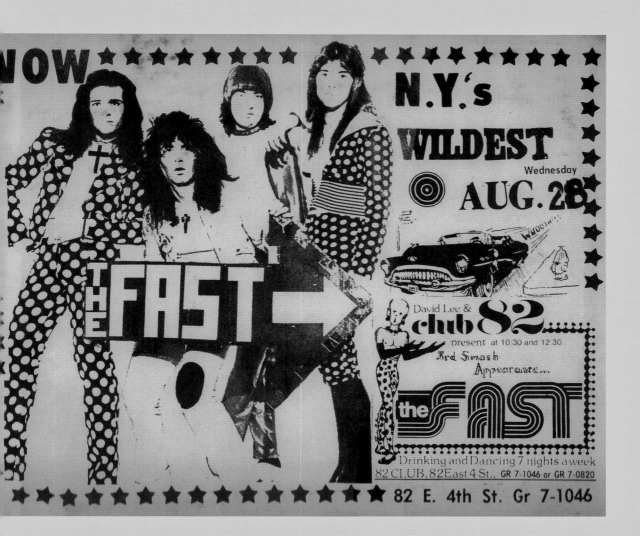

Justin Strauss
(Milk 'n' Cookies) /
Club 82, 1974

Ian North (Milk 'n' Cookies)
/ Paul's bedroom,
Brooklyn, 1974

Joey Ramone (The
Ramones) / Zone
family home 5am,
Brooklyn, 1974

Connie Gripp and Miki Zone
(The Fast) / CBGB, 1974

Eric Emerson (The Magic
Tramps), Dorothy Van Ooy /
Greenwich Village, 1974

Eric Emerson (The Magic
Tramps), Dorothy Van Ooy /
Greenwich Village, 1974

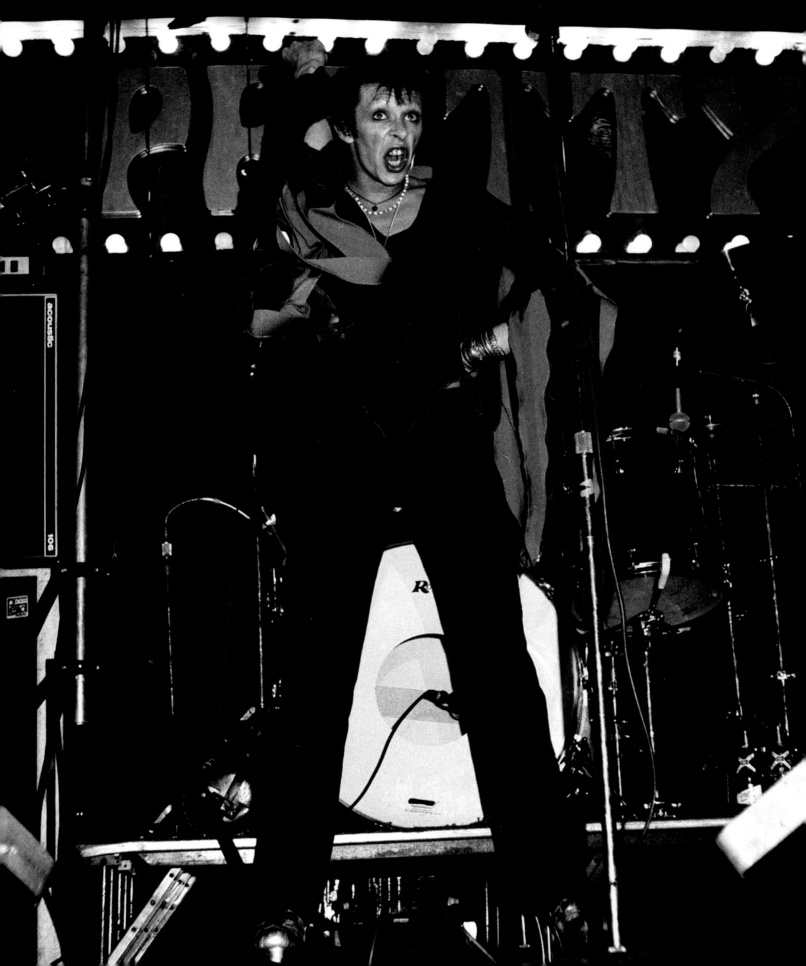

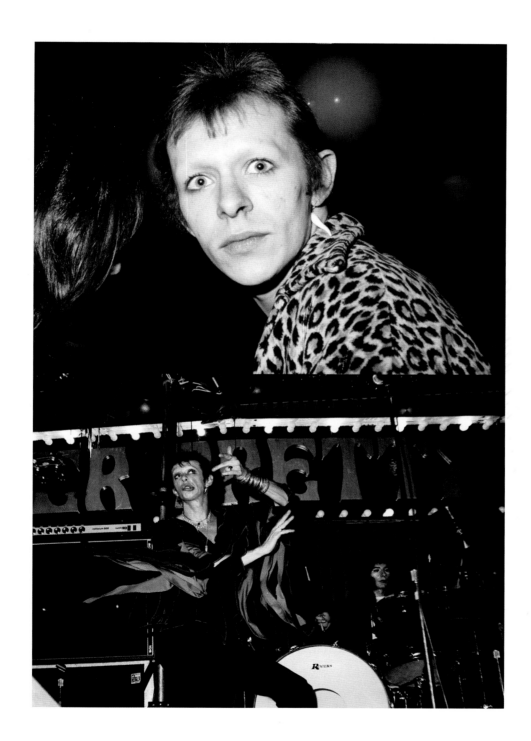

T. Roth (Another
Pretty Face) / Club
82, 1974 (top)

T. Roth (Another
Pretty Face) /
Hotel Diplomat,
1974 (bottom)

T. Roth (Another
Pretty Face) /
Hotel Diplomat,
1974

New York Dolls /
Academy of Music,
February 15, 1974

P100

Wayne County /
Club 82, 1974

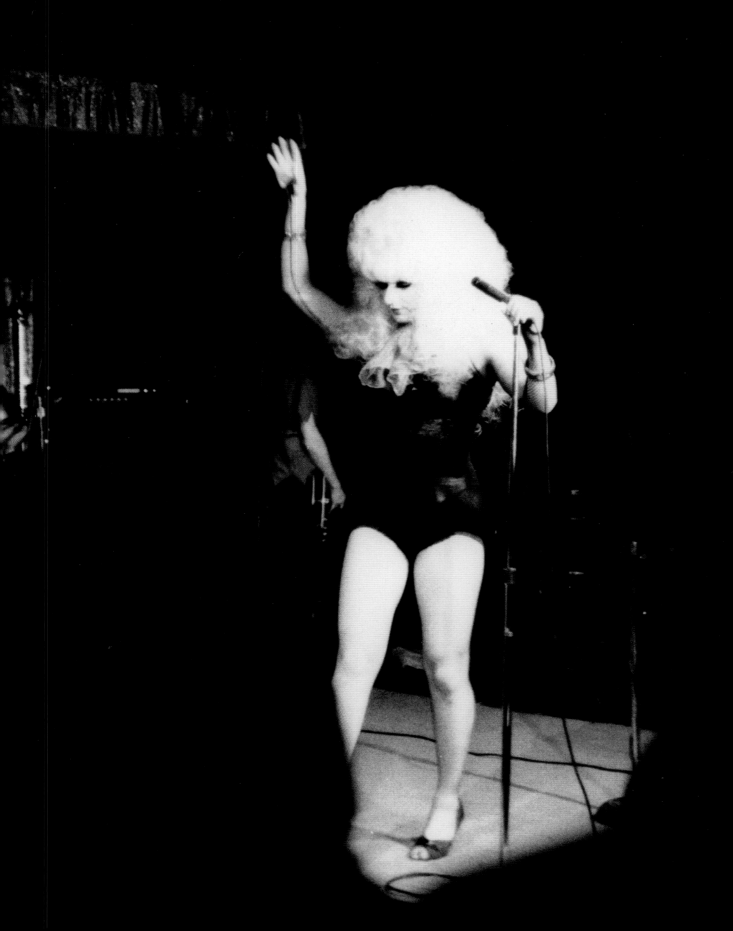

Alan Vega, Martin Rev
(Suicide) / Townhouse
Theatre, March 16, 1974
(left)

Alan Vega (Suicide) /
Townhouse Theatre,
March 16, 1974
(right)

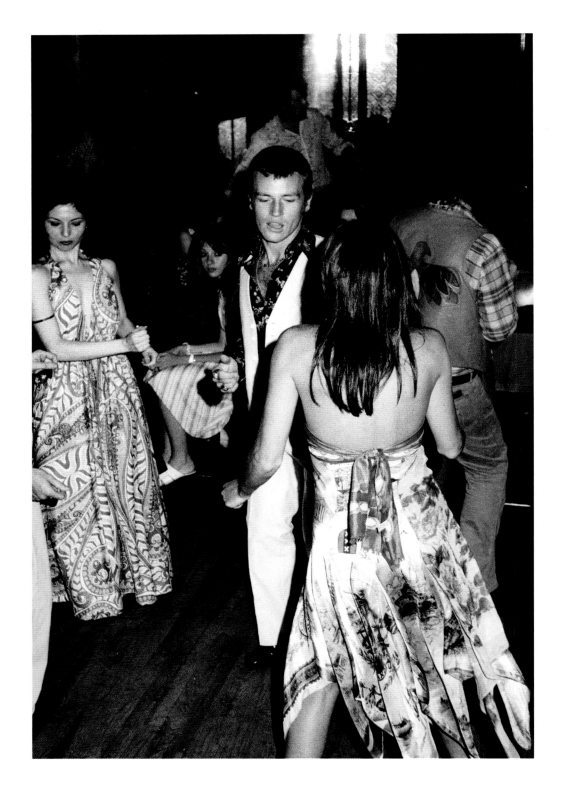

Mark Farner (Grand Funk
Railroad) / Le Jardin Disco,
dancefloor, 1974

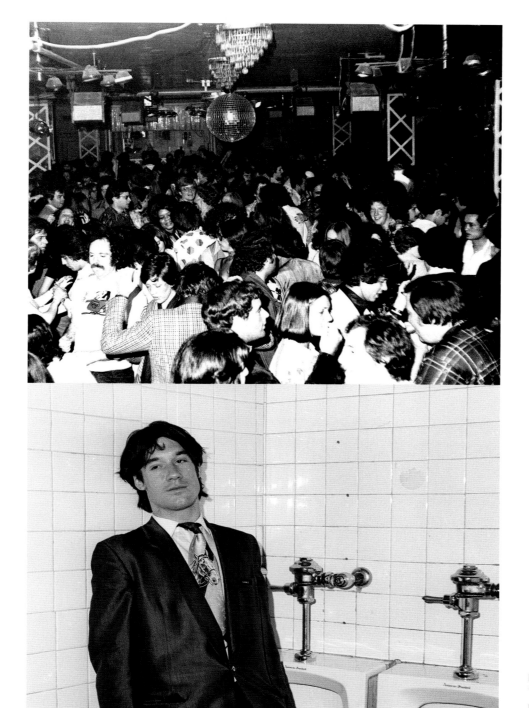

Le Jardin Disco,
1974 (top)

Lance Loud /
Le Jardin Disco,
men's room,
1974 (bottom)

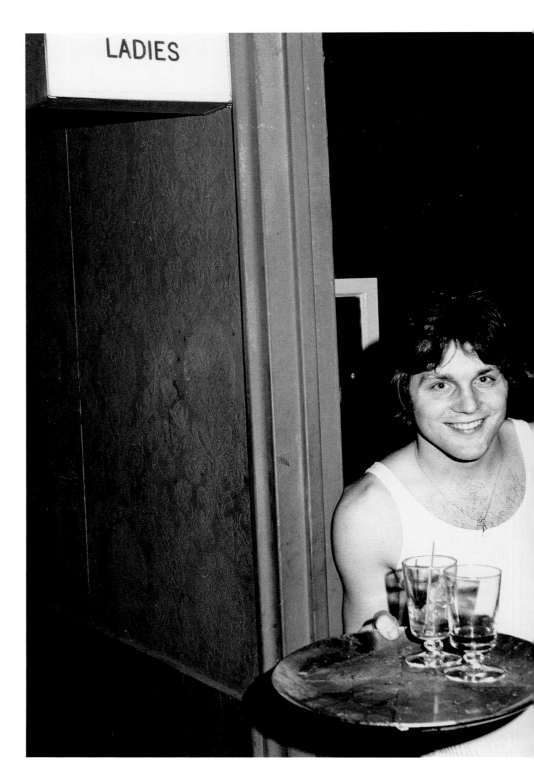

Unknown / Le
Jardin Disco,
1974

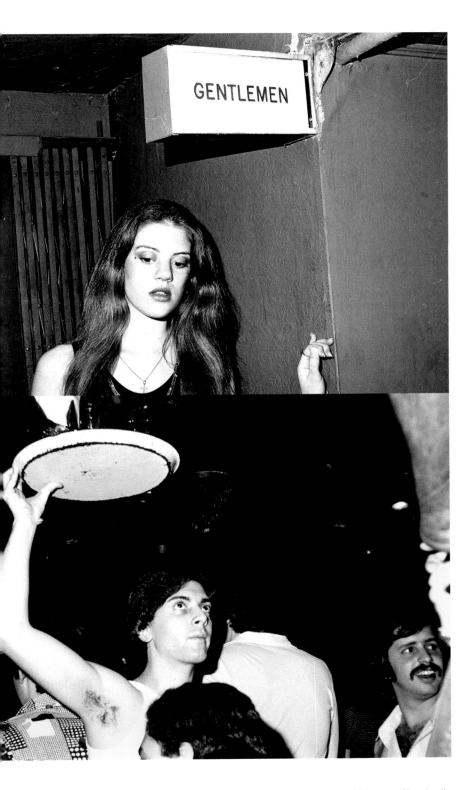

Unknown / Le Jardin
Disco, 1974 (top)

Unknown / Le Jardin
Disco, 1974 (bottom)

Patti Smith (Disco
Ball) / Blue Hawaii
Discotheque,
November 10, 1974

P109

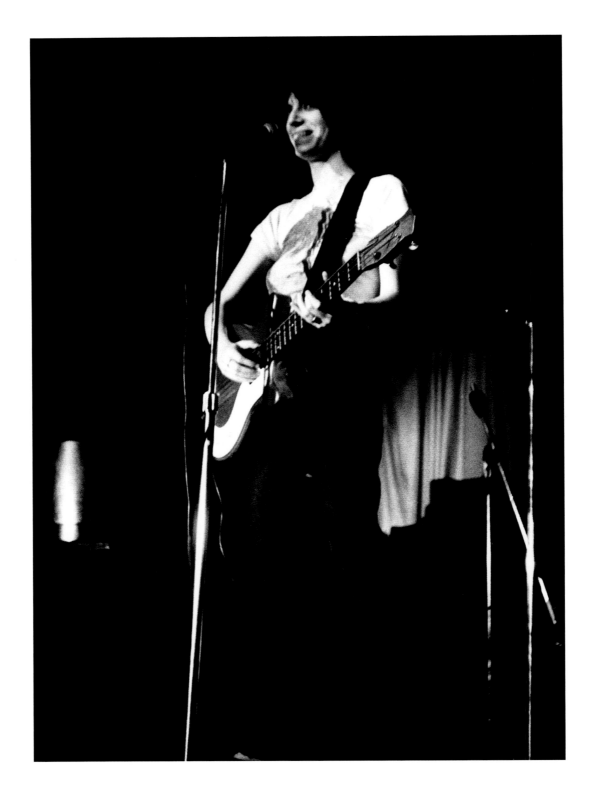

Patti Smith / Blue
Hawaii Discotheque,
November 10, 1974

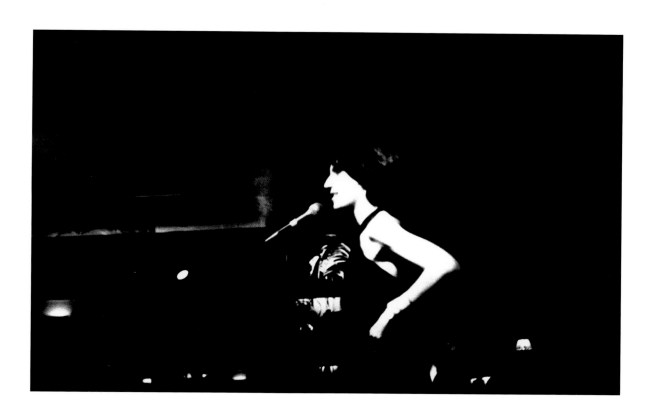

Patti Smith / Blue
Hawaii Discotheque,
November 10, 1974

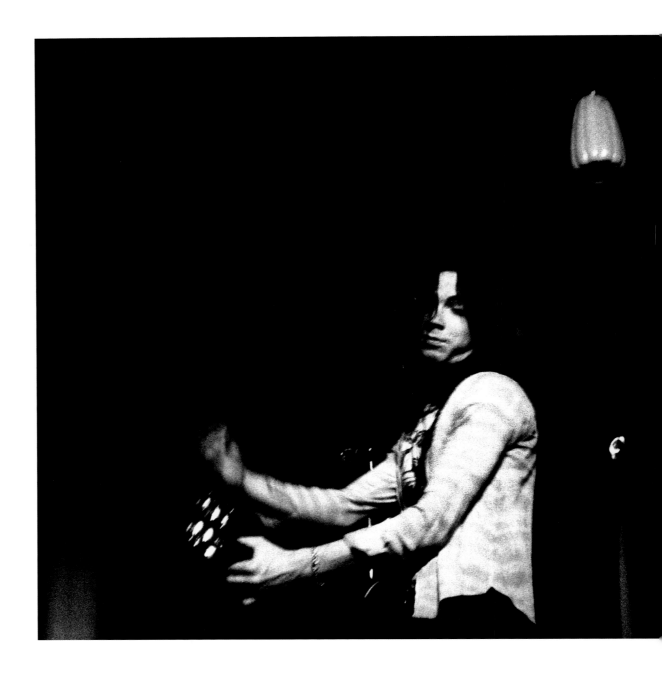

Binky Phillips (The Planets) / Coventry, Queens, NY, 1974

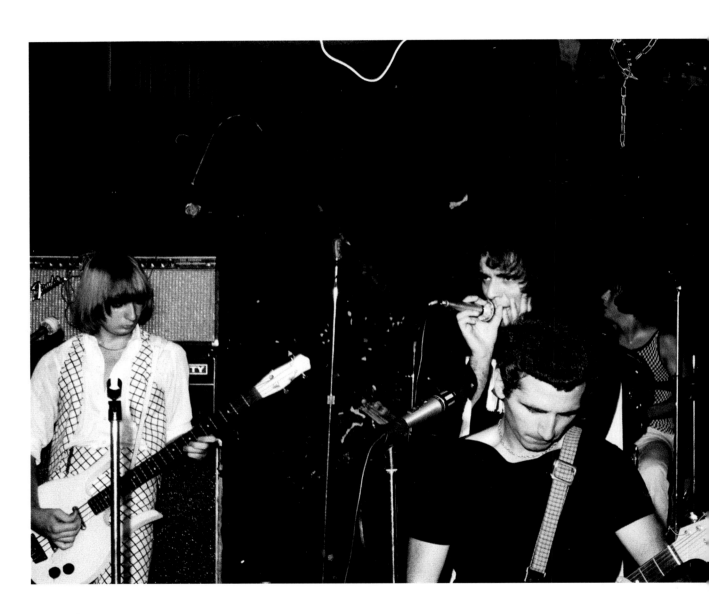

The Fast /
CBGB, 1975

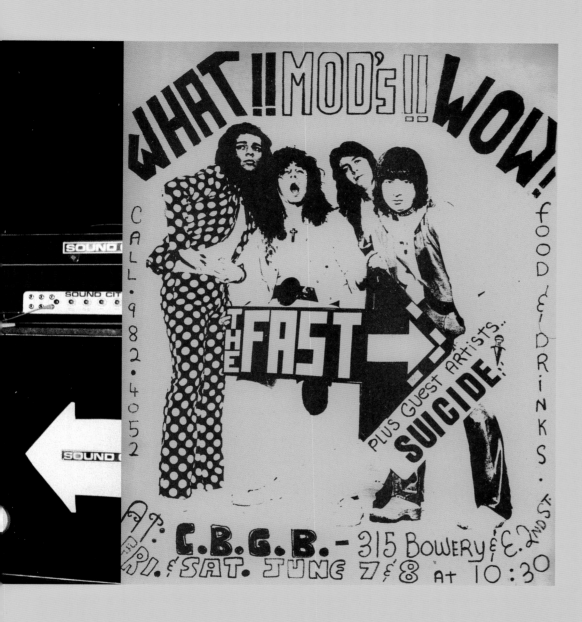

P116

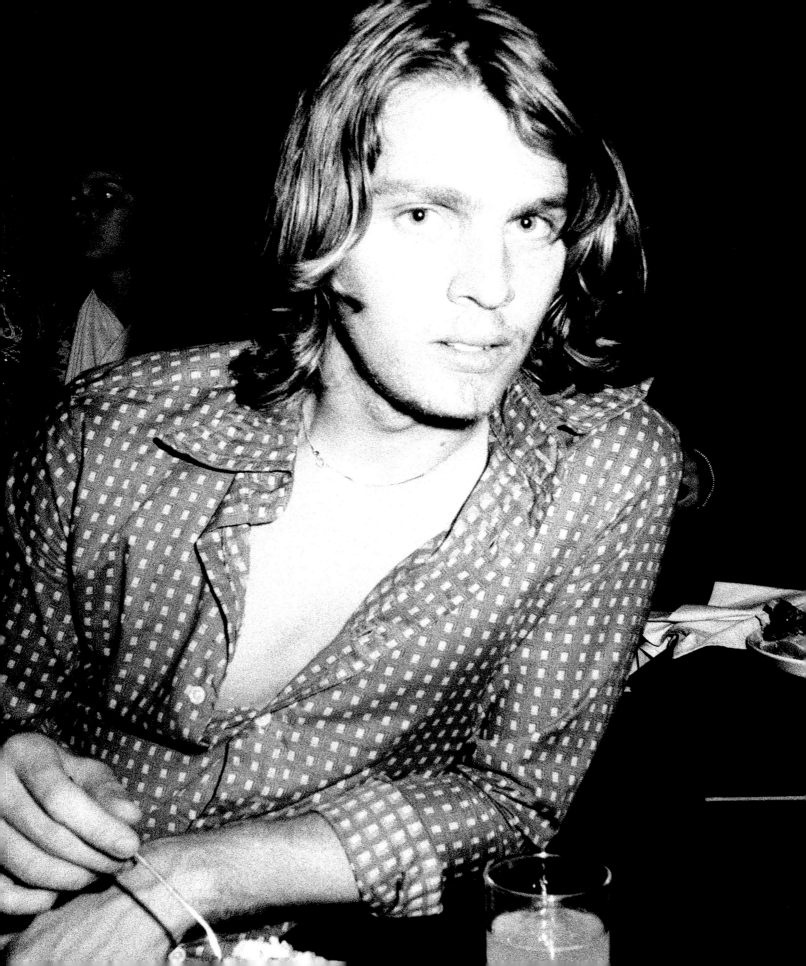

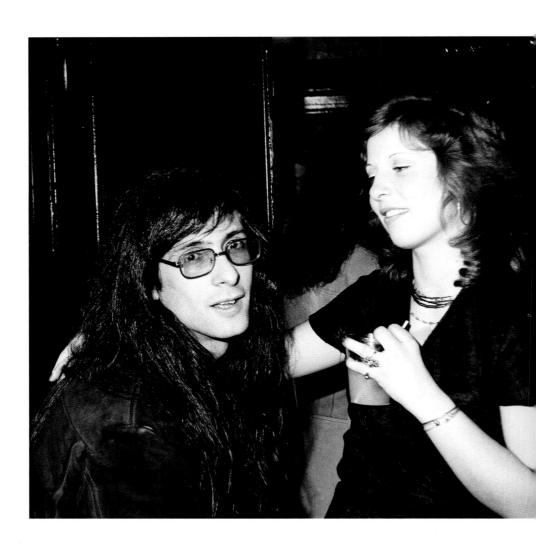

Lenny Kaye /
CBGB, Spring,
1975

Richard Sohl, Patti
Smith / CBGB,
Spring, 1975 (left)

Tom Verlaine, Patti
Smith / CBGB,
Spring, 1975 (right)

Cynthia (Roxy) Whitney,
Anya Phillips / Mother's,
September, 1975

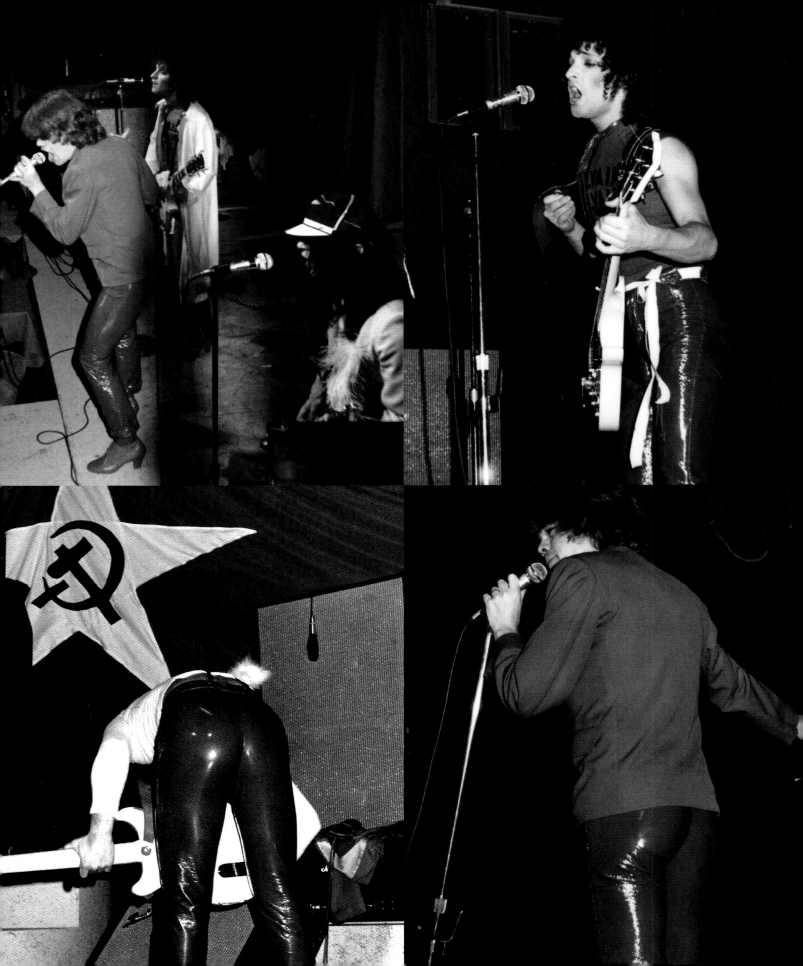

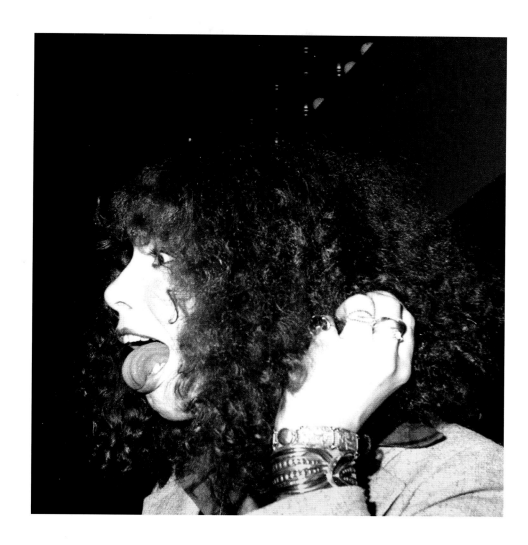

Janis Cafasso /
The Hippodrome,
March 7, 1975

David Johansen, Sylvain
Sylvain, Johnny Thunders
(New York Dolls) / The
Hippodrome, March 7, 1975
(top left)

Sylvain Sylvain (New York
Dolls) / The Hippodrome,
March 7, 1975
(top right)

Johnny Thunders (New York
Dolls) / The Hippodrome,
March 7, 1975
(bottom left)

David Johansen (New York
Dolls) / The Hippodrome,
March 7, 1975
(bottom right)

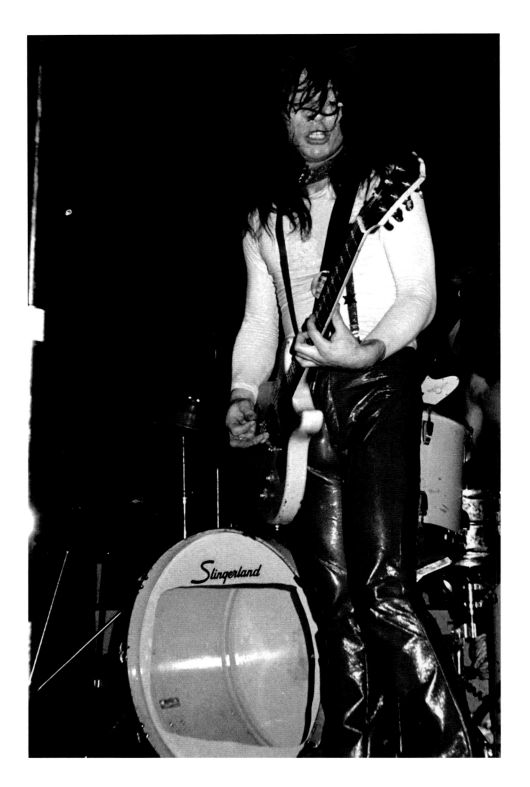

Johnny Thunders
(New York Dolls) /
The Hippodrome,
March 7, 1975

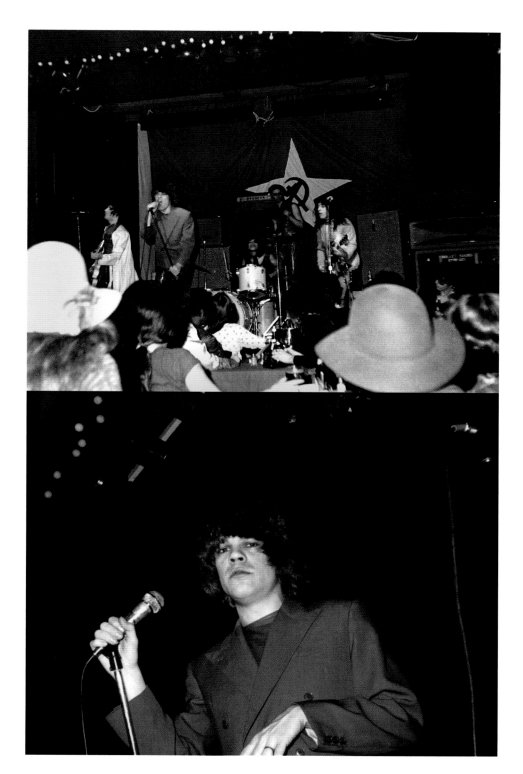

New York Dolls /
The Hippodrome,
March 7, 1975
(top)

David Johansen
(New York Dolls) /
The Hippodrome,
March 7, 1975
(bottom)

Ray Davies (The Kinks)
/ Academy of Music, 1975

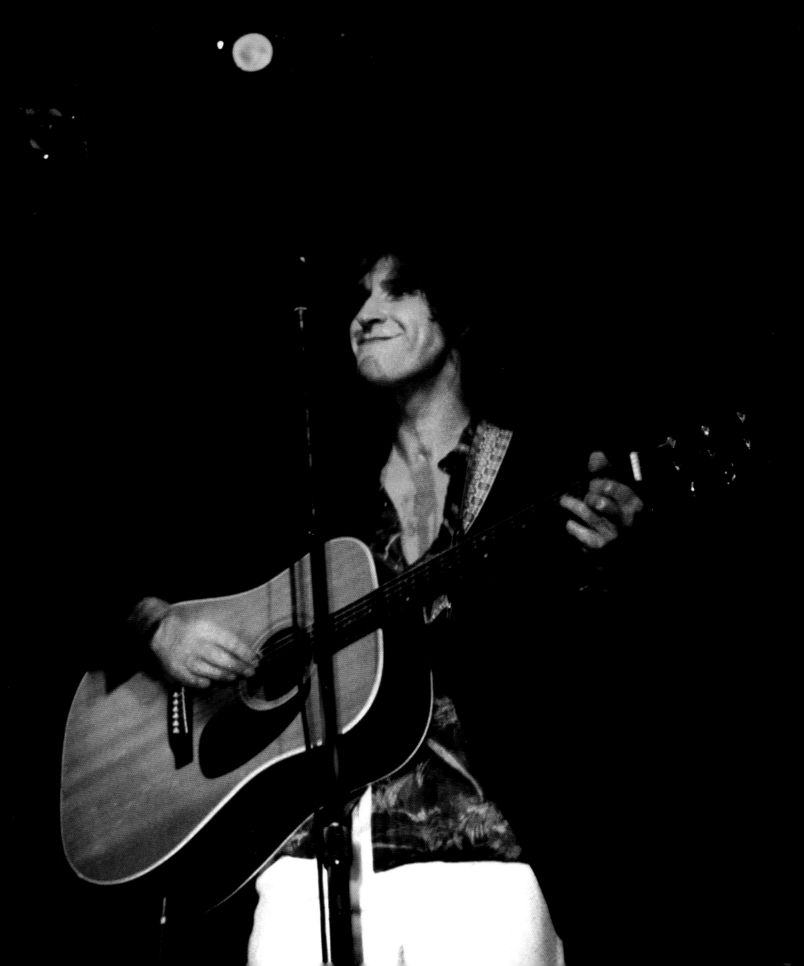

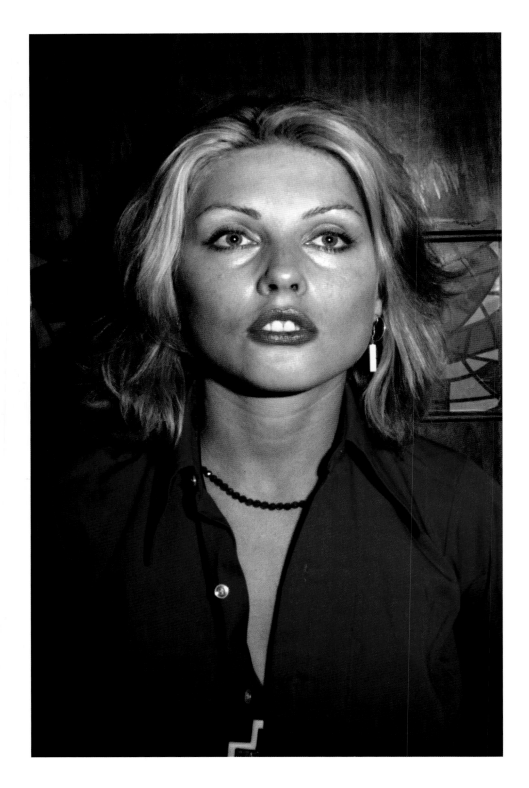

Debbie Harry (Blondie) /
Mother's, November 13, 1975

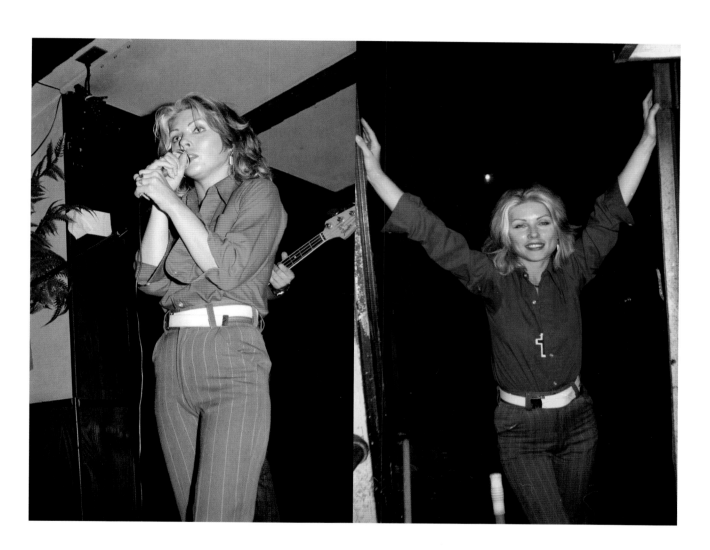

Debbie Harry (Blondie) /
Mother's, November 13, 1975

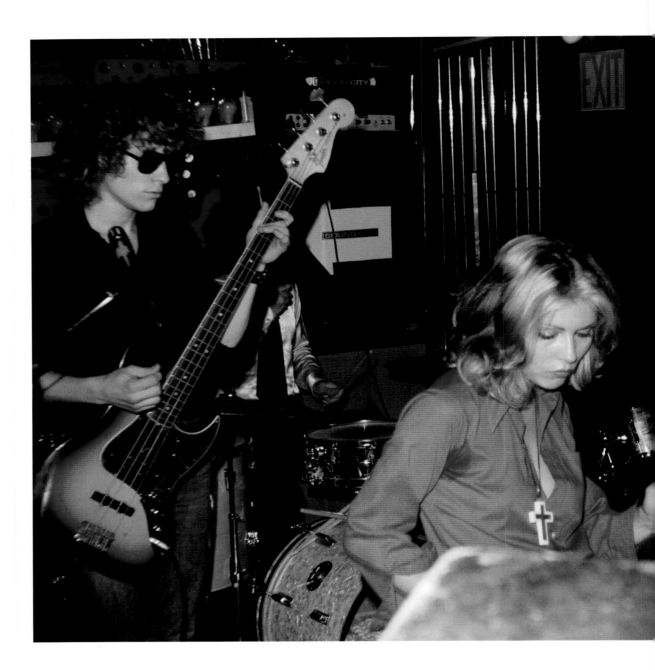

Gary Valentine, Clem
Burke, Debbie Harry, Chris
Stein (Blondie) / Mother's,
November 13, 1975

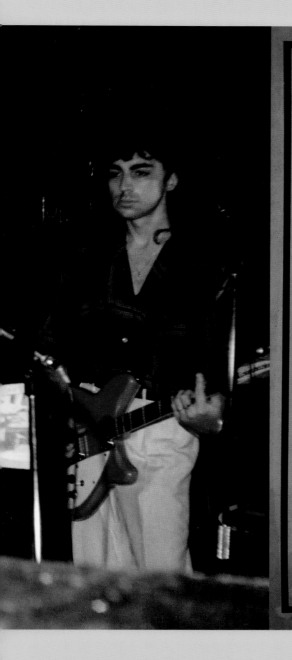

COUNTY LINE PRESENTS

Tues. Wed. and Thurs.
Showtime 10:30 p.m

NEW YORK'S
HOTTEST ROCK
AND ROLL BANDS

Fri. Sat. and Sun.
10:30 p.m. & 12:30 a.m.

TUES. NOV. 4
CLEAR CLOUD

WED. NOV. 5
MINK DE VILLE
with
Special Guests

THURS. NOV. 6
THE FAST
SNIPER

TUES. NOV. 11
BOYZ
DODGER

WED. NOV. 12
MINK DE VILLE
BUZZIE WEILER band

THURS. NOV. 13
THE FAST
BLONDIE

TUES. NOV. 18
STRAY CAT

WED. NOV. 19
MINK DE VILLE
THE FAST

THURS. NOV. 20
THE FAST
KNICKERS

SUNDAY NOV. 23
ANTENNA
RAGS

924-9780

Oct. 31, Nov. 1, 2.
JOHN COLLINS
SMALDOG
Nov. 7, 8, & 9.
EMILIO CUBEIRO
ROSIE ROSS
Nov. 14, 15, & 16
HEART BREAKERS
THE FAST

Nov. 21, 22.
WAYNE COUNTY
THE OUTKIDS

Nov. 28 29, 30.
TALKING HEADS
SNIPER

dec. 5, 6, 7.
RAMONES

MOTHERS

267 West 23rd Street at eighth ave.

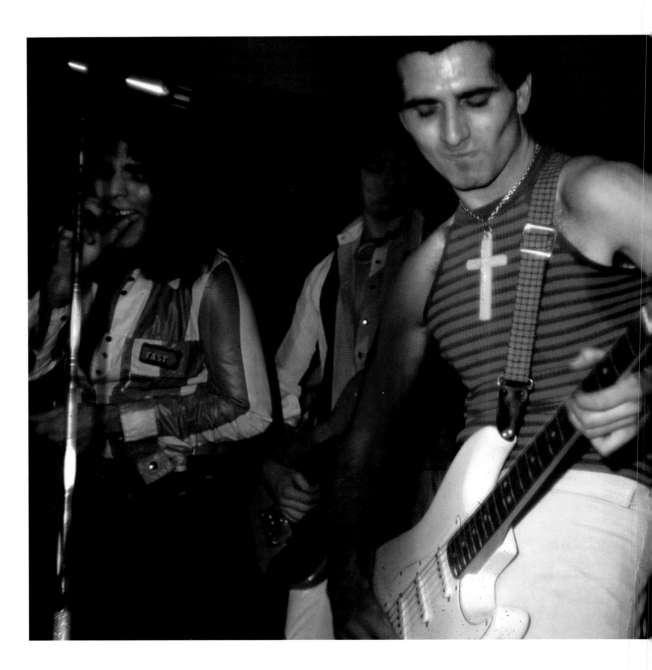

The Fast / Mother's,
September 6, 1975

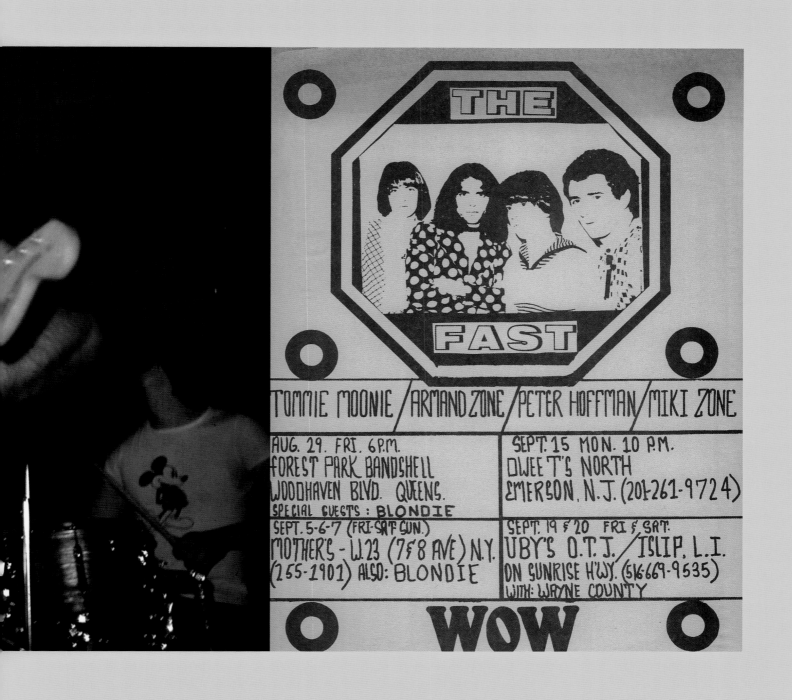

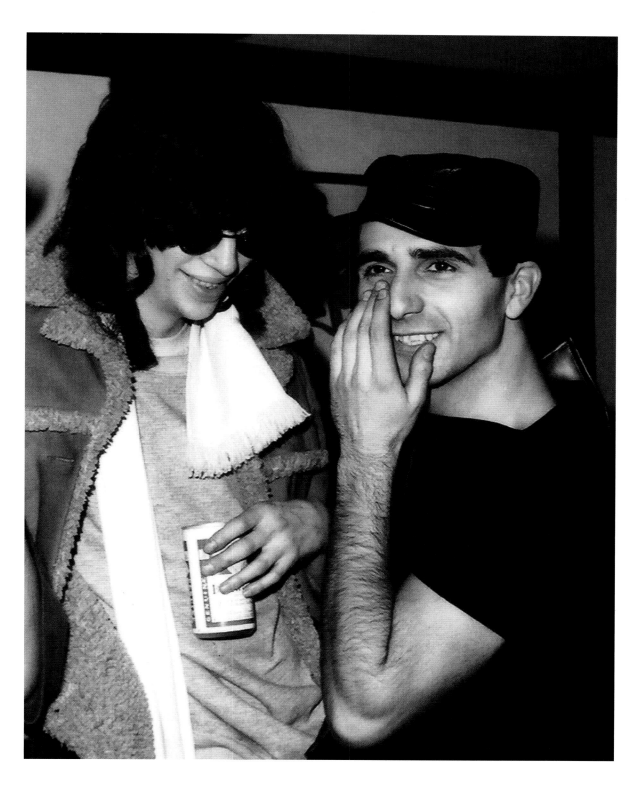

Joey Ramone (The
Ramones), Miki Zone
(The Fast) / Mother's,
October, 1975

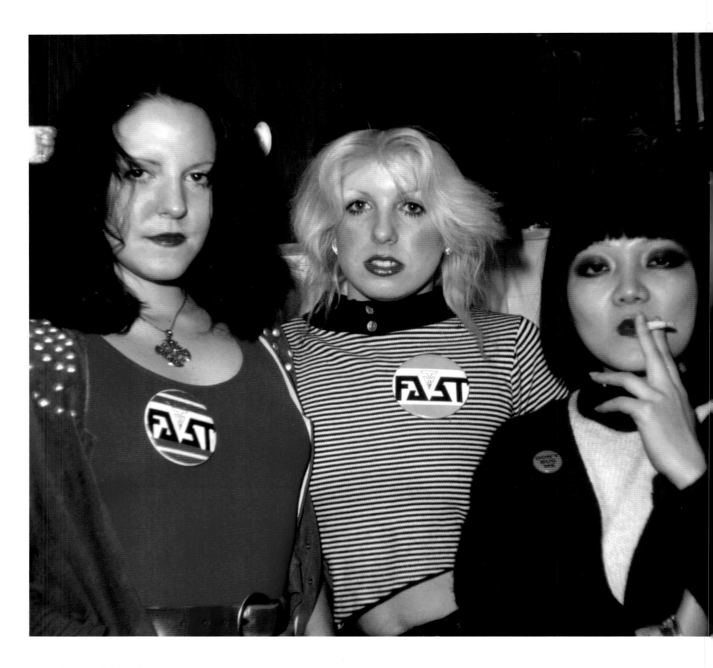

Eileen Polk, Cathi (Honi)
O'Rourke, Anya Phillips /
Mother's, September, 1975

COUNTY LINE PRESENTS

NEW YORK'S
HOTTEST ROCK
AND ROLL BANDS

FRIDAY THRU SUNDAY
SHOWS AT 11:00 & 1:00

SEPT. 5, 6, 7.

THE FAST

BLONDIE

SEPT. 12, 13, 14.

EMILIO CUBEIRO

and
Edwin's Hot Little Band

SEPT. 19, 20, 21.

DIRECT FROM DETROIT
THE MOTOR CITY SENSATIONS

THE MUTANTS

with

BANDIT

SEPT. 26, 27, 28.

JOHN COLLINS
EVE MOON

OCT. 3, 4, 5.

THE RAMONES
BLONDIE

Oct. 10, 11, 12.

THE PLANETS
MINK DE VILLE

Oct. 17, 18, 19.

TELEVISION

THE FAST
with
Special Guests
EVERY THURSDAY
AT 10:00 p.m.
[$2.00 Cover]

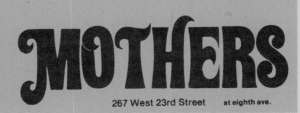

MOTHERS

267 West 23rd Street at eighth ave.

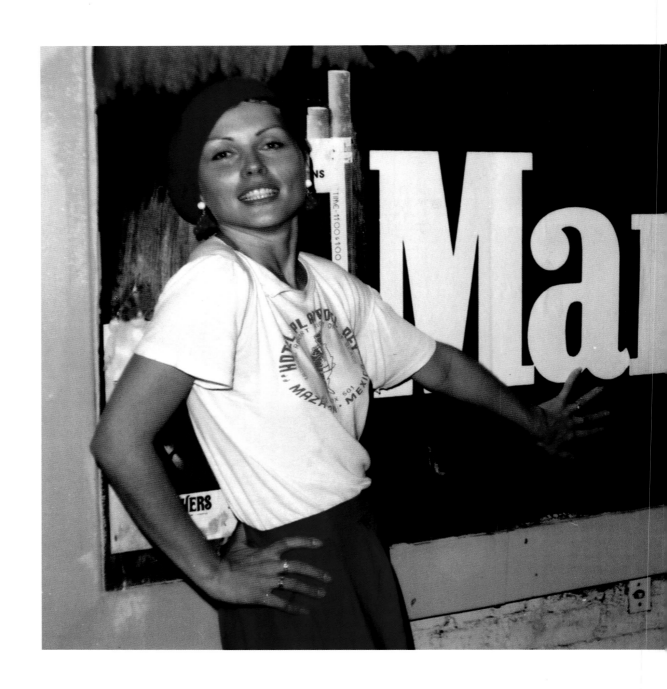

Debbie Harry / Outside
Mother's, 23rd St.,
August, 1975

YMCA - Chelsea Hotel
/ Outside Mother's,
23rd St., August, 1975

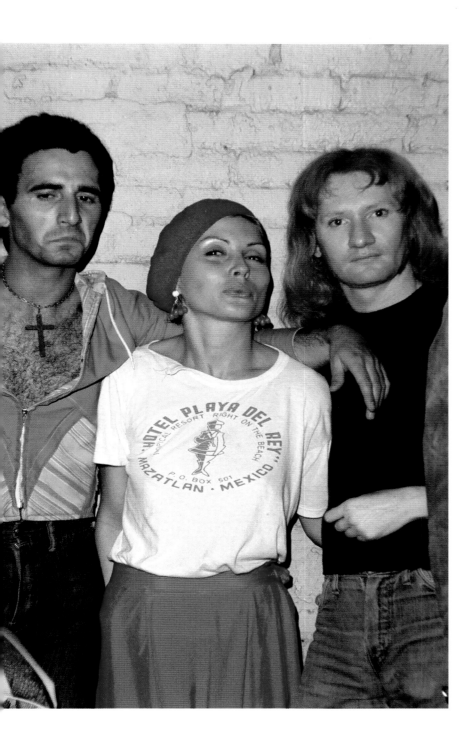

Miki Zone (The Fast),
Debbie Harry (Blondie),
Wayne County / Outside
Mother's, 23rd St.,
August, 1975

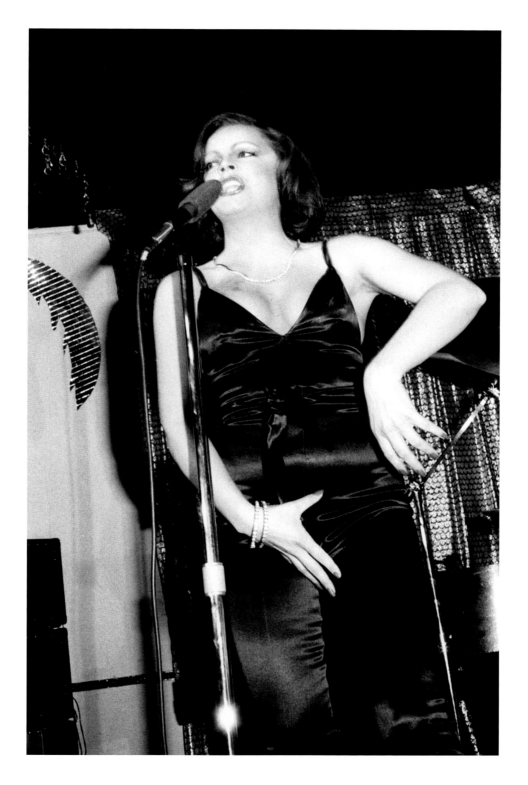

Cherry Vanilla /
Trude Heller's,
May 3, 1975

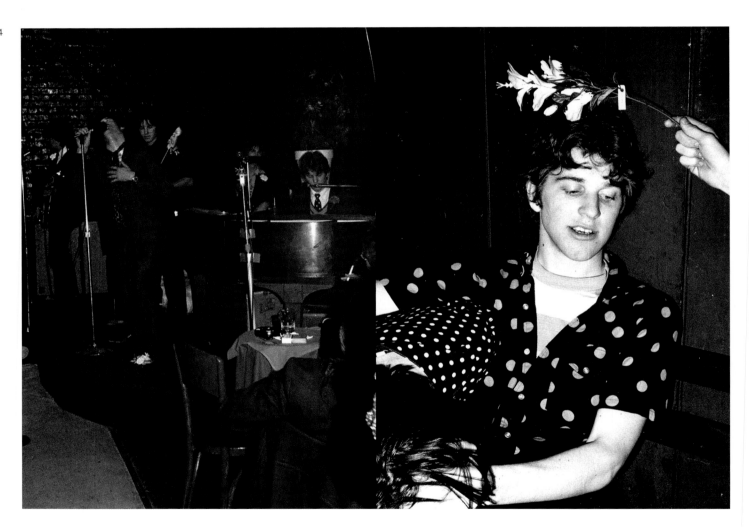

The Mumps /
Trude Heller's,
May 3, 1975
(left)

Kristian Hoffman
(The Mumps) /
Trude Heller's,
May 3, 1975
(right)

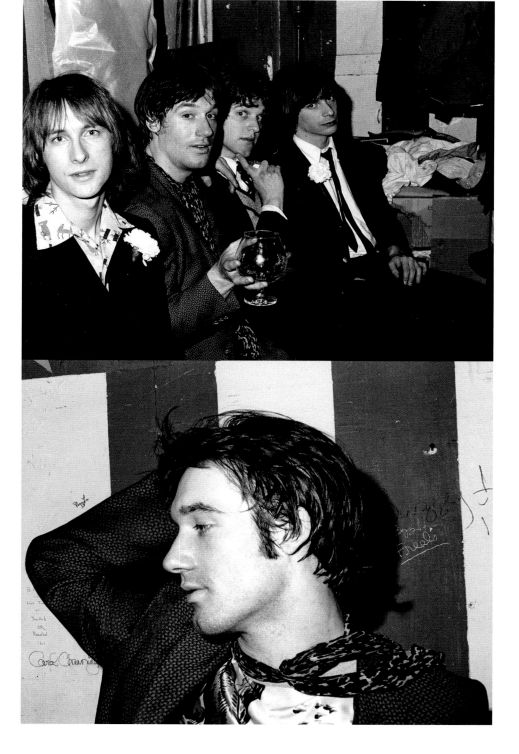

Jay Dee Daugherty, Lance Loud, Kristian Hoffman, Rob DuPrey (The Mumps) / Trude Heller's, May 3, 1975 (top)

Lance Loud (The Mumps) / Trude Heller's, May 3, 1975 (bottom)

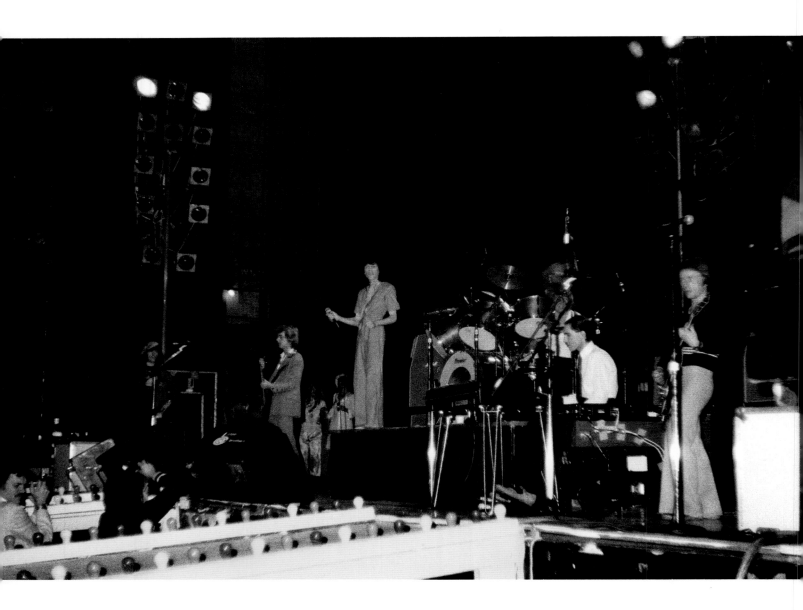

Sparks / Academy of
Music, May 9, 1975

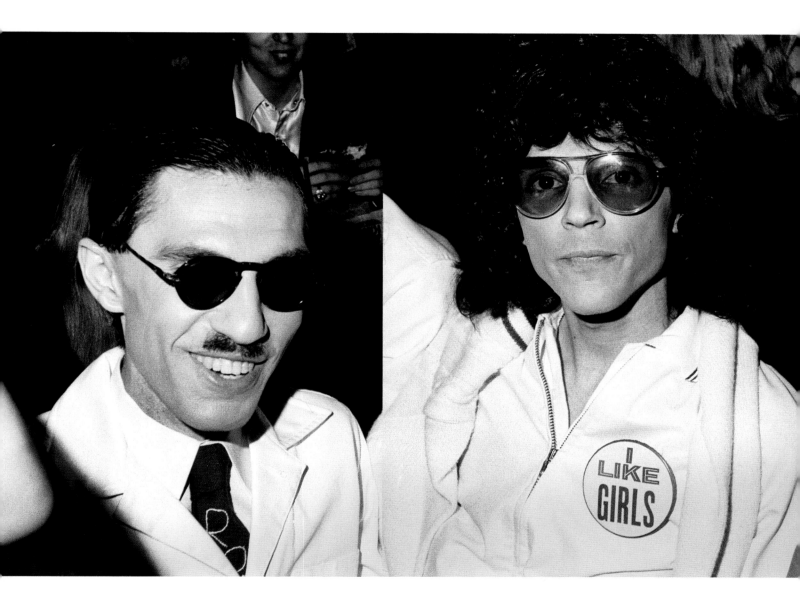

Ron Mael (Sparks) / Burger
King, May 9, 1975 (left)

Russell Mael (Sparks) / Burger
King, May 9, 1975 (right)

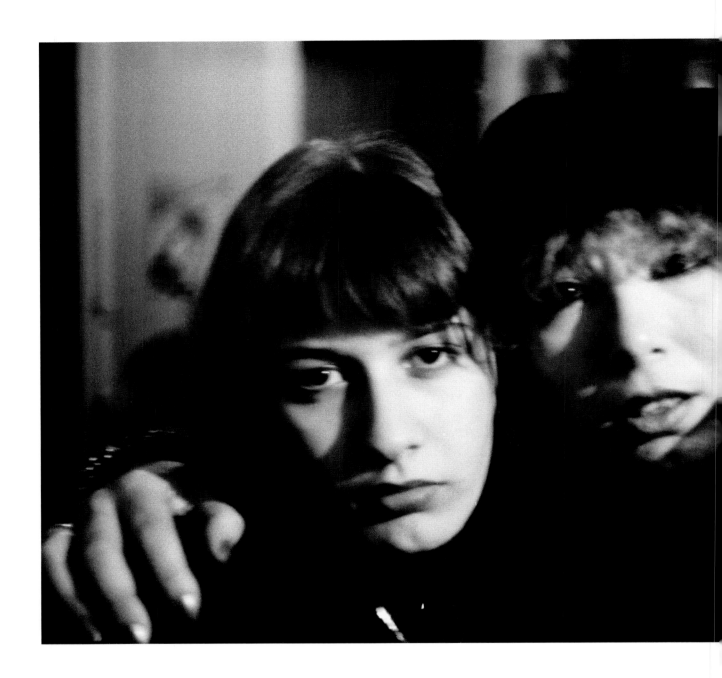

Abbijane Schifrin,
Janis Cafasso /
Manhattan, 1975

Tommy Dean /
Rock Bottom's,
8th St., 1978

Wayne County,
Peter Crowley / Max's
Kansas City's kitchen,
1975

Wayne County
/ Max's Kansas
City's DJ booth,
1975

Dee Dee Ramone
(The Ramones),
Connie Gripp /
Max's Kansas City's
kitchen, 1975

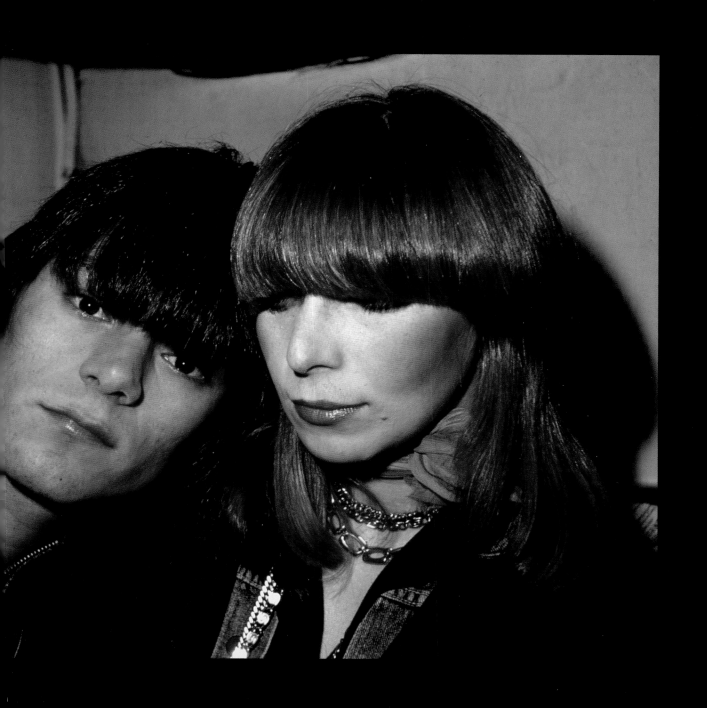

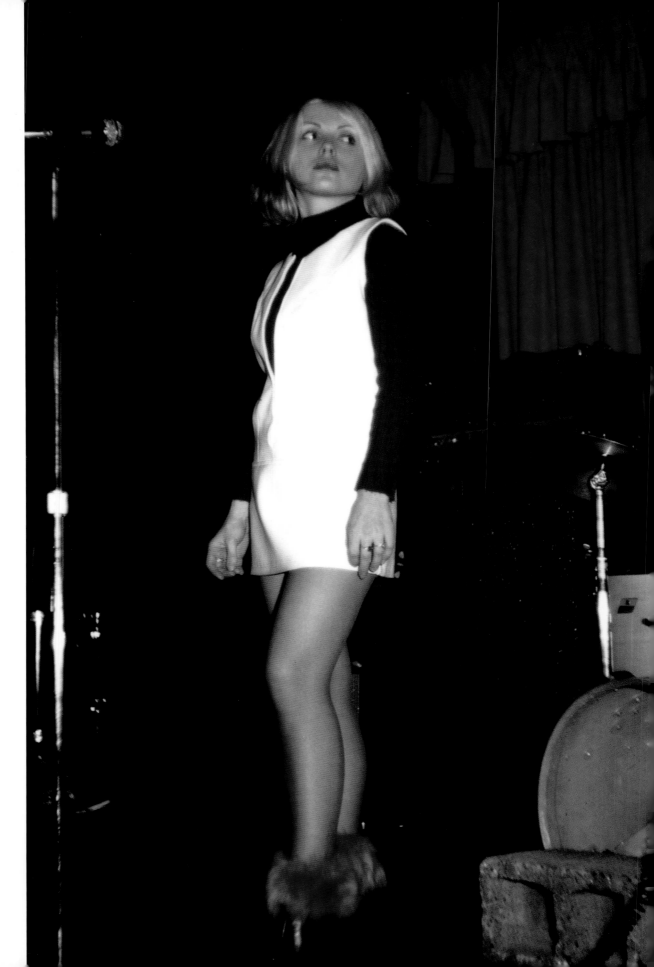

P156

Debbie Harry
(Blondie) / Max's
Kansas City, 1975

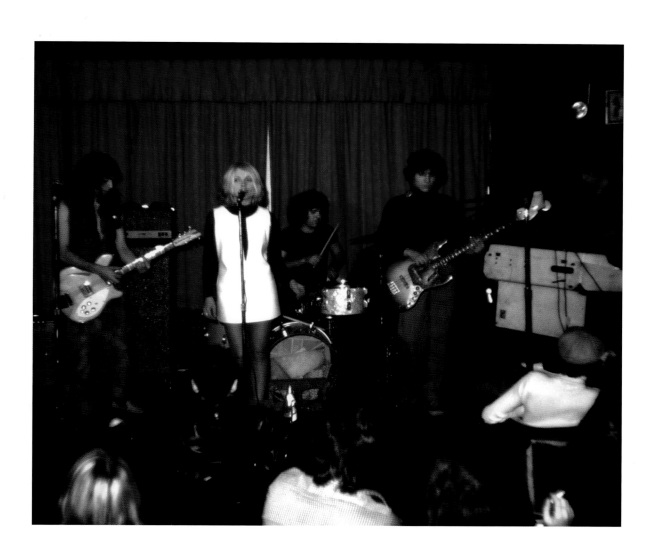

Blondie / Max's
Kansas City,
1975

P158

Blondie / Arturo
Vega's loft,
1975

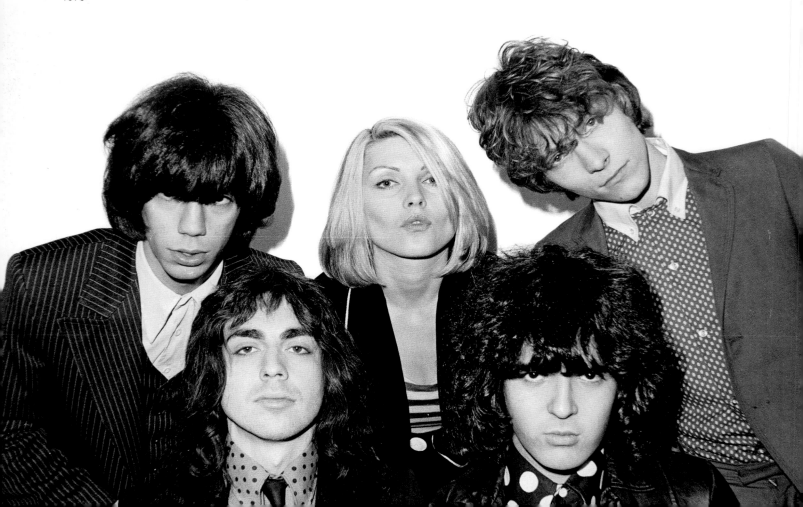

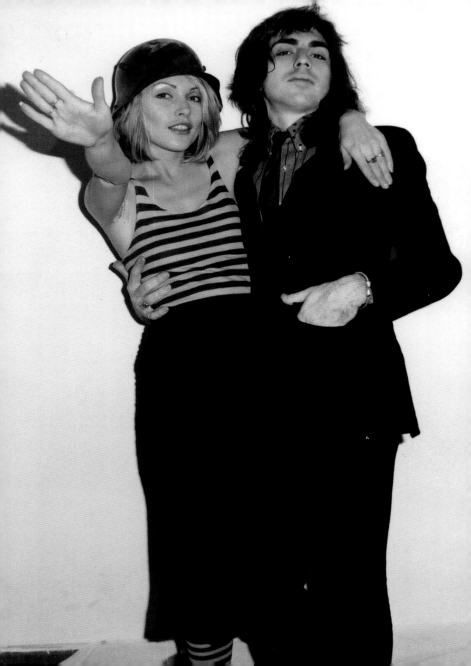

Debbie Harry
(Blondie) / Arturo
Vega's loft, 1975

Contact Sheet
(Blondie) / Arturo
Vega's loft, 1975

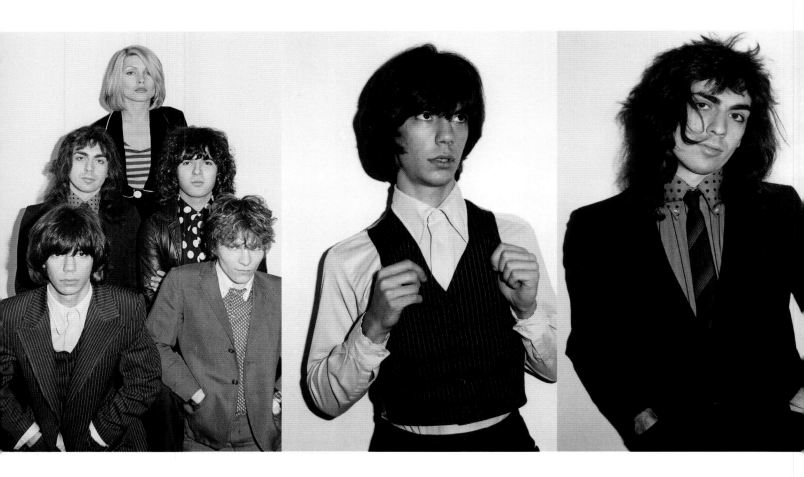

Blondie / Arturo Vega's
loft, 1975
(left)

Jimmy Destri (Blondie) /
Arturo Vega's loft, 1975
(center)

Chris Stein (Blondie) /
Arturo Vega's loft, 1975
(right)

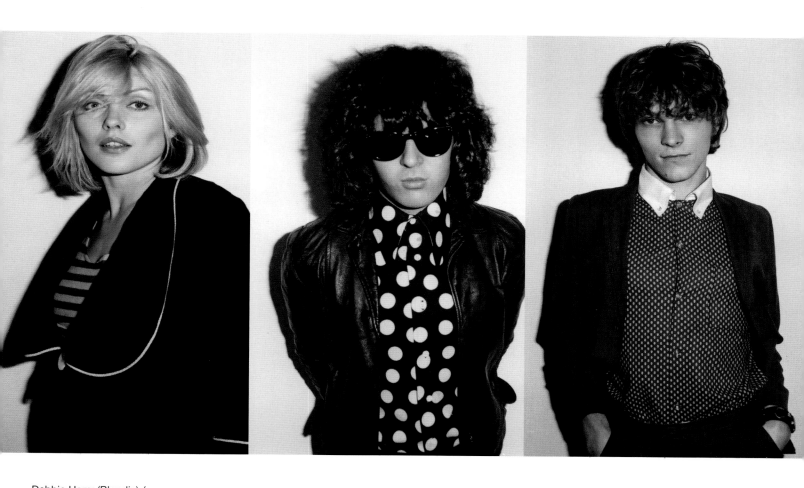

Debbie Harry (Blondie) /
Arturo Vega's loft, 1975
(left)

Clem Burke (Blondie) /
Arturo Vega's loft, 1975
(center)

Gary Valentine (Blondie)
/ Arturo Vega's loft, 1975
(right)

Arturo Vega
/ At Home,
1975

David Johansen (New
York Dolls) / Max's
Kansas City, 1975

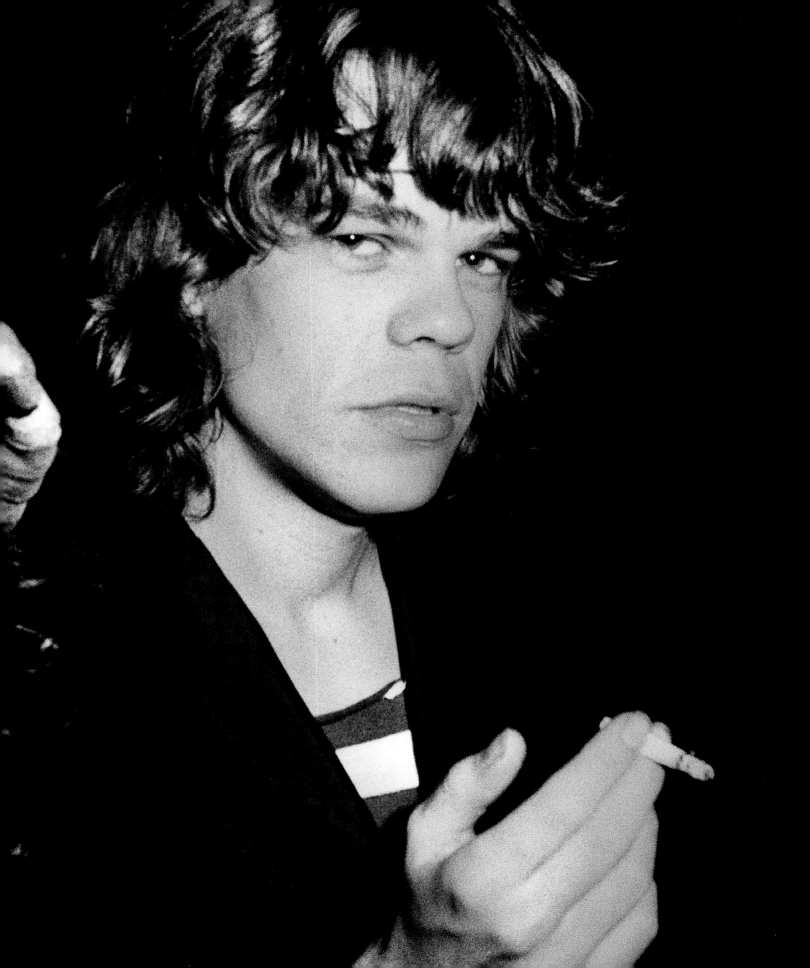

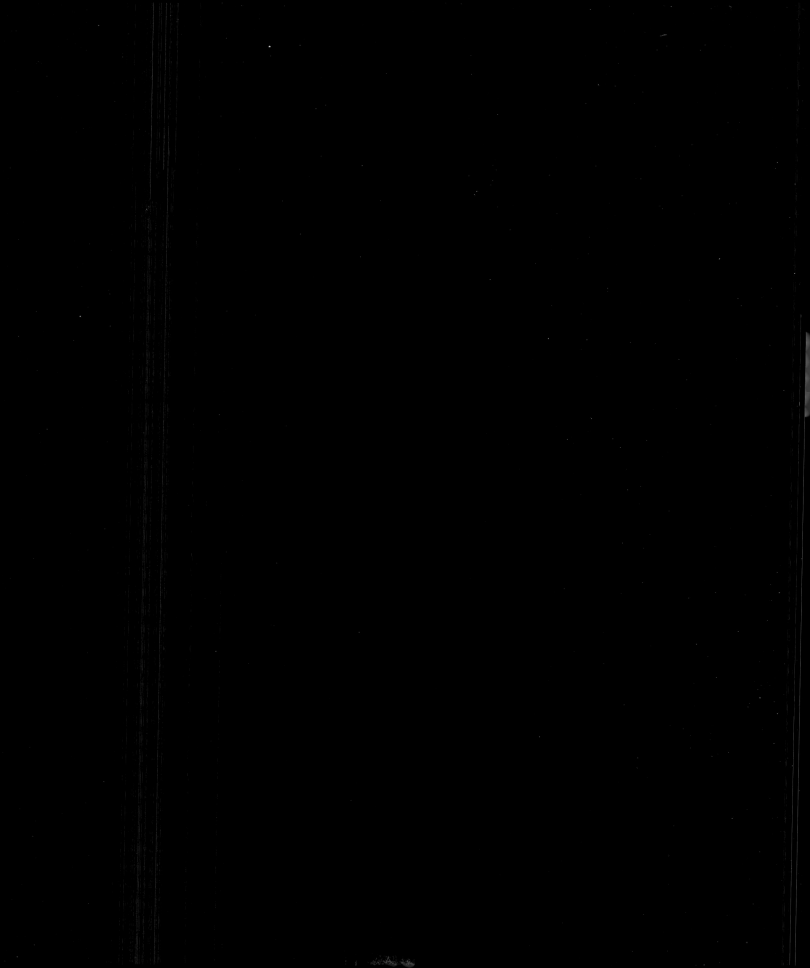

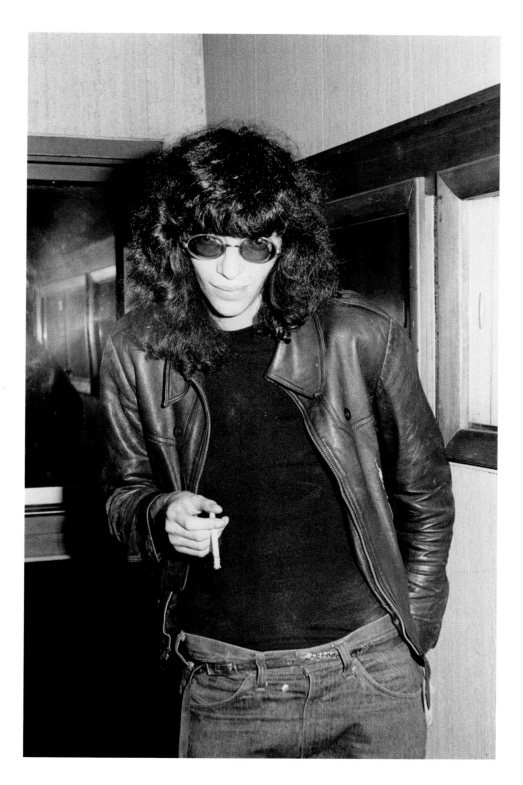

Joey Ramone
(The Ramones)
/ Max's Kansas
City, 1975

Alan Vega, Martin
Rev (Suicide) /
Upstairs at Max's
Kansas City, 1975

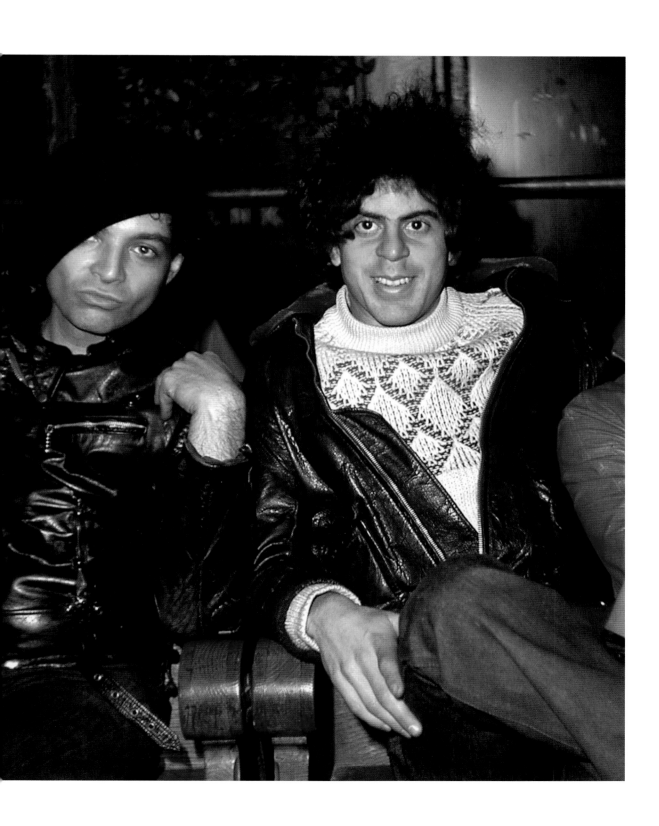

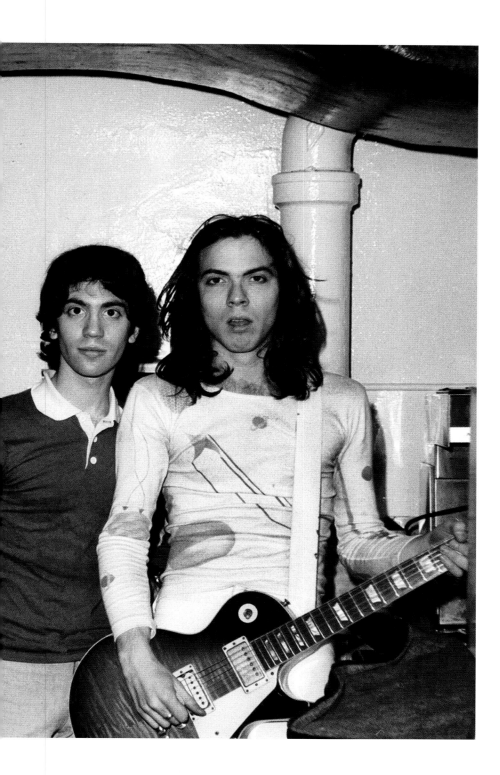

Anthony Jones, Tally
Taliaferrow, Steve
Kroff, Binky Phillips
(The Planets) / Max's
Kansas City, 1975

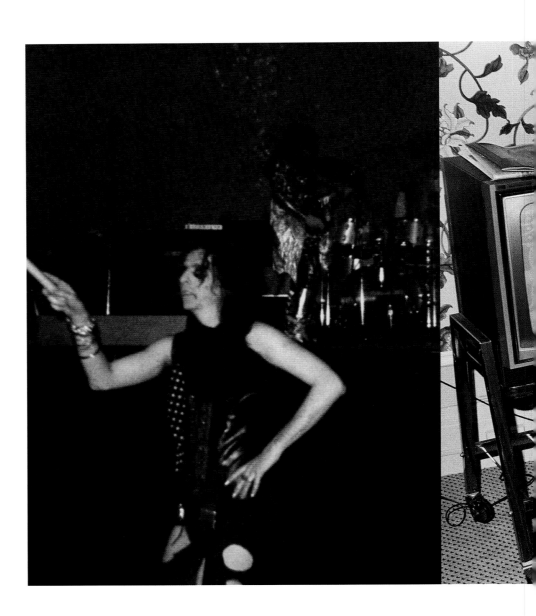

Alice Cooper /
Academy of Music,
December 1, 1971

Alice Cooper /
Manhattan hotel
room, 1975

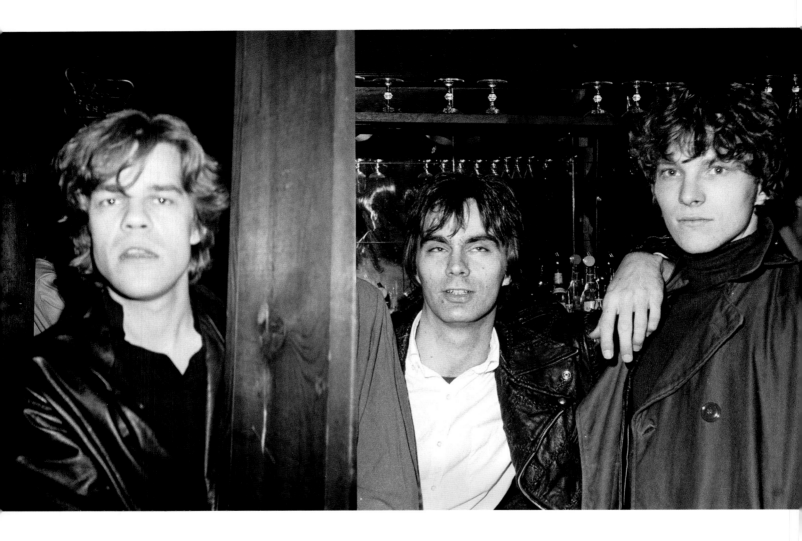

David Johansen
(New York Dolls) /
CBGB, 1975
(left)

Walter Lure (The
Heartbreakers), Gary
Valentine (Blondie) /
CBGB, 1975
(right)

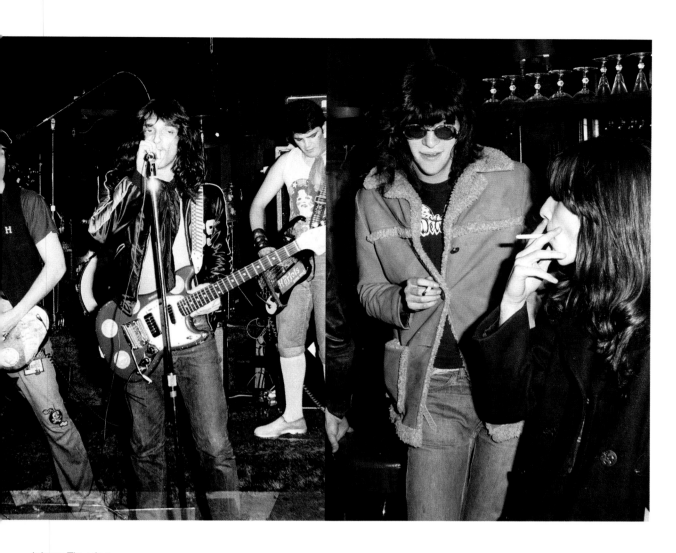

Johnny Thunders
(New York Dolls, The
Heartbreakers) and The
Harlots / CBGB, 1975
(left)

Joey Ramone (The
Ramones), Louis Bova
(The Fast) / CBGB 1975
(right)

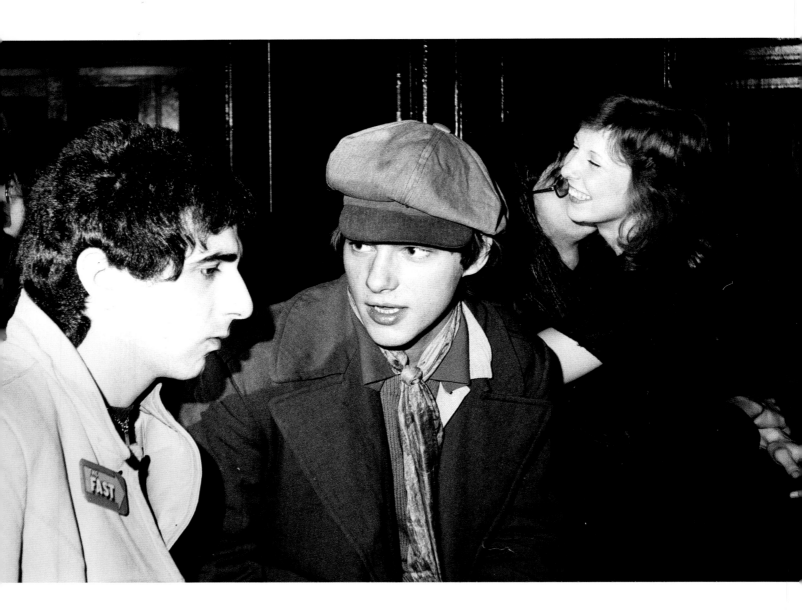

Miki Zone (The Fast),
Richard Lloyd (Television)
/ CBGB, 1975

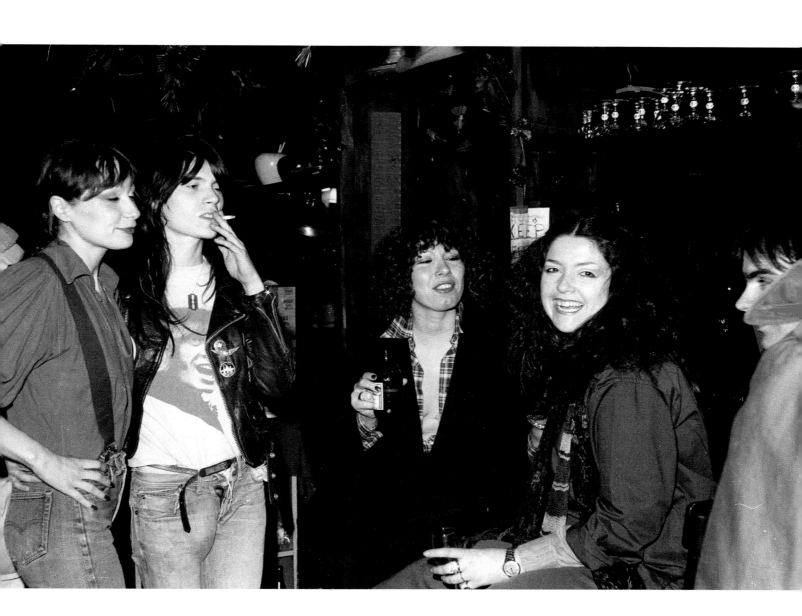

Babbett, Philippe Marcade (The Senders),
Janis Cafasso, Gail Higgins, and Walter Lure
(The Heartbreakers) / CBGB, 1975

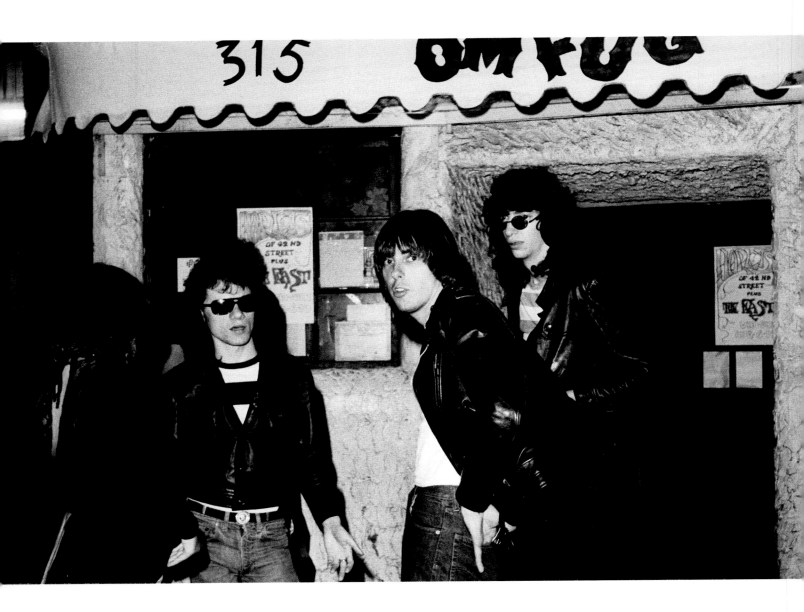

Tommy Ramone, Johnny
Ramone and Joey Ramone
(The Ramones) / Outside
CBGB, 1975

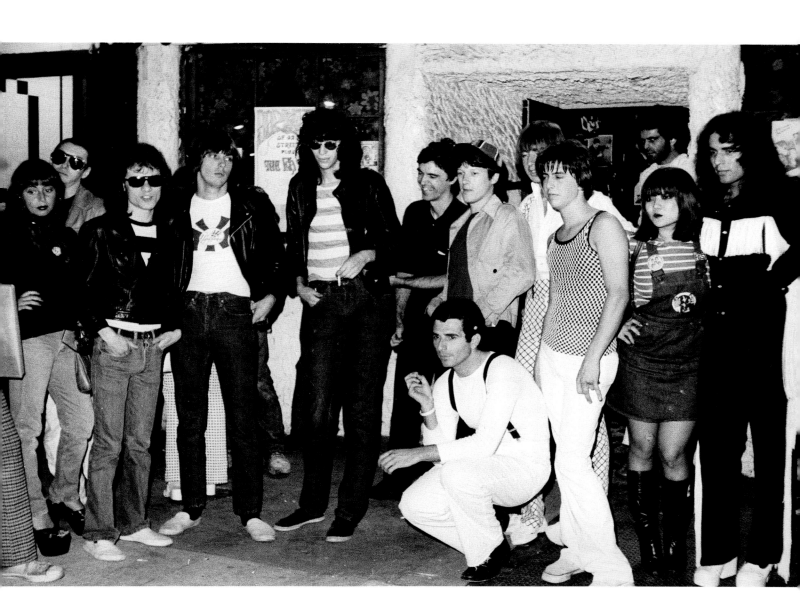

Arturo Vega, Tommy Ramone, Johnny
Ramone and Joey Ramone (The Ramones),
David Byrne and Chris Frantz (Talking
Heads), Miki Zone, Tommy Moonie and
Peter Hoffman (The Fast), Anya Phillips,
and Mandy Zone (The Fast) / Outside
CBGB, 1975

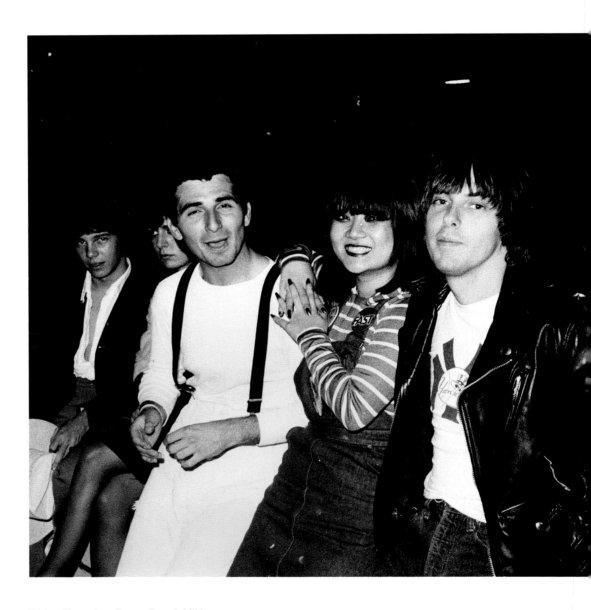

Walter Flemming, Donna Destri, Miki
Zone (The Fast), Anya Phillips, and
Johnny Ramone (The Ramones) /
Outside CBGB, 1975

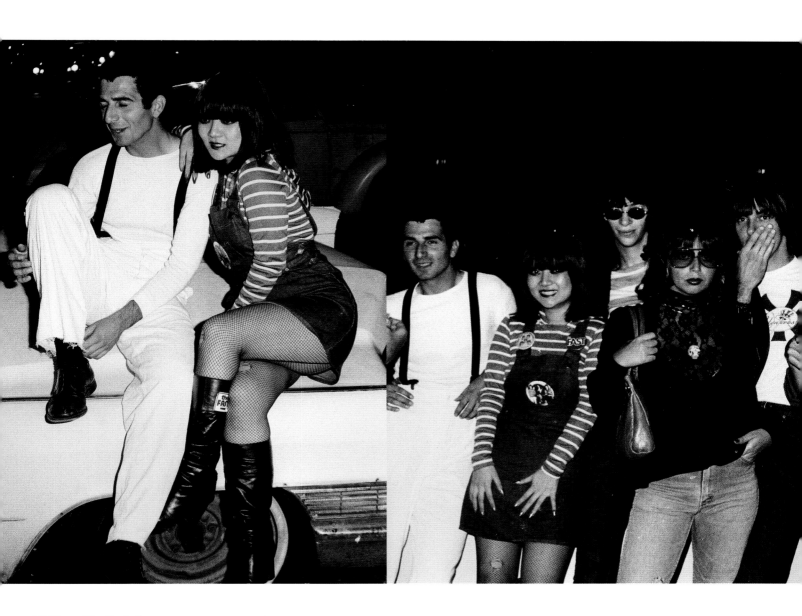

Miki Zone (The Fast), Anya
Phillips / Outside CBGB, 1975
(left)

Miki Zone (The Fast), Anya
Phillips, Joey Ramone and
Johnny Ramone (The Ramones)
/ Outside CBGB, 1975
(right)

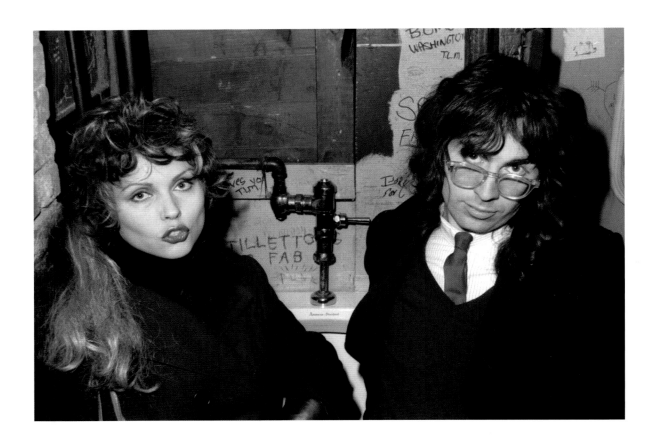

Debbie Harry and Chris
Stein (Blondie) / CBGB
men's room, 1975

Debbie Harry
(Blondie) / CBGB
men's room, 1975

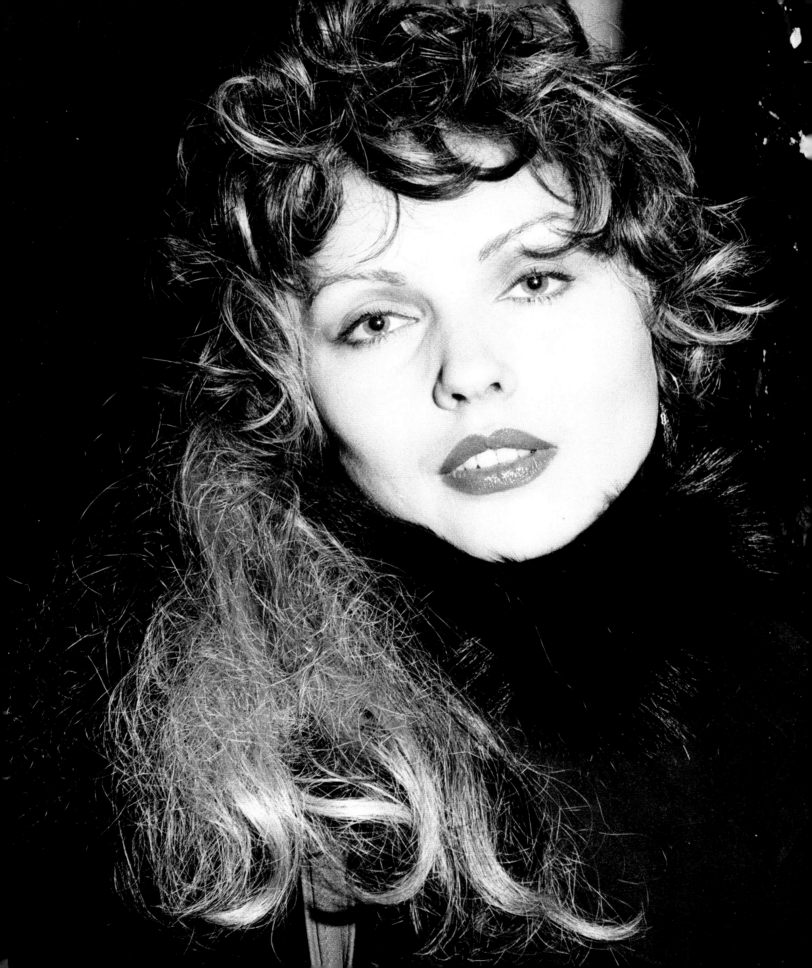

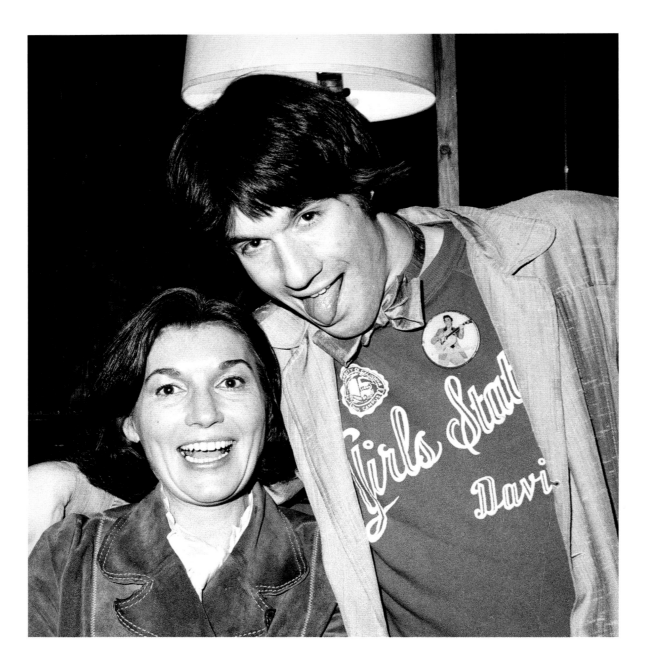

Pat Loud, Lance
Loud / CBGB,
August, 1975

Lance Loud (The
Mumps) / CBGB,
August, 1975

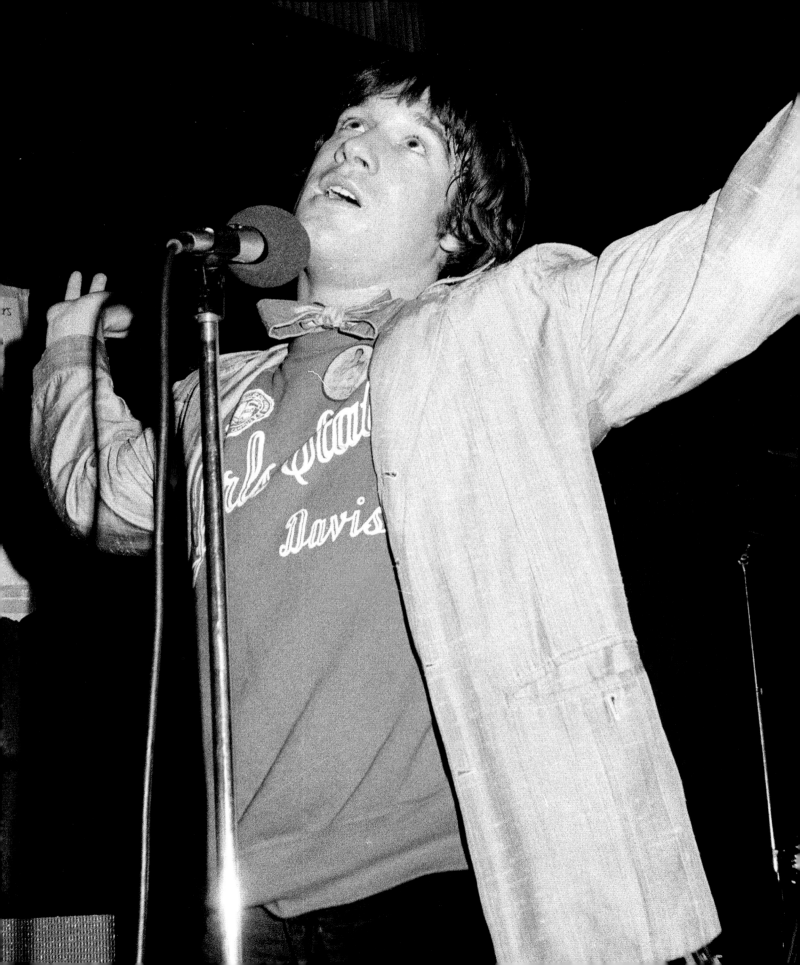

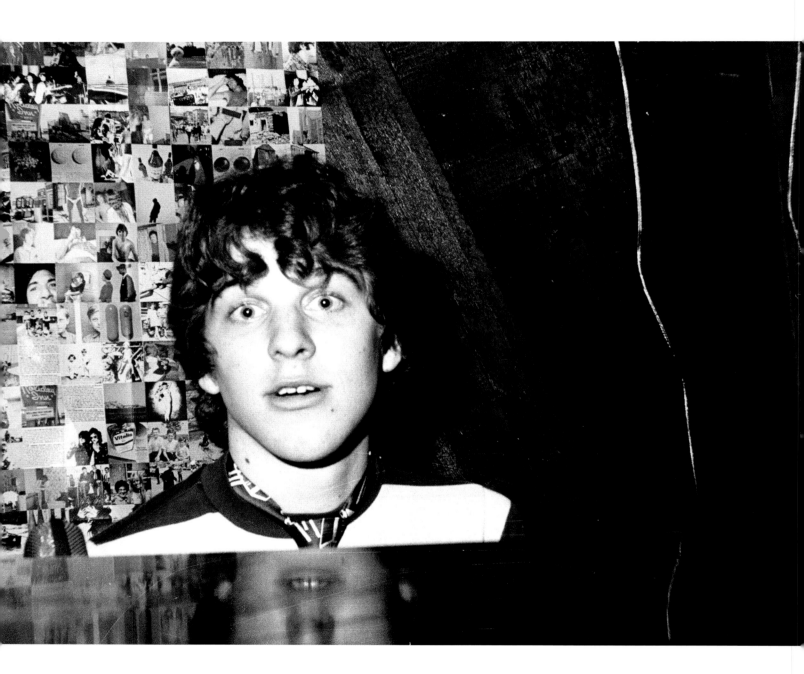

Kristian Hoffman (The
Mumps) / CBGB,
August, 1975

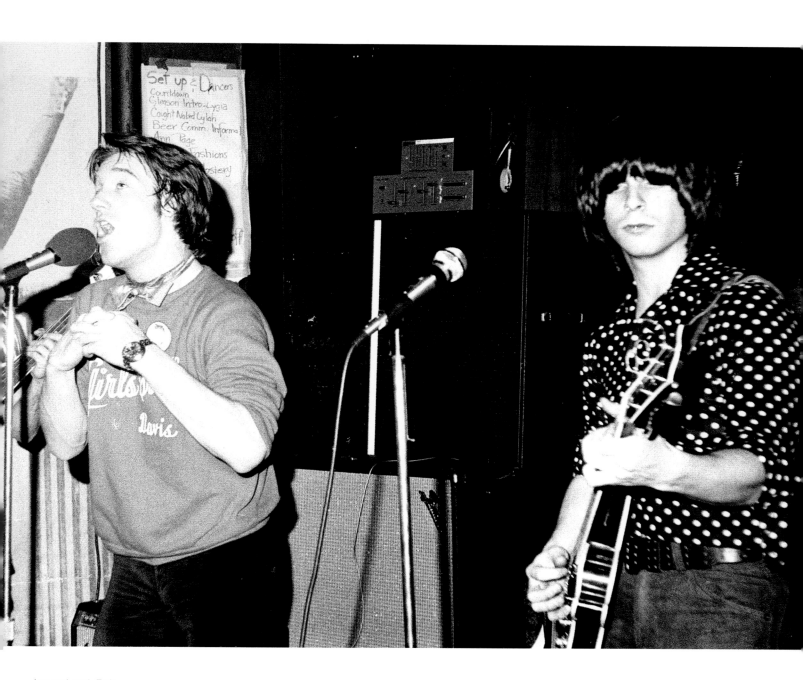

Lance Loud, Rob
DuPrey (The Mumps) /
CBGB, August, 1975

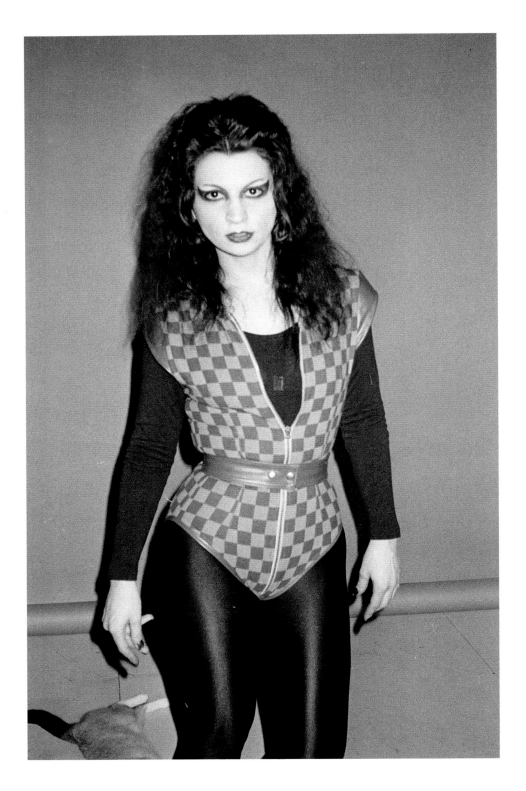

Natasha,
1977

Natasha,
1977

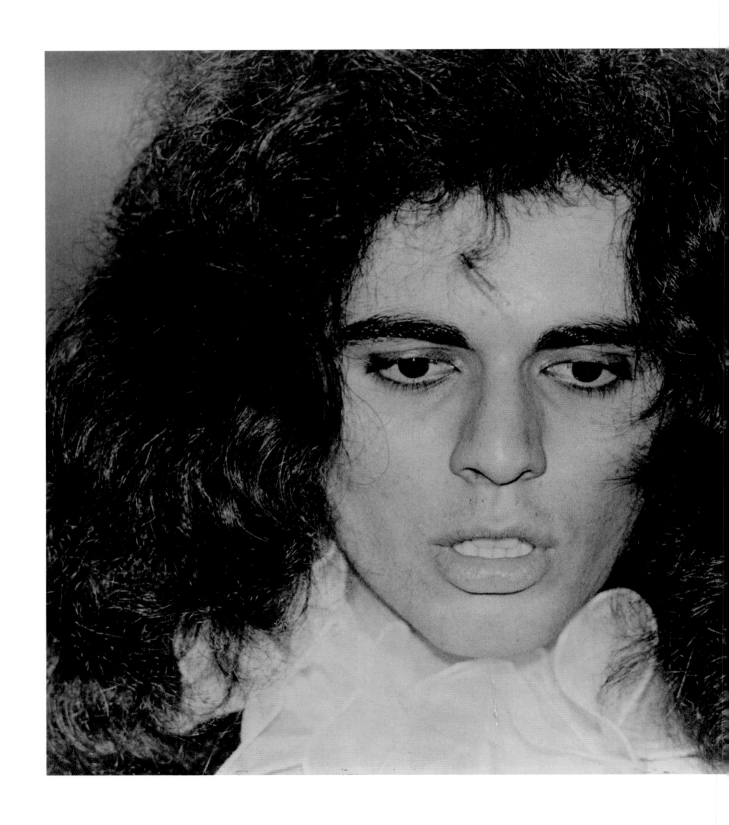

Mandy Zone,
1973

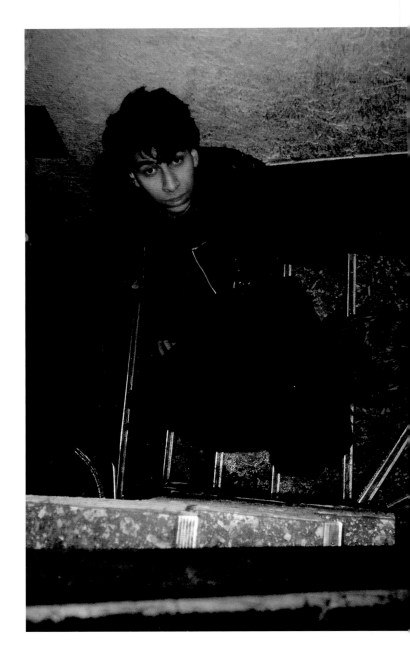

Kid Congo Powers
/ Max's Kansas City
stairway, 1979

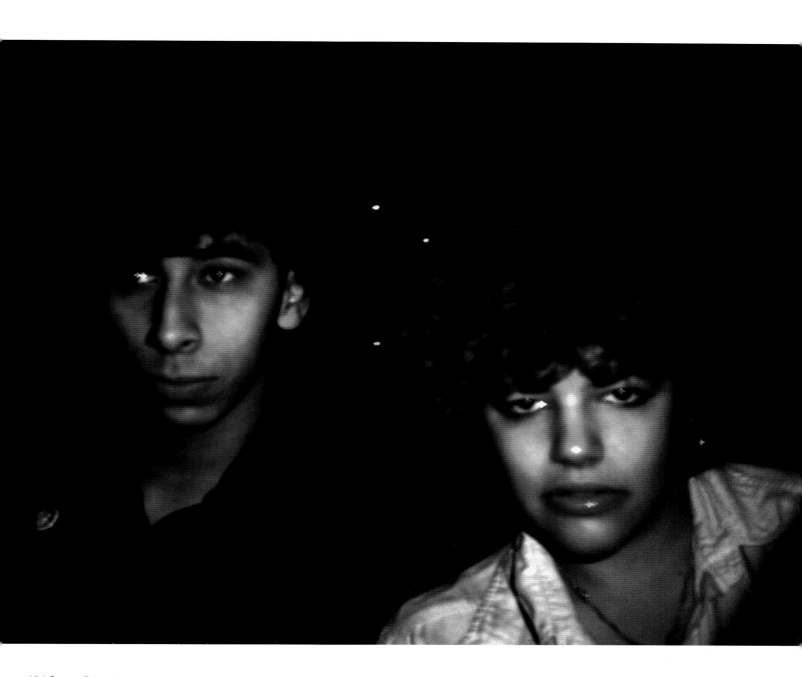

Kid Congo Powers,
Pleasant Gehman /
CBGB, 1978

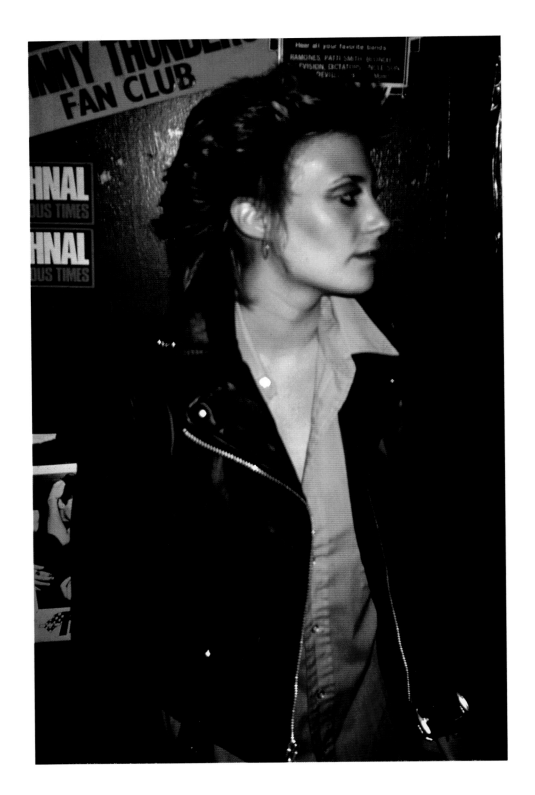

Janis Shaw (Crayola) /
Max's Kansas City, 1977

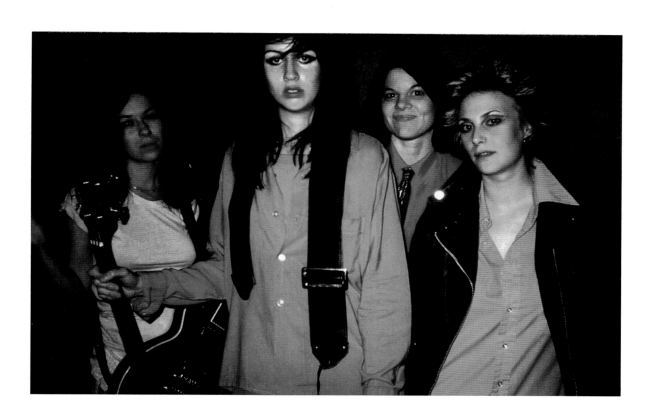

Janna Allen, Karen Boltax, Laura
Hayden, Janis Shaw (Crayola) /
Max's Kansas City, 1977

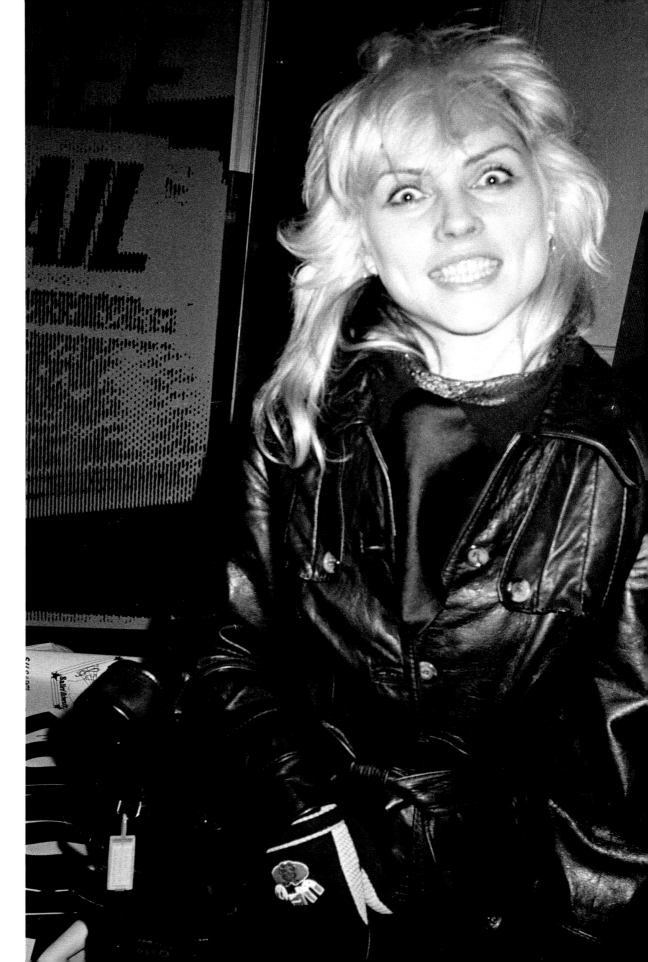

Debbie Harry
(Blondie) / Steven
Sprouse Loft, 1977

Steven Sprouse /
Steven Sprouse Loft,
1977

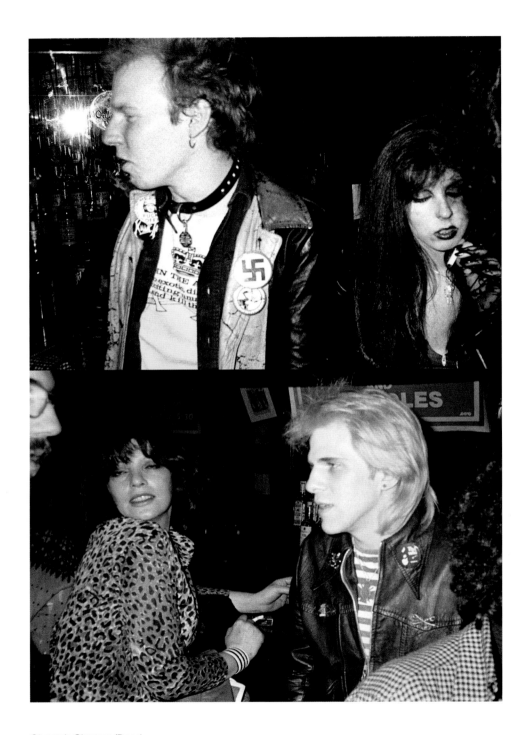

Cheetah Chrome (Dead
Boys), Gyda Gash / CBGB,
1977 (top)

Johnny Blitz (Dead Boys) /
CBGB, 1977 (bottom)

Stiv Bators (Dead
Boys) / Outside
CBGB, 1977

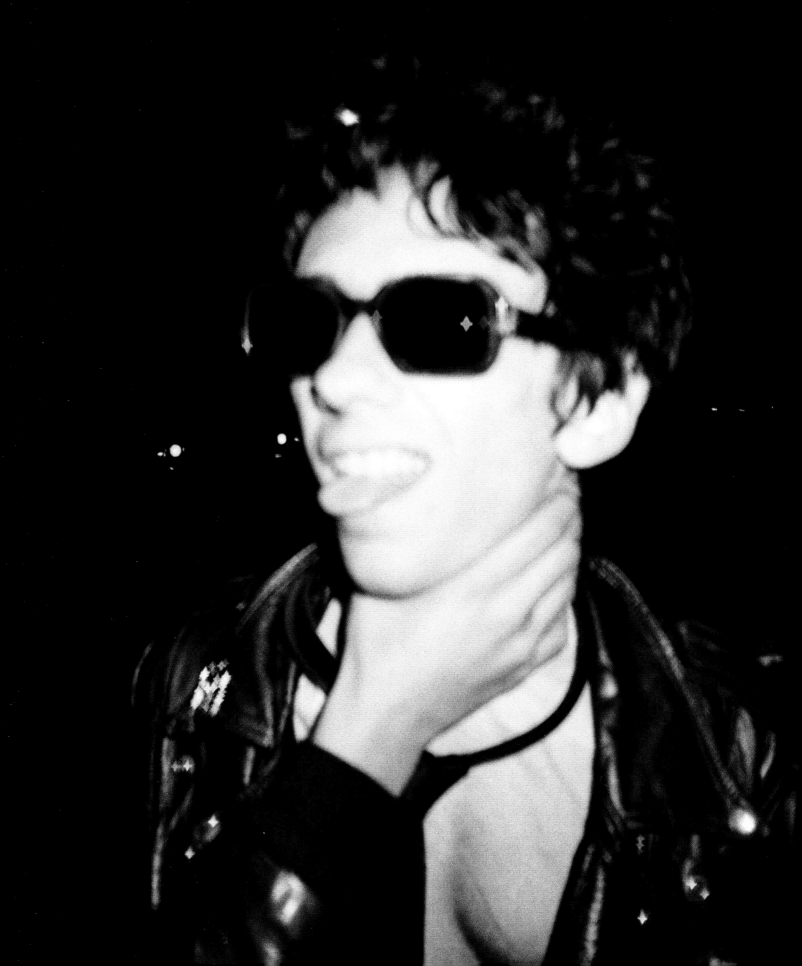

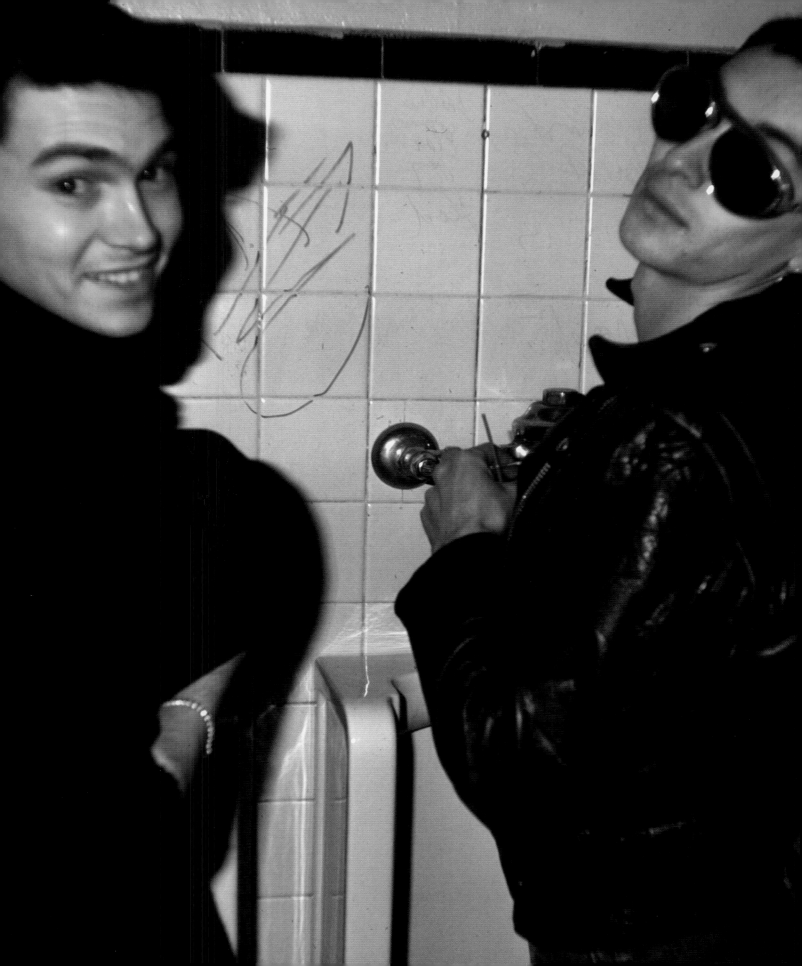

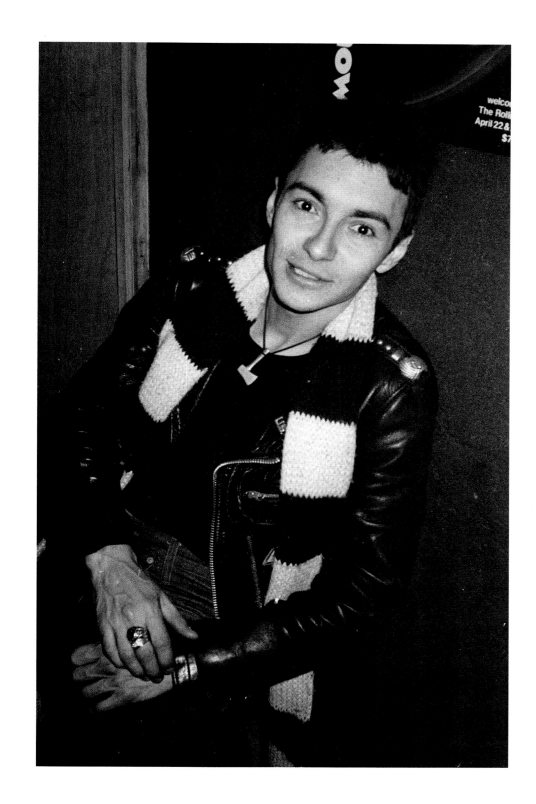

Arturo Vega /
Upstairs at Max's
Kansas City, 1978

Duncan Hannah,
Arturo Vega /
Max's Kansas
City men's
room, 1975

Michael Anthony
Alago / Max's
Kansas City,
1977

Johnny Ramone (The
Ramones), Miki Zone (The
Fast) / CBGB backstage,
September 11, 1976

MY FATHER'S PLACE

July 28-29
FREDDIE KING
Black Smoke

July 30-31
QUICKSILVER MESSENGER SERVICE

Aug 1
The Original
SPIRIT
The Runaways

Aug 2
'Reggae'
BLACK EAGLE
Full Hand Band

Aug 3
CBGB's at MFP
BLONDIE
THE FAST

Aug 4-5
Postponed to October
ROBERT PALMER

:Super:
Guest Attraction
Call for Info

Aug 6-8
GRINDERSWITCH
GREEZY WHEELS

Aug 11-12
The
DICTATORS

Aug 13-15
The
FLYING BURRITO BROS

Aug 16
BURNING SPEAR

Aug 18-20
The
GOOD OL' BOYS
Bluegrass Review

Aug 21-22
THUNDERBYRD
featuring
Roger McGuinn

19 Bryant Ave. Roslyn Village
516-621-3830

Ramones / The Fast
ALSO w/The Ramones July 30 & 31

The Fast
Max's Kansas City, N.Y.C.
Fri., Oct. 15, Sat., Oct. 16.

THE FAST
Max's Kansas City, N.Y.C.
Fri., Nov. 26.

CBGB
and
OMFUG
315 BOWERY
(at Bleecker)
(212) 982-4052
Shows beginning at 9 p.m.
RESERVATIONS HELD TILL 9:15
WEEKEND ADMISSION $4.00

WED SEPT 8, TUES & WED SEPT 14, 15
STARTS 7:30, FREE BUFFET
LOVE RECORDING for
"LIVE AT CBGB's" Vol
Some of the bands considered
for the recording:

Planets Joe Cool
Marbles Orchestra Luna
City Lights de Waves
Jesse Fields Band Cabiria
Rice Miller Band Aliens
Honey Davis Just Water

Smoker Craft
Call for specific dates

TH. FR. SAT SEPT 9, 10, 11
THE
RAMONES
RAMONES
RAMONES
THURS & FRI: **THE POPPEES**
SAT: **THE FAST**

Mon. Sept 13
Audition Showcase for
""Live at CBGB's" Vol. 2

Th. Fri. Sat. Sept 16, 17, 18
THE
HEARTBREAKERS
HEARTBREAKERS

COMING
TALKING HEADS, SHIRTS
MUSICA ORBIS
GOOD RATS, BLONDIE

max's kansas city

OCTOBER 27, WEDNESDAY
STUART'S HAMMER
SASS

OCTOBER 28, THURSDAY
DAY OLD BREAD
LUGER

OCTOBER 29, FRIDAY
RUBY AND THE REDNECKS
FOR SHAKES SAKE

OCTOBER 31, SUNDAY
THE FAST
JOHN COLLINS BAND

Special Halloween Show

OCTOBER 31, SUNDAY
Special
Featuring
KONGRESS
THE DEAD BOYS
THIRD RAIL

NOVEMBER 1, MONDAY
BRONX
ROAD HOUSE

NOVEMBER 2, TUESDAY
THE POPPEES
PEZ BAND

NOVEMBER 3, WEDNESDAY
FUSE
TANK

NOVEMBER 4, THURSDAY
LAUGHING DOGS
SUSAN

NOVEMBER 5, FRIDAY
WILLIE 'LOCO' ALEXANDER and
THE BOOM BOOM BAND
JUST WATER

NOVEMBER 6, SATURDAY
SUICIDE
THE INFLIKTORS
THE SCREWS

SHOWS AT 10, AND MIDNIGHT
213 PARK AVE SOUTH AT 17th ST.
777-7870 TICKETRON

max's kansas city

NOVEMBER 24, WEDNESDAY
THE LAUGHING DOGS
THE EELS

NOVEMBER 25, THURSDAY
DAY OLD BREAD
RIOT

NOVEMBER 26, FRIDAY
THE DOLLS
THE FAST

NOVEMBER 27, SATURDAY
SUICIDE
FUSE
THE CRAMPS

NOVEMBER 28, SUNDAY
KEN WILLIAMS REGGAE
with HUGH HENDRIX
and THE BUCCANEERS

NOVEMBER 29, MONDAY
BLAZE
SAVAGE

NOVEMBER 30, TUESDAY
SHADOW
PENTWATER

DECEMBER 1, WEDNESDAY
STUMBLEBUNNY
featuring Chris Robison
THE PIRATES

DECEMBER 2, THURSDAY
TUFF DARTS
HOUNDS
FOX PASS

DECEMBER 3, FRIDAY
TUFF DARTS
THE BRATS

DECEMBER 4, SATURDAY
THE PLANETS
JOHN COLLINS

PLEASE NOTE OUR NEW
PHONE NUMBER FOR
SHOW INFORMATION:
777-7871

SHOWS AT 10, AND MIDNIGHT
213 PARK AVE SOUTH AT 17th ST.
TICKETRON

P208

Viki Galves /
Brooklyn, 1978

Richard Hell
(Television, The
Heartbreakers)
/ Rum Bottoms,
Long Island, 1978

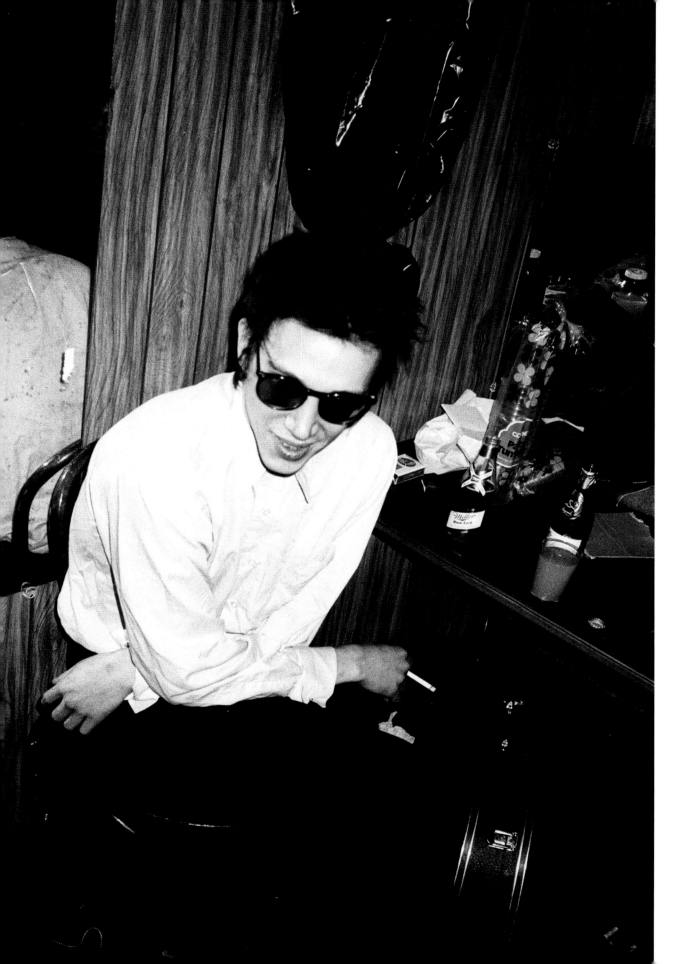

Anna Sui /
Max's Kansas
City, 1978

Billy Stark, Nick Berlin, Howie
Pyro, Brad Barnett (The Blessed)
/ Max's Kansas City, 1978

Howie Pyro,
Billy Stark (The
Blessed) / Max's
Kansas City, 1978

P216

Linda (Danielle)
Ramone / Coney
Island, 1978

Howie Pyro (The
Blessed) / Coney
Island, 1978

Anna Sui /
Coney Island,
1978

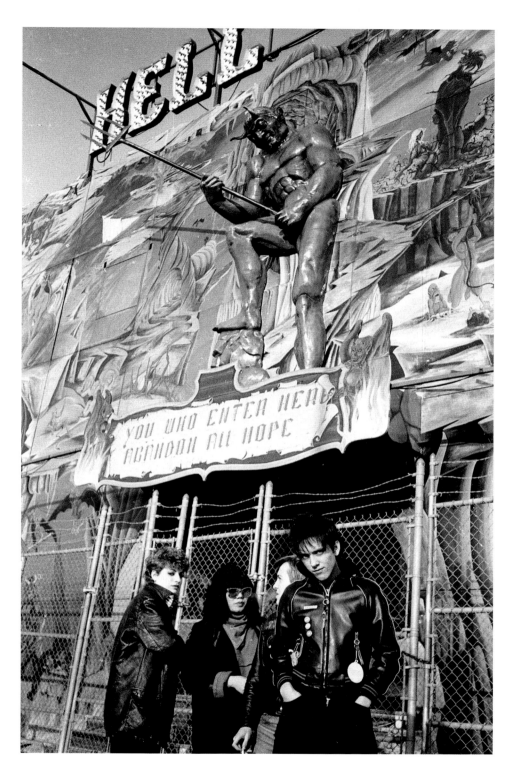

Linda (Danielle) Ramone,
Anna Sui, Nick Berlin, Howie
Pyro / Coney Island, 1978

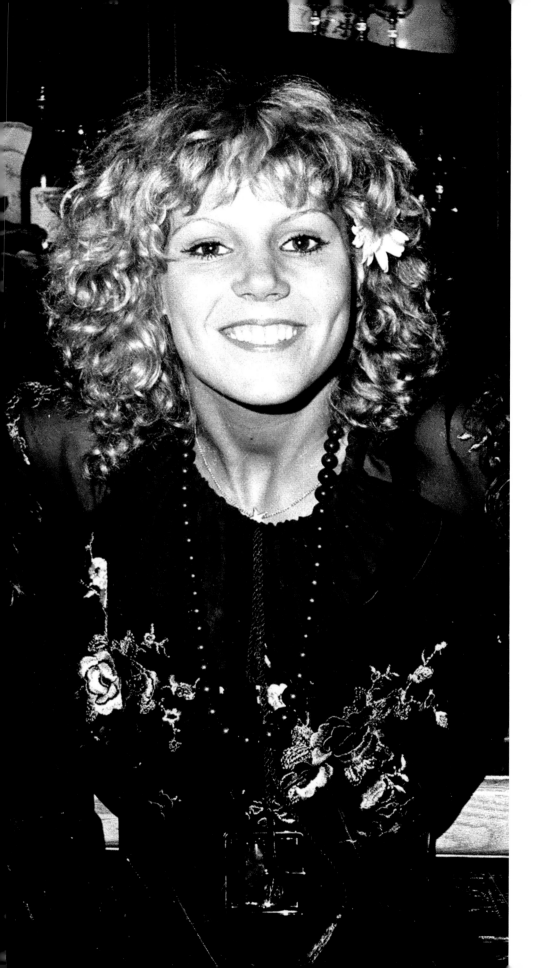

P221

Sable Starr /
CBGB, 1978

P222

David Walter McDermott /
East Village, 1978

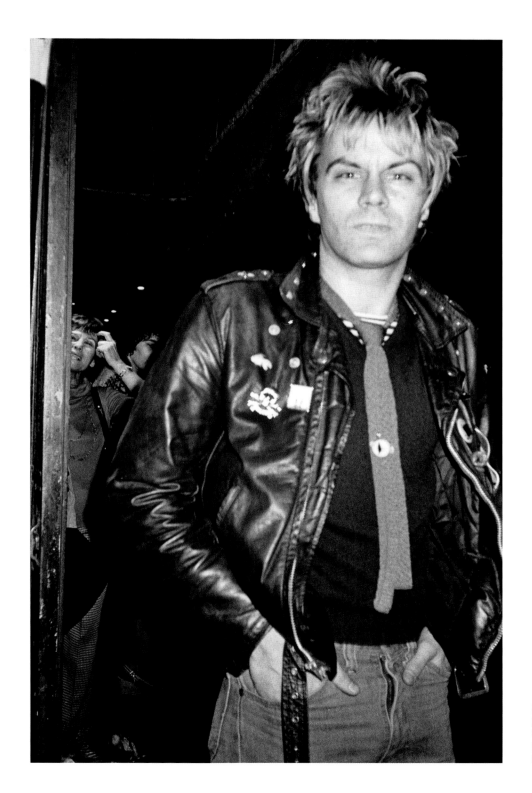

Karen Kristal (Hilly
Kristal's x-wife),
Walter Lure (The
Heartbreakers) /
CBGB, 1978

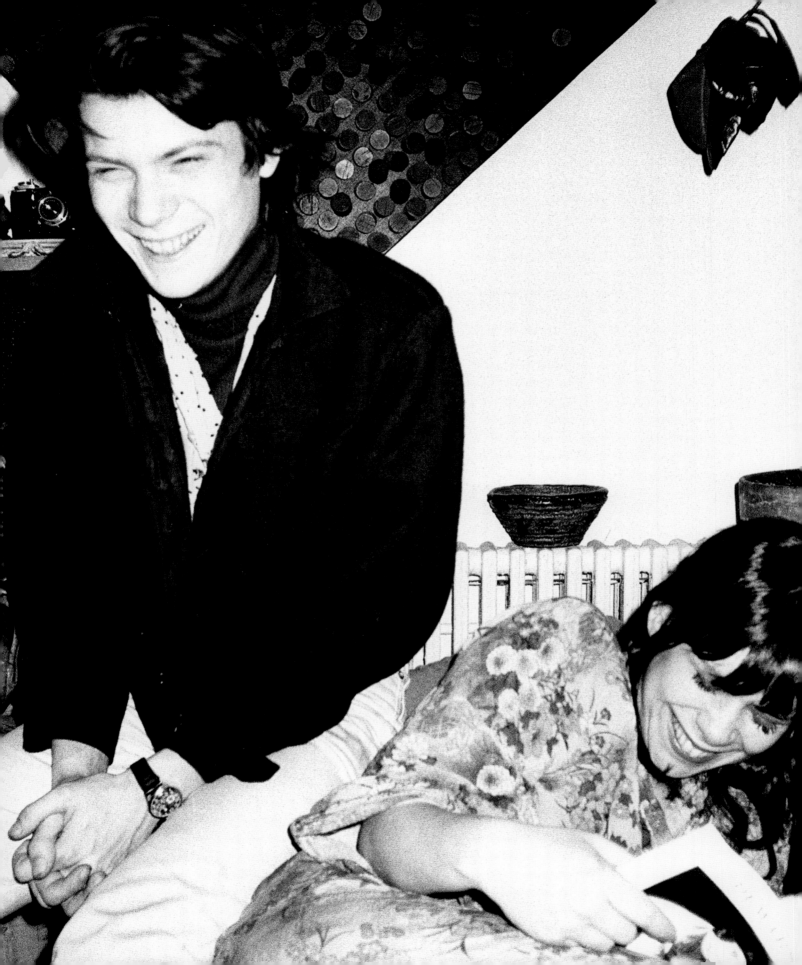

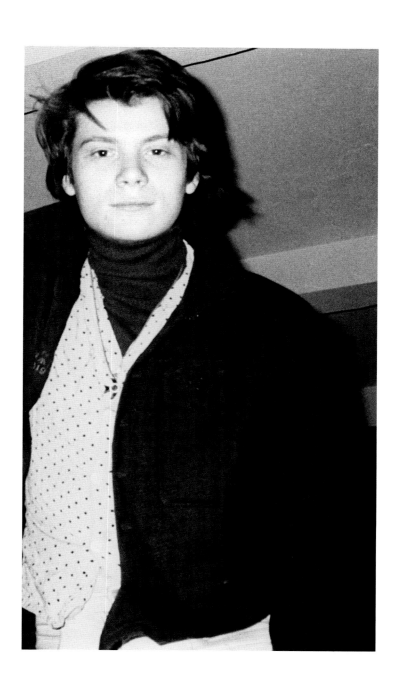

Philippe Marcade
(The Senders) / Max's
Kansas City, 1978

Philippe Marcade
(The Senders),
Phyllis Stein / Max's
Kansas City, 1978

Lydia Lunch
(Teenage Jesus and
the Jerks) / Max's
Kansas City, 1978

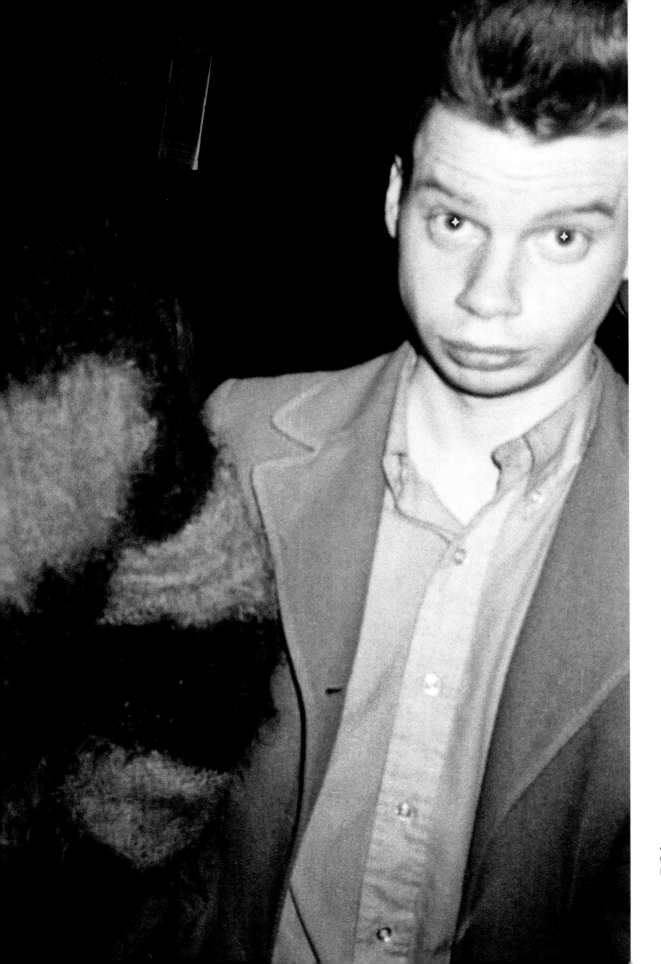

James Chance (The
Contortions) / Max's
Kansas City, 1978

Tish and Snooky (with Linda Limey) / Manic Panic, St. Marks Pl., 1978

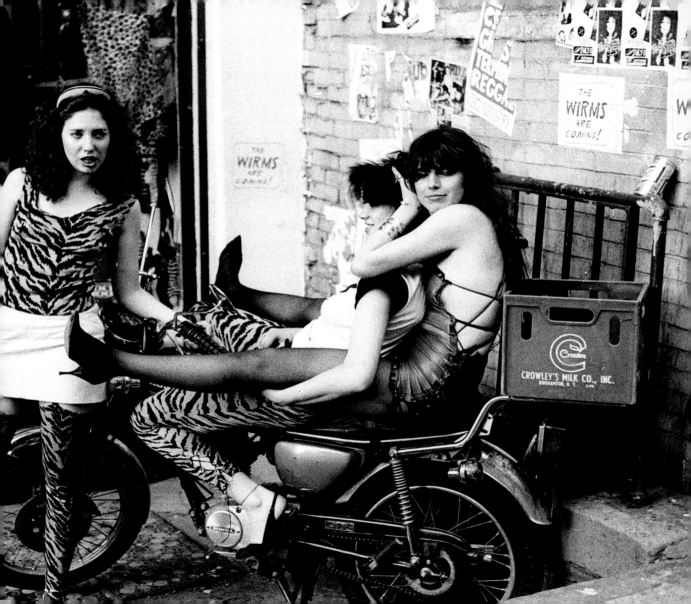

Grand Opening, 14th
St., NYC, 1978

East Village
NYC, 1977

P234

Broadway,
1976

Empire State
Building, 1976

Brooklyn Bridge
(from Brooklyn to
Manhattan), 1973

PHOTO CREDITS